PANORAMIC PHOTOGRAPHY

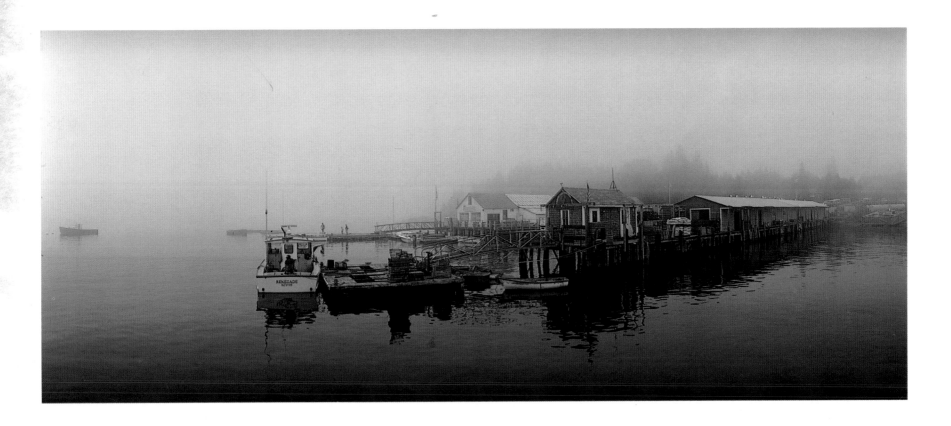

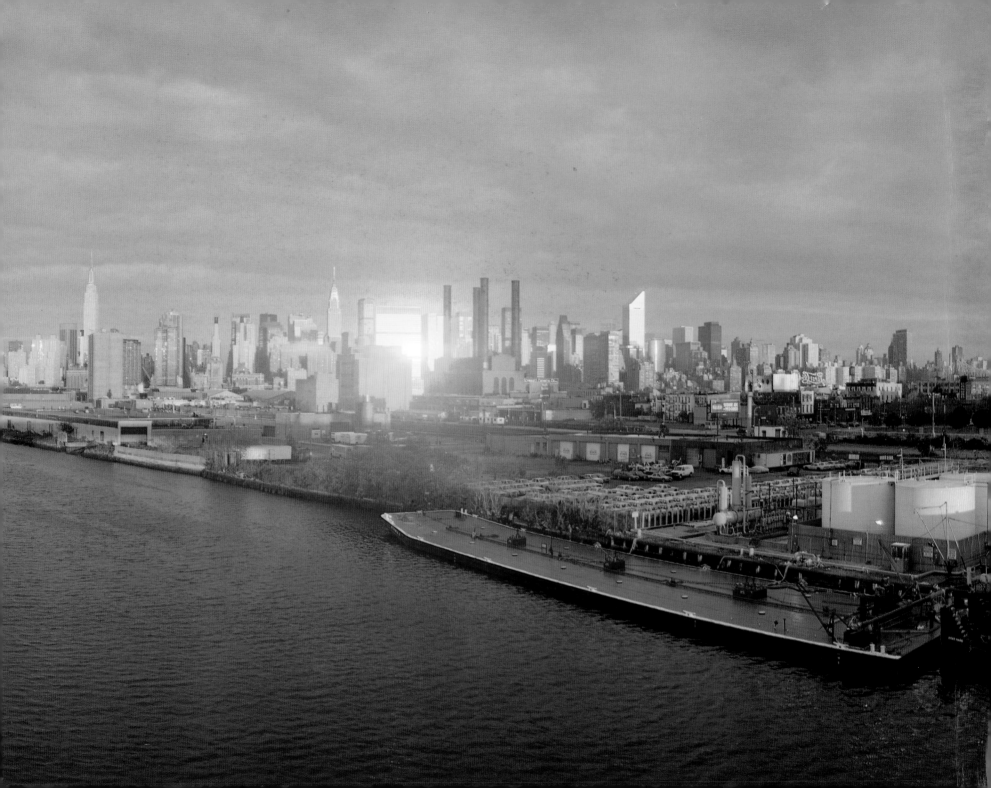

PANORAMIC PHOTOGRAPHY

Joseph Meehan

AMPHOTO

An Imprint of Watson-Guptill Publications/New York

Joseph Meehan is a professional photographer and a professor in the State University of New York system. He has been teaching on the college level for twenty years. In 1982 he was a visiting instructor at the National Academy of Arts in Taiwan, and he has also taught photography and visual-design courses at Ealing College's School of Art in London. Meehan has led workshops with the *f*64 group in California and the New England Photo Workshops. His articles and photographs have appeared in such publications as *Popular Photography*, *Industrial Photography*, *Darkroom Photography*, *Photo District News*, and *The British Photography Yearbook*.

Editorial Concept by Robin Simmen
Edited by Liz Harvey
Designed by Areta Buk
Graphic Production by Hector Campbell

Copyright © 1990 by Joseph Meehan
First published 1990 in New York by AMPHOTO,
an imprint of Watson-Guptill Publications,
a division of BPI Communications, Inc.,
1515 Broadway, New York, NY 10036

Library of Congress Cataloging-in-Publication Data
Meehan, Joseph.
 Panoramic photography.
 Includes bibliographical references and index.
 1. Photography, Panoramic. I. Title.
 TR661.N65 1990 778.3'6—dc20 90-5352
 ISBN 0-8174-5348-2
 ISBN 0-8174-5349-0 (pbk.)

Manufactured in Singapore

1 2 3 4 5 6 7 8 9/98 97 96 95 94 93 92 91 90

*M*any people made this first book on panoramic-photography techniques possible, and I would like to thank them for their time and contributions. I would also like to acknowledge both the support of Amphoto's senior editor, Robin Simmen, and editor, Liz Harvey, whose guidance and direction were invaluable throughout the development of the book, and Lynn Casey, who provided original artwork. A very special thanks goes to Ingeborg Bruckmann, whose tireless efforts in compiling the final manuscript and useful suggestions throughout are very much appreciated.

To my parents,
who taught me that love and sharing
are the basis of life

PREFACE

Anyone who sees a panoramic photograph is immediately struck by how different it is from a conventional photograph. A panoramic image is much longer and contains a great deal to look at, so you have to stop and scan the picture to appreciate its details. And as the word itself implies, panoramas show everything in a scene at once. The ideal subjects are ones of epic proportions: vast landscapes, huge harbor views, large groups of people, and crowded skylines. Someone once said that the difference between conventional and panoramic photography is the difference between looking at a city from a small office window and from a rooftop. Panoramic cameras replace the limited angles of view of conventional lenses that mimic human vision with angles that sweep through wide arcs of a circle. What makes panoramic photography so exciting is its ability to go beyond traditional photography's measurements of reality.

But shooting panoramic images isn't simple. Photographers aren't used to working with cameras that see more of a subject than they do, as well as see it differently. And while the novelty of using unusual cameras that rotate during picture-taking or have wide-angles of view on long formats is appealing, it eventually wears off.

When their pictures all begin to look the same, photographers discover that they must develop a whole new way of looking at the world to successfully use panoramic cameras. For some, this discouraging realization ends their exploration of panoramic photography, while others regard it as a challenge. They want to learn another way to portray the three-dimensional world on the two-dimensional photographic media.

My involvement with panoramic photography began years ago. At first, I thought it was simply fun and different. But soon I found it intriguing—it was giving me glimpses of a new perceptual framework that often contradicted my training and experiences in traditional photography. By taking pictures, experimenting, and, most of all, seeing the images of other photographers, I slowly started to piece together what I call the panoramic viewpoint. While creators of other art forms have struggled with this concept long before I did, I had to come up with my own understanding. For me, the panoramic viewpoint is an awareness that enables me to see vistas in which elements are bound together along a continuum. Every scene, no matter how large, is a whole. Although it was obvious that panoramic cameras could best capture such expanses on film—by

nature of their unique designs—I knew that they couldn't do it by themselves. It was up to me to develop this awareness. With it, I would be able to compose images filled with unified rather than disparate elements.

These experiences led me to write this book. I hope to share with you three important points. First, as a panoramic photographer, you must learn to think and see within a panoramic framework in order to exploit the camera technology. You must also accept that this panoramic viewpoint often opposes conventional photographic perceptions. Finally, you must understand how panoramic cameras affect the way images appear on film. Notice that I mentioned technology last, after visual orientation. Viewing the world in terms of panoramic possibilities will be far more helpful then merely knowing how to operate a camera. The book begins with a look at the 140-year history of panoramic photography. Next, I discuss the panoramic viewpoint in terms of panoramic and conventional composition and then move on to camera technology and other related points, such as exposure, film, and darkroom work. Finally, I explain alternative ways to achieve panoramic images and suggest ways to market your work successfully.

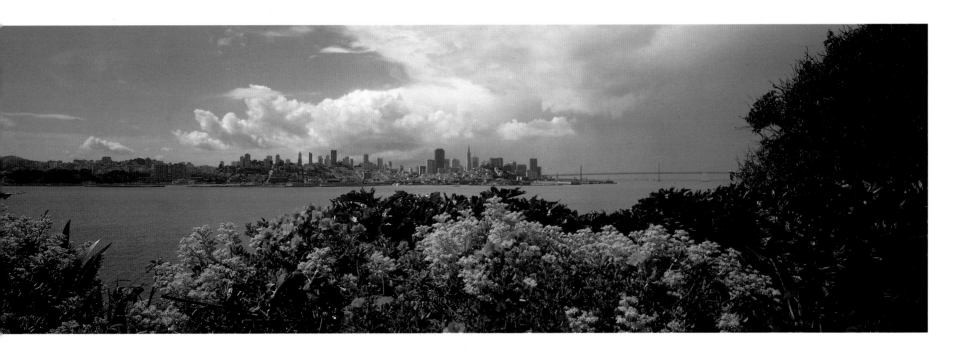

Panoramic photography is riding a wave of popularity and acceptance, in large part because of a whole new generation of cameras. Panoramic images are everywhere. Their uses range from advertisements in major magazines to postage stamps. Stores geared to professional photographers promote themselves as panoramic rental centers. There is even a stock-photography agency devoted entirely to panoramic images. In the jargon of the advertising world, panoramic photography is "hot." This widespread popularity offers you the chance to explore new ideas and interpretations.

I hope that the information and images in this book inspire you and help you to work with the new cameras. I also hope that you come to realize that the panoramic viewpoint will enable you to produce more creative, diverse photographs.

This photograph of the San Francisco Bay is a compelling combination of a cityscape and a natural landscape. The image graphically shows why panoramic images capture attention. (© M. Carter/P.S.I. Chicago 1990.)

INTRODUCTION

What do cave paintings of prehistoric animal hunts, reliefs of Egyptian pharaohs showing their worldly entourages, ancient Chinese scroll paintings depicting historical events, and medieval tapestries of famous battles have in common? They attempt to encapsulate particular world views in singular sweeping vistas. For example, the first artists often painted not single animals but herds—and included representations of themselves as hunters to provide viewers with a sense of both the expanse and the action of the hunt. Every major civilization has developed panoramic depictions of life through such mediums as painting, architecture, photography, and film. Regardless of the medium used, the panoramic concept has been a part of the art world since the beautiful depictions of animals on cave walls.

THE PRECURSORS: THE DIORAMA AND PANORAMIC PAINTINGS

At the time of photography's birth in the mid-nineteenth century, two art forms encouraged early photographers to experiment with making panoramic images: the diorama and panoramic paintings. In *World History of Photography* (New York: Abbeville Press, Inc., 1984), photo historian Naomi Rosenblum defines the diorama as a

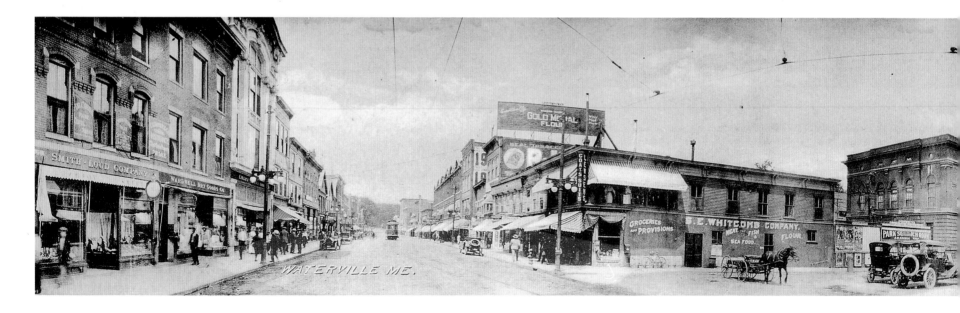

combination of stage scenery and painting that "contrived to suggest three-dimensionality and atmospheric effects through the action of light on a series of realistically painted flat scrims." As audiences sat in darkened rooms and theaters to watch a diorama, lights played on and through these transparent paintings, and background sound effects helped to create an impressive sense of panoramic realism. Typical subjects for dioramas were important historical moments and geographical settings.

Panoramic paintings consisting of huge canvases filled with vistas of historical themes were even more popular and widespread. Audiences were captivated by these sweeping views that sometimes reached up to 10,000 square feet in size. Exhibition openings became major social events, complete with music and narration.

Postcards were, and continue to be, a favorite outlet for panoramic photographers. The image on this postcard was shot in Waterville, Maine, in 1914—when mailing a postcard cost a single cent.

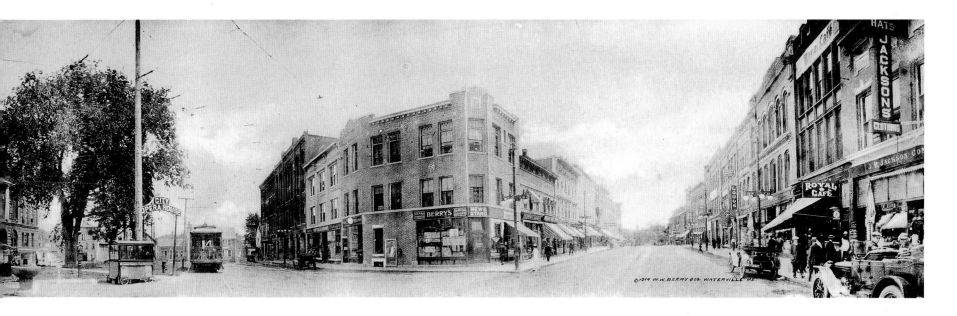

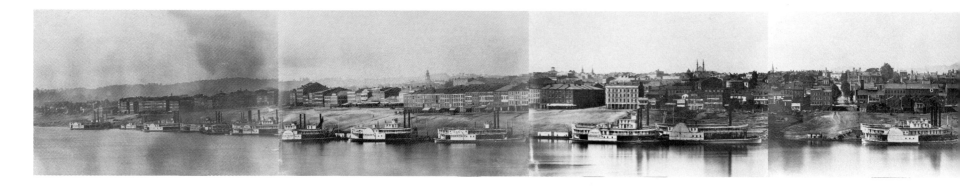

EARLY PANORAMIC ASSEMBLAGES: THE SEGMENTED PANORAMA

Photography has had a panoramic element since its beginning. Louis Daguerre, one of the medium's founders, co-invented the daguerreotype, a photograph formed when a highly polished copper plate, coated with a light-sensitive, silver-based material, was exposed in a camera and then developed in mercury vapor. The result was a remarkably detailed image. Daguerre also assisted the most important panoramic painter of the nineteenth century, Pierre Prévost, and claimed to be the inventor of the diorama. Another famous pioneer of photography, William Henry Fox Talbot, was probably the first photographer to join two or more pictures to produce a wider, or panoramic, impression. This technique, referred to as panoramic assemblages or segmented panoramas today, was introduced by Talbot in 1843; a two-shot panorama of his studio-lab in Reading, England made in 1846 is his most famous example. Both pictures were calo-

types, another early process Talbot invented. Calotypes were made by treating sheets of high-quality paper with photochemicals. The paper was then exposed in a camera and developed in a solution of silver nitrate and gallic acid. The result was a paper negative, which was used to make positive images by passing light through the paper negative to a second calotype sheet.

Eadweard Muybridge, best known for his work photographing movement and developing motion pictures, was actually the prominent creator of segmented panoramas during the Victorian age. He photographed several cities, including San Francisco, in the late 1870s. One of these panoramas was shot in thirteen sections with an 18 × 12-inch field camera and assembled into a 7-foot picture. A second version reached 17 feet in size and was butted together so perfectly that the joints, usually visible, were undetectable. Other notable Victorian panoramists include Roger Fenton, who founded the Royal Photographic Society and photographed the Crimean

War; Francis Firth, who shot Egypt in 1858; and Carleton E. Watkins, who concentrated on the western wilderness of the United States.

These early panoramists preferred using large cameras because they were shooting one-of-a-kind daguerreotypes. Attempts to create huge panoramas were hindered somewhat by the borders between each plate. Later, the enlargement process and a general improvement in photographic technique and equipment made huge, continuous panoramas with minimal signs of segmentation possible. In fact, it seemed that there would be no end to larger and larger panoramas during the latter half of the nineteenth century. Muybridge's photographs no longer seemed unusual. For example, Watkins assembled images up to 10 feet long, for which he became famous in the United States. And Bernard Otto Holtermann photographed Sydney's harbor under what can only be described as extraordinary circumstances. Holtermann positioned himself and his equipment—including three

glass negatives, each of which was a little more than 3 × 5 feet in size and weighed 60 pounds—on top of a 70-foot tall tower. The resulting image measured 15 feet. In a later attempt to capture the same scene, he shot with much smaller glass plates in order to assemble a 33-foot rendering.

In Italy in 1904, the ultimate panorama, a 5 × 40-foot colossus depicting the Gulf of Naples, was created by Neue Photographische Gesellschaft of Berlin. This magnificent panorama was retouched by artists and caused a sensation at the St. Louis World's Fair. In an article entitled "The Early Panoramists" in *Darkroom Photography* (January/February 1984), photo historian Peter Palmquist's description of how the panorama was made is evidence of the incredible perseverance, ingenuity, and imagination of these early panoramists.

Six negatives were made, each about 8¼ × 10½ inches. With an enlarging apparatus fitted a specially made condenser 12½

inches in diameter, six separate exposures, (one for each negative) were made on a single long piece of bromide photographic paper. These exposures each measured 60 × 80 inches.

The print was processed on a large vertical wheel 6 feet wide, with a diameter of 13 feet, and a circumference of about 41 feet. Three troughs of processing solutions were prepared. Each trough was on wheels which ran on a railway underneath the huge print wheel, where the solution was applied with sponges. When the development was complete, the print was flushed with dilute glacial acetic acid to stop development. Then, after fixing, the final washing took place in a trough 50 feet long containing 3,000 gallons. This step lasted 8 hours and used more than 80,000 gallons of water. All operations, by the way, were conducted in the open, at night. The finished panorama was spectacular.

This eight-plate daguerreotype of the Cincinnati riverfront was photographed in 1848 by Fontayne and Porter and now hangs as a long mural on the first floor of the Public Library of Cincinnati, Hamilton County. (Courtesy: Public Library of Cincinnati and Hamilton County, Ohio.)

Segmented panoramas weren't limited to printed pictures. There was a parallel, although not as widespread, development of projected panoramas that we now refer to as multi-screen slide shows and movies-in-the-round. The first panoramic movies were shown as a demonstration of motion-picture-film technology in 1896 and were appropriately called *cineoramas*. But such presentations were limited in number, and they didn't actually become an option until later in the twentieth century. Still projections, or multi-screen slide-shows-in-the-round, however, garnered some attention before fading by the time of World War I. For example, at the 1893 Chicago World's Fair, Charles A. Close astounded audiences with "Electric Cyclorama," an event that can probably be regarded as the first 360-degree slide show. Similar presentations were staged shortly thereafter in the United States by Thomas Barber, who created "Electrorama" and in France by August and Louis Lumière, who put on "Photorama." The Lumière brothers' show was quite popular with Parisians because of its 360-degree views of the French countryside.

EARLY PANORAMIC CAMERAS

While all of these panoramic assemblages flourished and then faded, other panoramists were developing cameras that could make single negatives of sweeping views up to 360 degrees. The first "true" panoramic camera was built in 1844 by Friedrich von Martens. The Megaskop, as it was called, was a short-rotation, or swing-lens, camera with a slit behind the optics. The camera produced an image measuring 4.7 × 17.5 inches on a daguerreotype plate as the lens, moved by a handle connected to a set of gears, traveled through a 150-degree arc. The end of the tube holding the moving lens was almost completely closed, leaving only a slit opening whose top half was slightly wider than the bottom. As a result, more exposure was given to the sky than to the foreground. A later version of the Megaskop was designed for wet-plate, curved-glass emulsions.

Between the development of von Martens' Megaskop and modern panoramic cameras, many cameras built by creative individuals appeared for short periods of time in very limited numbers. These cameras often had unusual designs or means of operation. For example, the "pigeon" panoramic camera devised by Dr. Julius Neubronner of Bavaria was strapped around a bird and set for exposure by a windup, delay-trigger mechanism. At the same time, several commercial cameras were produced in significant numbers and remained available for quite a few years. These included the Al Vista camera, manufactured by the Multiscope Film Company, and the No. 4 Panorama of 1899, Kodak's first panoramic camera, which remained available in other models until the 1920s. These short-rotation designs were marketed almost like modern snapshot cameras: they were aimed at a wide market and were quite handholdable. In fact, other types of short-rotation models were available through early Sears, Roebuck catalogs.

Panoramic cameras based on a stationary-wide-angle-lens design first appeared in significant numbers after 1860. These cameras, too, were sometimes rather unusual. In 1859 Thomas Sutton came up with a design that featured a spherical lens filled with water to achieve the wide-field effect. Other designers tried conical mirrors and lenses with curved front elements in order to achieve the same effect. Some of these cameras were built for specific purposes. The Robin Hill Cloud camera, for example, was intended for photographing the sky. A group of large, stationary-lens cameras were named "banquet" cameras because photographers primarily used them to shoot huge dinner parties and conventions. These cameras combined wide-angle lenses with sheet film that measured 7 × 17 inches or 12 × 20 inches.

Although many photographers regard Kodak's Cirkut camera as one of the earliest panoramic cameras, they don't know that the first Cirkut models weren't built by Kodak. These were produced by the Rochester Panoramic Camera Company in 1904, sixty years after the introduction of the Megaskop. The confusion about the origin of the Cirkut cameras arises because Rochester Panoramic merged with the Century Company and later was bought out by Eastman Kodak in 1907. Then, although the cameras were officially produced by the Folmer and Schwing Division of Eastman Kodak, they became known

This photograph of the No. 10 Cirkut camera was printed in the camera's original instruction manual. (Courtesy: J. C. Lipari.)

universally as the Kodak Cirkut cameras. They were the most widely used panoramic cameras capable of creating 360-degree images; the No. 10 model was the most popular. In *Cameras: From Daguerreotypes to Instant Pictures* (London: Crown Publishers, 1978), Brian Coe describes the Cirkut cameras.

The Cirkut cameras were made in five sizes; two, the Nos. 6 and 8 Cirkut outfits, were in the form of panoramic backs. These could be fitted to Revolving Back Cycle Graphic and Century Stand cameras of conventional pattern, which could also be used for ordinary photography. The Nos. 5, 10 and 15 Cirkut cameras were suitable for taking panoramic pictures only. The maximum picture sizes obtainable with the five models were: for the No. 6, 6.5 × 72 in (165 × 1,829mm); for the No. 8, 8 × 96 in (203 × 2,438mm); for the No. 5, 5 × 42 in (127 × 1,067mm); for the No. 10, 10 × 144 in (254 × 3,658mm); and for the No. 16, 16 × 240 in (406 × 6,096mm). The three larger Cirkut cameras were also adapted to take the rolls of smaller width; for example, in addition to the 10-in (254mm) wide films, the No. 10 would take the 8-in (203mm) and 6-in (152mm) wide films. All the Cirkut models worked in essentially the same way. The camera was rotated by a clockwork motor, driving an interchangeable gear wheel, which meshed with a large, circular rack on the outside of the tripod top. The choice of gear-wheel size determined the length of film exposed, and a sliding scale on the camera, marked in degrees and inches, allowed the photographer to select the gear wheel most suitable for his subject from the wide range provided. The speed of the clockwork motor was adjustable, giving a range of exposure times from ½ to ¹/₁₂ second. Most of the lenses supplied with the various models of the Cirkut camera were convertible, giving a choice of three focal lengths, depending on whether the front, the rear, or both lens components were used. For example, the Turner-Reich Series II No. 4 lens, fitted to the No. 10 Cirkut camera, had a front component of 24-in (610mm) and a rear component of 18-in (457mm) focal length, giving a combined focal length of 10.5 in (267mm). These various adjustments gave the photographer a considerable choice of image size, picture width, and angle of view covered. All cameras could take up to 360-degree angles of view, but this was not recommended, as uneven lighting almost invariably spoilt the results, and the length of film was excessive. All sizes of the Cirkut camera except the No. 10 were discontinued in the mid-1920's, but the No. 10 model remained on the market until 1941. The Cirkut camera was, and still is, extensively used for large group photographs.

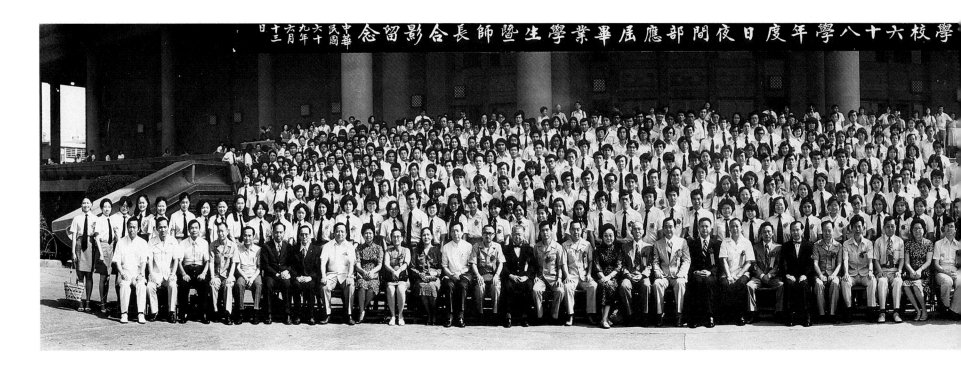

日十六九六民中念留影合長師暨生學業畢屆應部閒夜日度年學八十六校學

EARLY PANORAMIC PHOTOGRAPHERS

Panoramic photography proved to be a remarkably stable art form for its first 100 years or so. Throughout this period, with few exceptions, the same subjects were photographed, and the basically same cameras were used. In a sense, this was a time when panoramists were exploring this type of photography and developing its potential along traditional lines. Unfortunately, the names of most of these pioneers have been forgotten. But their legacy—early panoramic images of landscapes, cityscapes, natural calamities, and wars—remains. They inspired the next generation of panoramists to photograph dramatic war shots and beautiful aerial views. The most popular panoramic image, however is still the large-group shot. Eugene O. Goldbeck, panoramist extraordinaire of the post-World War II era, once photographed 21,765 United States soldiers at an air base as he perched on a tower that he had constructed just for the picture. Goldbeck was following in the brave, creative footsteps of such earlier photographers as turn-of-the-century panoramist George Lawrence, who suspended panoramic cameras from balloons and kites, then triggered them remotely—and produced spectacular images. Lawrence is generally accepted as the first aerial photographer. Panoramic photographers were a unique, talented breed who, in part because of the unusual design of their cameras, often performed amazing feats as a matter of course.

PANORAMIC PHOTOGRAPHY TODAY

As the post-World War II era came to a close and photography began to enter a period of seemingly endless technological advances, many traditional panoramic photographers continued to click and twirl away with their now antique cameras. Most of them were shooting with the Kodak Cirkut No. 10, and it remains a panoramic

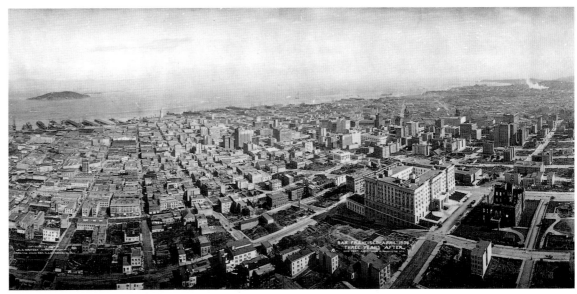

workhorse (in rebuilt form) even to this day. By the 1970s, however, new cameras began to appear. The Widelux 35 cameras were among the first rotation cameras, while the Fuji G617 and the Linhof 612 Technorama are direct descendents of stationary-wide-angle-lens cameras; both use elongated film formats to take in a wide field of view. By the 1980s, a revolution in panoramic-camera technology was well under way. Modern panoramic cameras have traveled into space and under water, and a blind photographer has used a panoramic camera, as David Plakke and Tim Vallender pointed out in "Speaking Visually: A Blind Aesthetic," a 1987 exhibition of Widelux photographs at the New York Academy of Sciences, "to visually portray how one blind person perceives his environment."

Panoramic photography has begun to emerge from its traditional patterns and is becoming a unique art form that enables imaginative, innovative photographers to go past conventional picture-taking. So while the large-group and landscape photographs are still the most popular subjects, today's photographers have the potential to take this medium far beyond its historical roots and to explore new and exciting applications never dreamed of by the panoramists who recorded those first scenes.

Old panoramic cameras, such as Kodak's No. 10 Cirkut camera, are still used today all over the world. In fact, one was used to photograph a class at Taiwan's National Academy of Arts, shown above on the left.

The photograph of San Francisco shown directly above is one of George Lawrence's early aerial panoramic shots, taken in 1909. The camera was probably suspended from kites, and the shutter was triggered from the ground. (Courtesy: The Bancroft Library, University of California.)

COMPOSING PANORAMIC

Panoramic photography is different from conventional photography. The cameras are different, the rules of composition are different, and therefore the photographer's view of the world is different. As in all art forms, the makeup of the final product is influenced by the technology used to produce it. And, inevitably, the question of how much artists are controlled by their equipment and materials and vice versa comes up. Neither conventional nor panoramic photography has escaped this controversy. I believe that photographers should learn about visual concepts before turning to technology. You'll be better able to create images if you can look at the world with an understanding of panoramic composition and not just familiarity with a particular camera's design. Cameras are only tools, but photographers are the sources of creativity.

PANORAMIC VERSUS CONVENTIONAL COMPOSITION

Composing a conventional photograph contrasts sharply with composing a panorama. Owners of 35mm single-lens-reflex (SLR) cameras are accustomed to going out to look for subjects, confident that with a single zoom lens they can shoot the same theme in a number of different ways. They might walk along with their lenses in the wide-angle position and take "grab shots" of children playing. Then they might see doorways illuminated by beautiful sidelighting and capture them using the macro setting. Perhaps they shoot moving cars with their lenses in the telephoto position; here, the blurred background gives the impression of motion. These photographers handhold their 35mm cameras for all of these shots and allow the autoexposure mode to take care of the changing light conditions.

When panoramic photographers, on the other hand, walk down the same streets, they are far from ready to shoot. Instead, they pause and ask such visual questions as "What is this street all about?", "Is it a neighborhood?", and "Is it just a segment of a bigger entity, the city?" Panoramic photographers know that their cameras take in large views filled with smaller components that act as supporting elements. For example, the children, the doorways, and the moving cars are organized and unified in one image rather than isolated in three 35mm shots. Instead of "zeroing in" on their subjects, panoramic photographers would look for a way to pull together the "street" concept.

Thinking about panoramic photography in such all-encompassing terms enables you to develop the necessary viewpoint: a way to see and conceptualize the world that lets you use your equipment for maximum effect. This doesn't mean that panoramic photographers don't take pictures of children playing, cars in motion, or spectacularly illuminated doors. It means that they look first at the whole scene and then at its parts. For example, a few summers ago, I was traveling up and down the California-Oregon coast, shooting images for an exhibition eventually titled "West Coast Panoramas." I had a specific purpose: to capture the diversity of this geographic area (deserts, mountains, seascapes, cities) and to show how each element evoked a feeling of a wide-open, sprawling expanse. I had two panoramic cameras with me. One took in an angle of view of about 90 degrees of the arc of a circle on film measuring 2¼ × 6¾ inches, and the other's lens moved through an arc of 150 degrees, producing a 2¼ × 5-inch image. The resulting images showed extensive views of the coast on long strips of film.

PHOTOGRAPHS

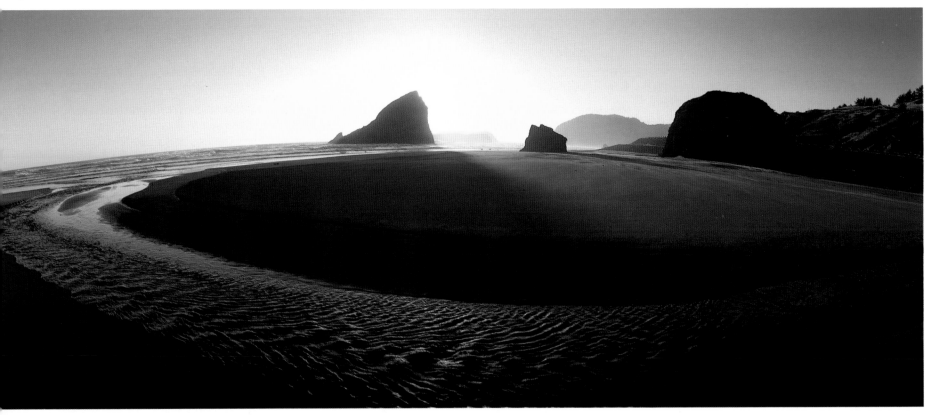

This photograph of the Northern California coastline at sunset under a light mist is one of my most popular images.

Another assignment involved photographing an aerospace testing facility in the California desert. The company wanted pictures of the facility but hadn't been able to obtain satisfactory results with conventional cameras. Its problem was typical: how to show the huge size and configuration of this large outdoor installation without losing background subjects. The complex consisted of three rocket-motor testing towers with their support buildings, set about a half-mile apart. Conventional cameras equipped with normal or moderate wide-angle lenses couldn't capture all the subject matter because the terrain made it impossible for me to distance myself sufficiently. The use of ultrawide-angle lenses took in all the buildings but rendered the two sites in the background so small that they looked like dots in the desert.

I composed the shot using my short-rotation (150-degree) panoramic camera with its large viewing angle to make sure that I recorded all of the elements in the scene: the rocket-motor testing sites that provide details about the structure; the primary building; the two other buildings in the background; a giant service crane; and a pickup truck. The expanse of the desert locale serves as an overall frame. The white line just to the right of center, which looks like a scratch, is actually an access road about 10 miles away and indicates scale. Finally, the storage tank in the far right corner provides a sense of depth. Because

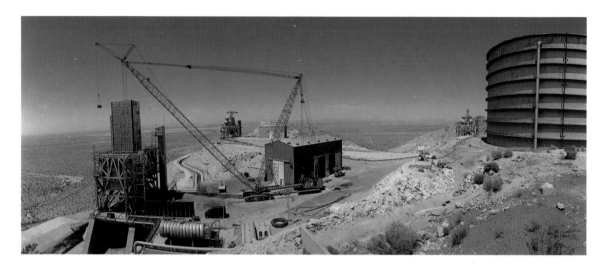

the film I used is long and narrow, I was able to show the multi-site testing facility without huge expanses of sky and foreground. The composition is successful because it is unified.

CHOOSING PANORAMIC SUBJECTS

When you consider various scenes as potential subjects for panoramic photographs, you need to think about how individual elements in each will both work as a whole and translate onto a narrow strip of film. You have to remember to scan scenes from side to side rather than zero in on a single dominant element. Some subjects lend themselves to the panoramic approach more than others. Consider your own area's environment for a moment. Your list of possible subjects might include bridges, canyons, rivers, sea-

scapes, skylines, deserts, large gardens, parks, arenas, and stadiums. The events held in these places, such as picnics, races, and ball games, also make great panoramic subjects.

But you aren't limited to outdoor scenes. Environmental portraits, which show one person or several people in a large workspace, can also be shot with panoramic cameras. Other popular applications include the large-group shot and the interior shot; perfect places for these are boardrooms, museums, and galleries—any place that contains long rooms. Don't overlook stage productions, either. Once you've developed a panoramic viewpoint, potential subjects become obvious to you. This might be a challenge at first because you are accustomed to composing in a compact framework.

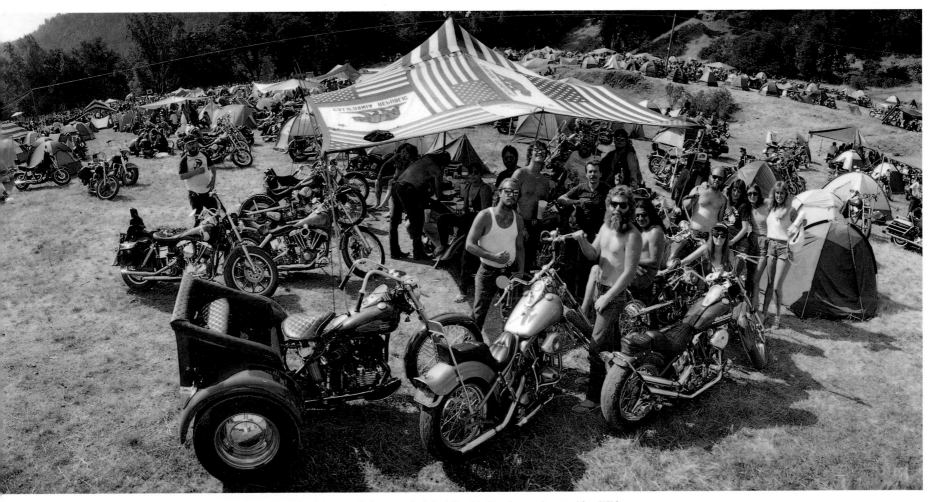

I used a Widelux 1500 camera on a tripod to shoot the photograph on the opposite page of the Edwards Air Force Base rocket-motor testing complex in California. Standing about 2000 yards away from the nearest testing tower in order to record as much of the scene as possible, I exposed at f/22 for 1/60 sec. The result: a unified composition.

I photographed the bikers' rally, shown above, with a Widelux 1500 camera in order to capture the most detail.

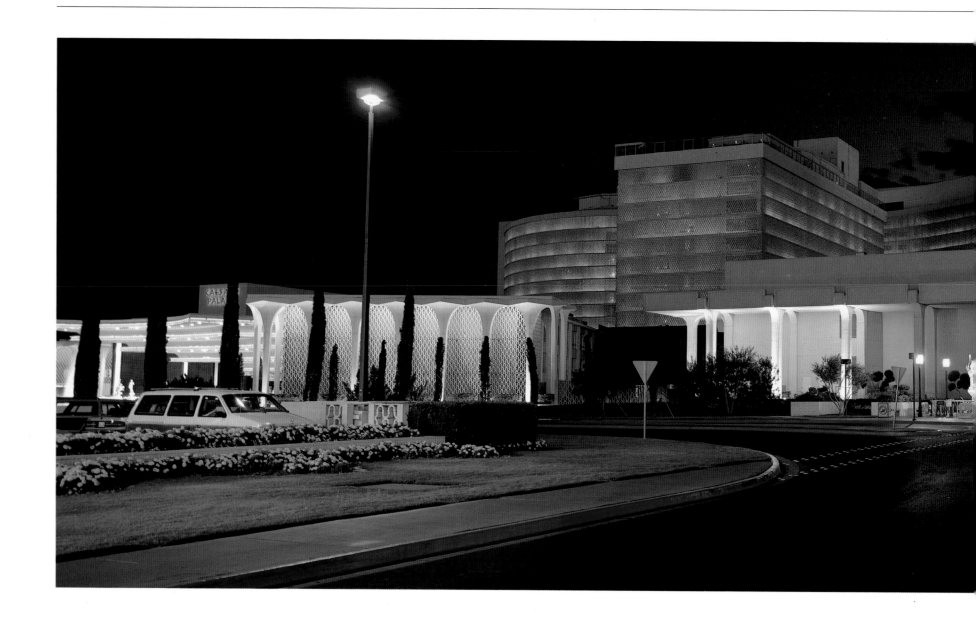

I photographed this Las Vegas nightclub during the evening with a Fuji 617 camera.

Most photographs of Machu Picchu, Peru, are shot at infinity. As a result, viewers miss out on the area's ancient mystical landscaping. For the image on the overleaf, Mark Segal used a rotating Hulcherama camera and Fujichrome 100 film to create a sense of continuity from near focus to infinity. The combination of thick, high clouds; open, quiet space; smooth earth; and unusual historic significance provides a compelling view of this landscape—a perfect subject for a panorama. (© Mark Segal/P.S.I. Chicago 1990.)

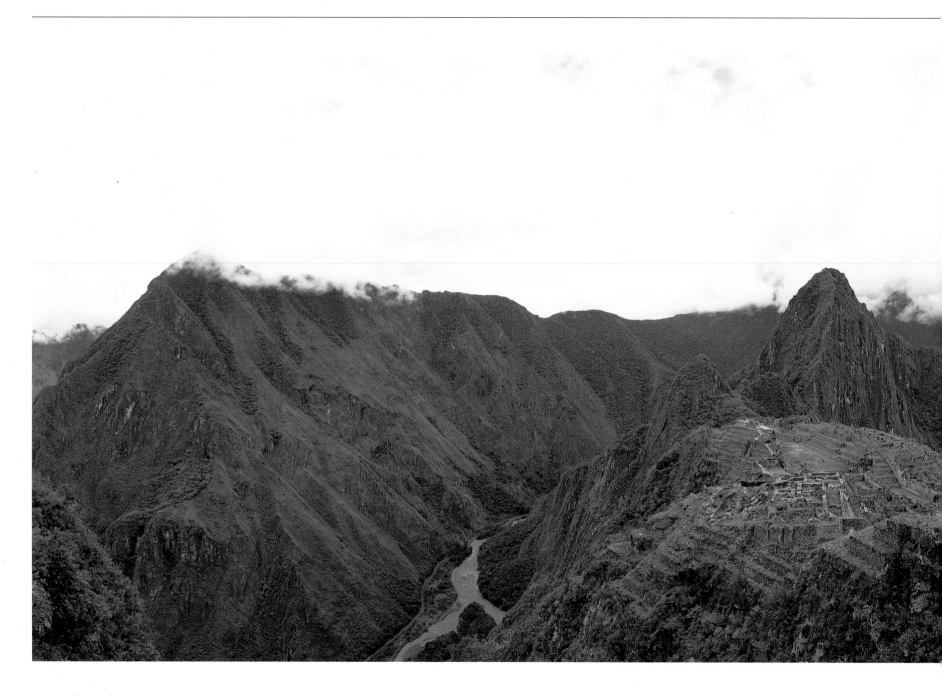

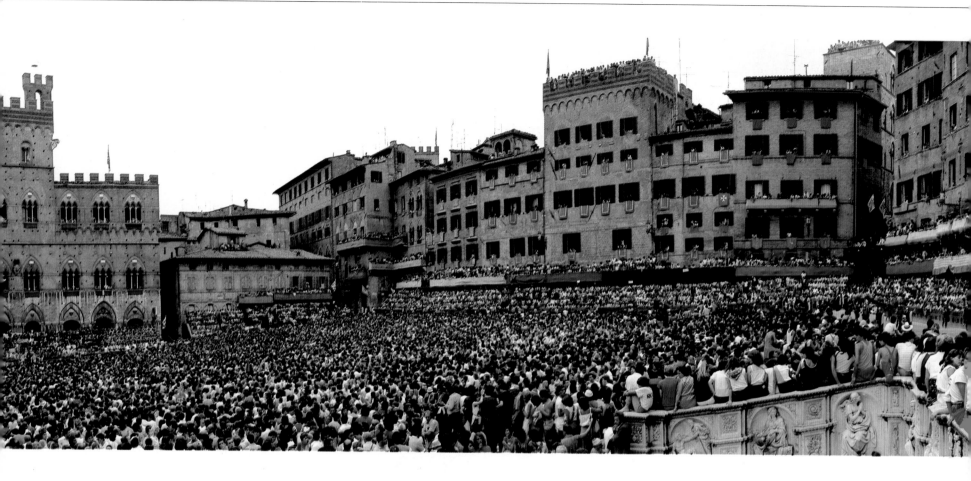

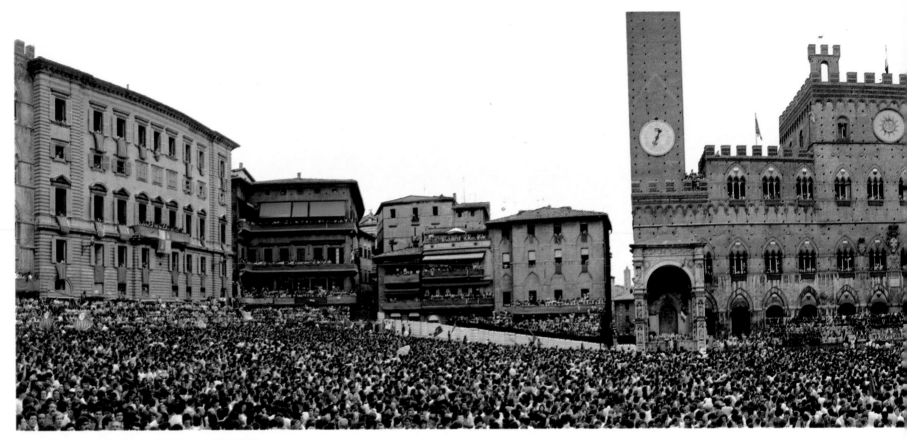

The Palio de Siena, the famous horse race with 80,000 spectators, provides a perfect subject for a panoramic shot. This 360-degree view demonstrates the uniqueness of full-circle panoramic photography. No other form of photography is capable of such a sweeping view. (Courtesy: Karl Heinz, Inc.)

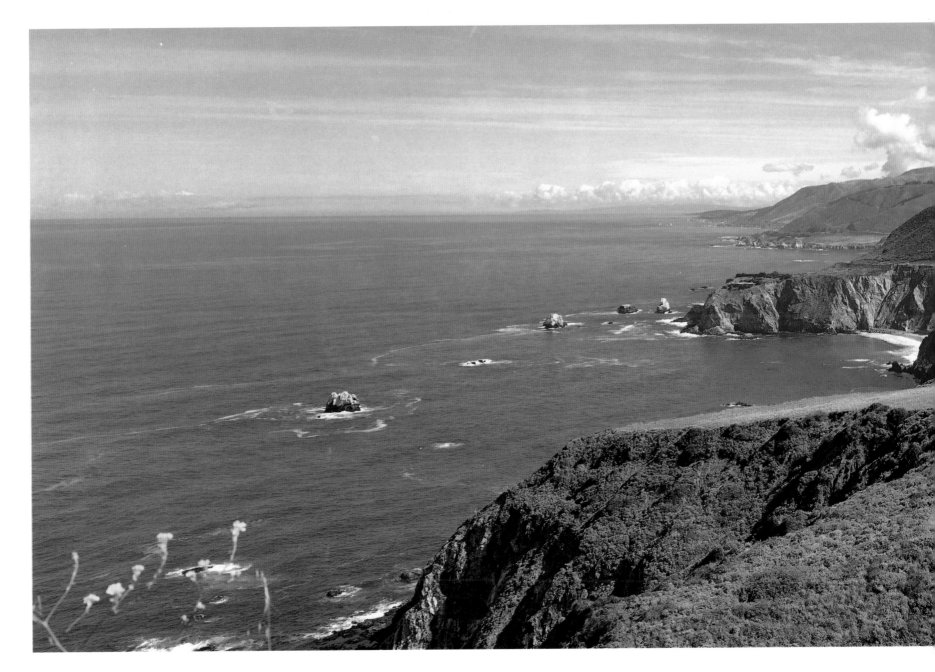

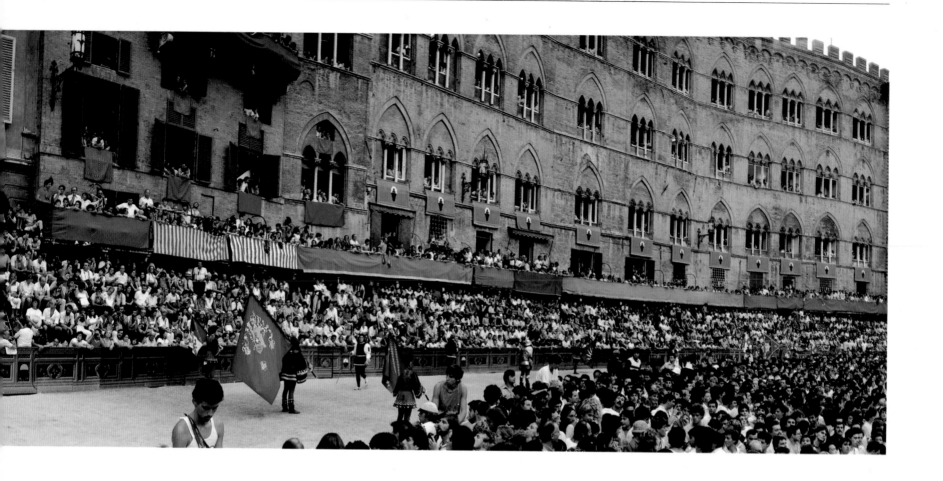

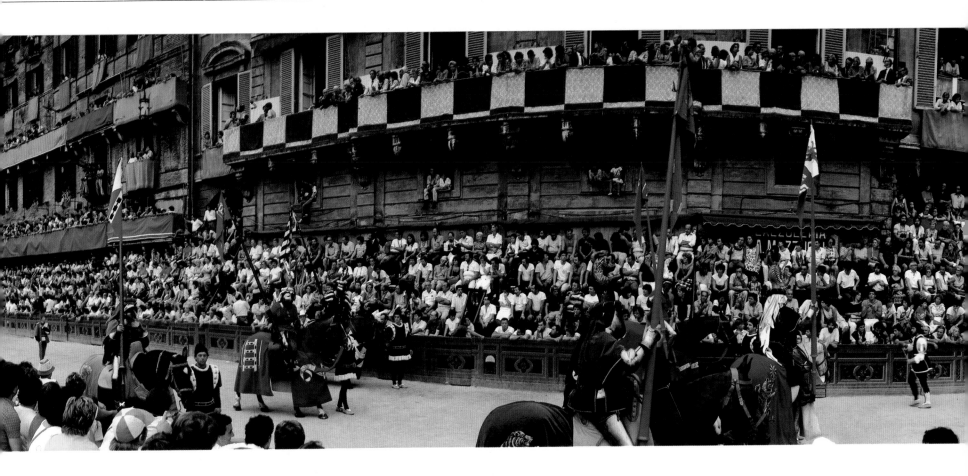

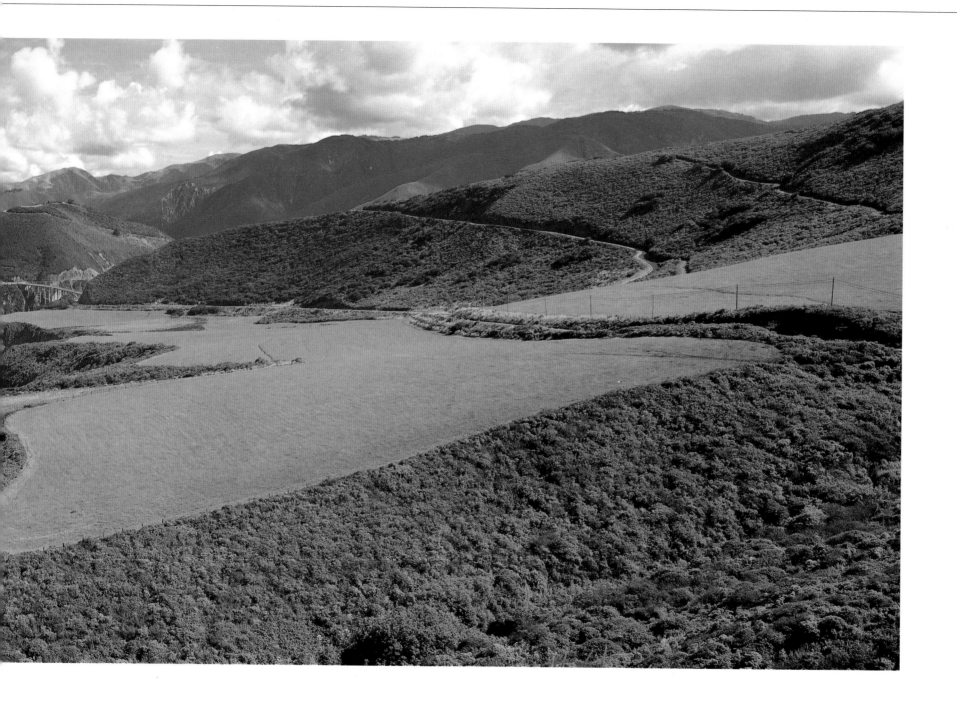

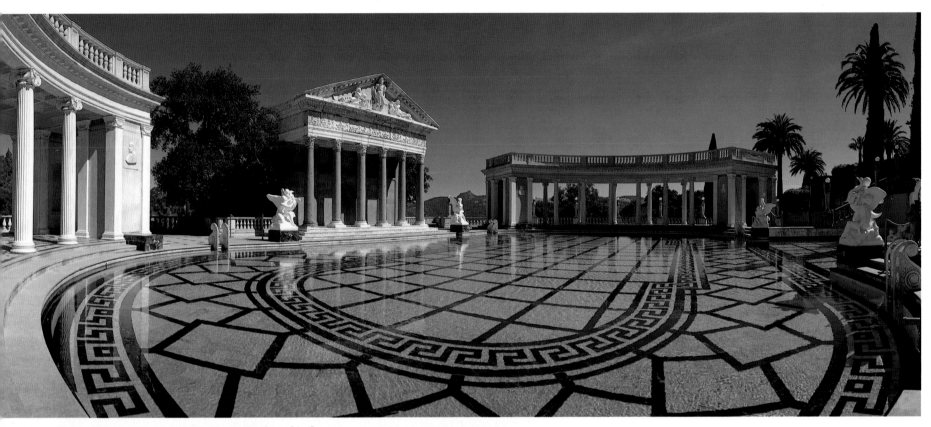

For the picture shown above of the Hearst Castle pool in San
Simeon, California, I used a Widelux 1500 camera. I exposed
at f/22 for 1/60 sec.

I photographed the view of the California shoreline shown on
the opposite page with a Fuji 617 camera.

CONVENTIONAL COMPOSITION TECHNIQUES

As any successful photographer will tell you, there are no rigid rules of composition, but there are guidelines that have proven to be helpful and that consistently show up in great photographs. When photographers look at the physical environment, they tend to organize and frame what they see. This habit stems from the belief that the main visual elements in a scene should be balanced harmoniously. Photographers use such terms as "subject," "background," and "foreground" to organize the various parts of the scene they surround with imagined borders. Reviewing the fundamentals of conventional composition will provide you with a basis of comparison before you consider panoramic composition.

Rule of Thirds

Painters and photographers rely on this concept when they arrange subject matter within a framework. This rule simply suggests that you mentally divide a scene into thirds, either by vertical or horizontal lines, or both. You can best achieve balance by placing the main visual elements on or near the intersections of the horizonal and vertical lines. Because you can balance the elements in the upper, middle, or lower third of a scene, you can use all three sections when you compose the image.

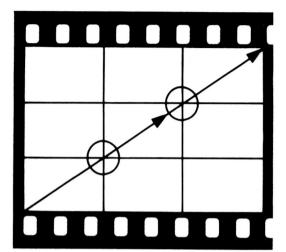

In this diagram, the circles indicate the best points to place a photograph's center of interest using the rule-of-thirds grid. Following this arrangement, no matter how loosely, produces more balance within the frame.

To create this image, shot with a 300mm lens on a 35mm SLR camera, I used the rule-of-thirds grid. I composed so that the rowboats were positioned at the upper and lower points of intersection.

Negative Space

A great deal of conventional photography is based on establishing specific centers of interest within a frame—at the intersections on the grid used with the rule of thirds. The remaining parts of a scene, which complete the picture, are referred to as negative space. For example, suppose you're composing a horizontal photograph of a person and you have posed your subject at the lower left point of intersection on the grid. The remaining upper two-thirds of the picture shows an out-of-focus background. Here, the center of interest is the person, and the background is negative space.

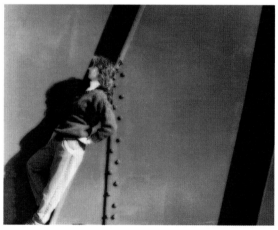

Placing the subject in the lower left section of this picture enabled me to "fill" the remainder of the frame with negative space, thereby achieving balance. I used a 6 × 7cm camera with a 105mm lens.

Framing the Subject

Another popular composition technique is to use part of the rule-of-thirds grid as a frame. For example, when you begin to shoot a building, you notice a tree limb extending across the upper third of the image. Here, balance is achieved through the use of an object rather than space.

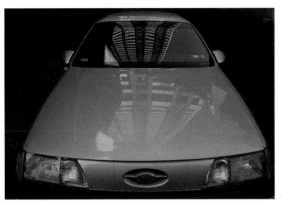

This photograph shows how foreground objects can be exaggerated in size so that they dominate the image. Shooting with a 28mm wide-angle lens on a 35mm SLR camera, I moved in as close as possible to the car's hood. The triangular shape of the vehicle, caused by the foreground-dominance effect, also gives the impression of lines receding into the rear of the picture.

Foreground Dominance

You can impart a sense of depth to a photograph by having lines in the foreground (the lower third of a scene) recede into the background (the middle or upper third). Imagine a shot of a highway or of railroad tracks in which the lines extend from the foreground to a vanishing point in the upper portion of the scene. Wide-angle lenses enhance this effect because they exaggerate foregrounds and reduce backgrounds.

Dynamic Diagonals

Still another way of organizing subjects is to use a diagonal arrangement. This produces a dynamic effect—the subject matter is shot at an angle, implying motion. A speeding train photographed at a slight angle to the direction of the train's movement is a perfect example of this technique. The train seems to lean forward, rushing toward its destination.

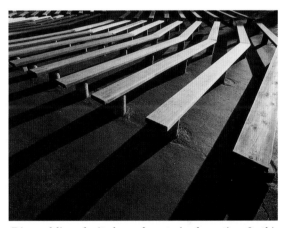

Diagonal lines don't always have to imply motion. In this photograph of benches in a Cape Cod amphitheater, the strong diagonals seem to lead your eye to a vanishing point. Here, I used a 645 camera with a 40mm lens.

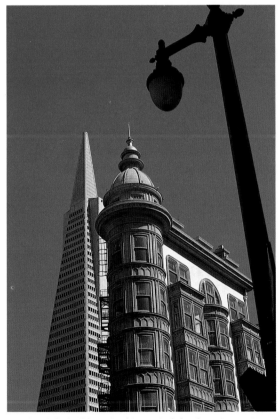

I isolated the buildings in this vertical shot by using a 105mm lens on a 35mm SLR camera. The foreground lamppost serves as a frame. I placed a polarizing filter on the lens to deepen the color of the blue sky.

ELEMENTS OF PANORAMIC COMPOSITION

When you photograph panoramas, you'll have to adjust your usual organization and framing techniques. You'll be much less concerned with subjects at the top or the bottom or on the diagonal plane of a scene. In panoramic shots, the "action" is in the middle section of the image. The design of panoramic cameras is to some extent responsible, for two reasons: the large aspect ratios of panoramic film, and the wide angles of view of the cameras' lenses.

Aspect Ratios

These are defined as the proportion of the height of an image to its width. For example, a 2¼ × 5-inch (6 × 12cm) format has a 1:2 ratio, while a 2¼ × 10-inch (6 × 24cm) format has a 1:4 ratio. The term *aspect ratio* is often used by panoramic photographers to discuss the length of various panoramic formats and to compare images from different film sizes. Two common panoramic formats, 24 × 56mm on 35mm film and 6 × 12cm on 120 roll film, have approximately the same aspect ratio: 1:2. This 1:2 aspect ratio is the generally accepted minimum size for a panoramic perspective.

Angles of View

The lenses on panoramic cameras have extraordinarily large *angles of view*, also called *fields of view*. These interchangeable terms refer to how much of a scene you can record on film. For example, the angle of view of a telephoto lens is narrow. Conversely, a wide-angle lens has a

These three photographs were taken from the same position with 105mm lenses but on different formats. As you can see, each format produces a different visual impression. Shooting at the same exposure of f/8 for 1/250 sec., I used a telephoto lens on a 35mm camera for the shot above on the left, a normal lens on a 6 × 7cm camera for the shot above on the right, and a wide-angle lens on a 6 × 17cm camera for the shot directly above.

Panoramic composition is based on concentrating subject matter in the center third of conventional composition's rule-of-thirds grid. In the diagram on the opposite page, the circles show the ideal locations for principal subjects.

CLASSIFYING LENSES

Lens	Angle of View	Format and Focal Length (mm) 35mm	6 × 6cm	4 × 5
Fisheye	180 to 220 degrees	6 to 10	24 to 30	—
Ultrawide-Angle	100 to 120 degrees	13 to 18	40	—
Very-Wide-Angle	84 to 94 degrees	20 to 24	50	65
Moderate Wide-Angle	62 to 75 degrees	28 to 35	60	90 to 100
Standard (Normal)	43 to 56 degrees	40 to 55	75 to 80	120 to 150
Short Telephoto	23 to 37 degrees	75 to 105	90 to 110	180 to 300
Medium Telephoto	12 to 21 degrees	120 to 150	150	360 to 480
Long Telephoto	5 to 8 degrees	300 to 500	250	—

Source: Ray, S. F. *Applied Optics*. (Stoneham, MA: Focal Press, 1988.) Reprinted with permission.

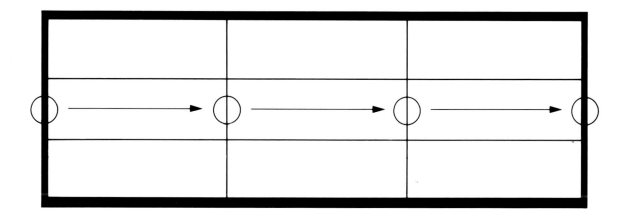

wide angle of view. Photographers who usually shoot in the 35mm format are used to thinking that a lens' focal length solely determines whether a lens is a wide-angle or a telephoto. For example, they consider a 35mm lens to be a moderate (or short) wide-angle lens and a 500mm lens to be an extreme telephoto lens. Actually, however, the combination of film format, focal length, and angle of view controls how much of the subject matter is recorded on film. Suppose you were shooting 35mm film and using a 105mm lens. This moderate telephoto lens is preferred for portrait shots. But if you were shooting 120 roll film with a medium-format camera that produces images measuring 2¼ × 2¾ inches (6 × 7cm), you would regard a 105mm lens as a normal lens. If you were then to take 120 roll film, load it into a panoramic camera that yields 2¼ × 6¾-inch (6 × 17cm) images, and use the same 105mm lens, you would consider it a wide-angle lens. The angle of view can be measured either horizontally, vertically, or diagonally, but the diagonal angle is used most often.

Center Dominance

Because panoramic images are much longer than conventional pictures, photographers tend to concentrate on subjects in the middle third of the rule-of-thirds grid—that is, along the entire plane of the middle-third of the image from edge to edge. This affinity for the middle, which is referred to as center dominance, is emphasized even further as the aspect ratio increases. As a result, the shape of an image becomes more and

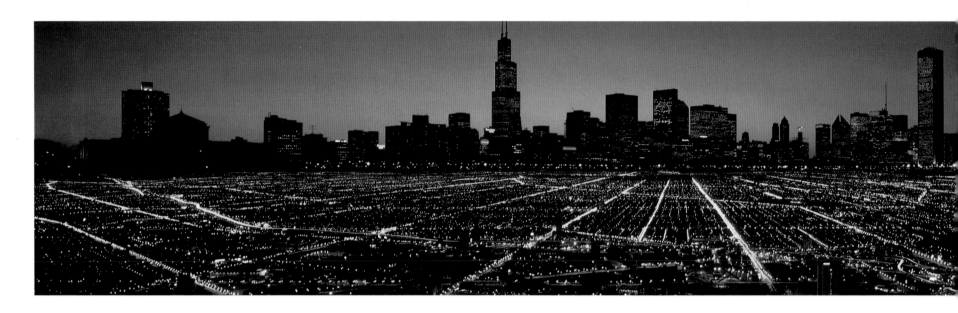

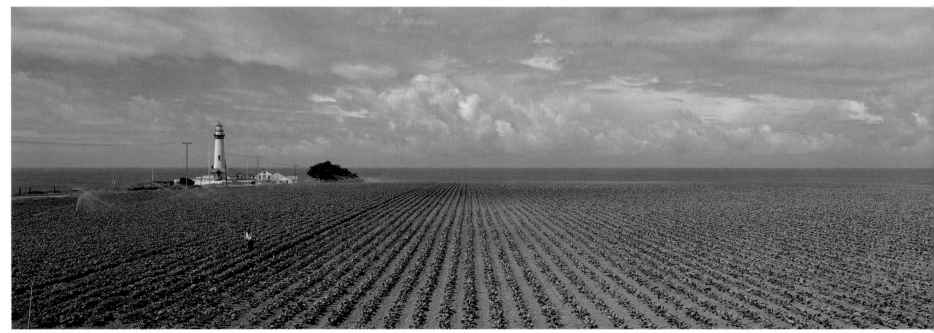

Mark Segal created this composite photograph of Chicago at night with a Linhof 6 × 17cm camera. The upper half of the image was made separately from the lower half. The bottom shows the grid of street lights that are visible when you fly into the city's airports. The skyline in the center of the image is the unifying element. (© Mark Segal/P.S.I. Chicago 1990.)

I shot the unusual combination of a lighthouse and farmland on the California coast shown on the opposite page with a Fuji 617 camera on a tripod at f/22 for 1/60 sec. The lines of the planted field lead the eye to the horizon in this vista.

more like a narrow strip. One of the primary characteristics of a panoramic photograph, then, is its long, wide view of a scene—or, in other words, a vista.

Unified Vistas

The lenses on most panoramic cameras are designated wide-angle lenses in relation to their formats. Some panoramic designs require a nonrotating, or fixed, lens; others call for a mechanism in which either the lens swings through a short arc of between 110 and 150 degrees of a circle or the entire camera moves through 360 degrees. Whether the lens is fixed or some rotation mechanism is involved, the wide angle of view combined with long formats affect panoramic composition several ways. The elongated format sets up the outline, or framework, of the picture. Also, the lenses control the amount of information recorded on film. And because the lenses on panoramic cameras take in much more on the horizontal plane than on the vertical one, they greatly influence the development of a panoramic viewpoint. Finally, the lenses' wide angles of view play a major role in the creation of a unified photograph. Precropping the image is necessary to eliminate the possibility of spreading out the subject matter; you must use the wide angles to capture on film only the most important information.

Consider two examples. In a photograph of a cityscape, some lines in the foreground run perpendicular to the middle line of the picture, and part of the sky is in the top half. But the power of the photograph comes from the expanse along the center: the flow of the skyline as a continuum of buildings and lights unifies the image and gives it impact. When you look at the picture, the dominant feature is the varied skyline, not an isolated building. Suppose, however, you were looking at a photograph of with a definite single center of interest, a lighthouse. If you were then to describe this picture, you would refer to it as "a vista of the sea and a lighthouse" rather than simply as "a shot of a lighthouse" because it's a panoramic view.

So, because of panoramic cameras' wide angles of view and large aspect ratios, you must think in terms of the indivisibility of action and events along a line or continuum. You can include diagonal or perpendicular lines in your images, but the essence of the composition should be parallel to the long side of the format, dominating the center. Any photographer who wants to create successful panoramic pictures should always concentrate on the middle third of the image and pay attention to subjects that run along a central line.

Although panoramic photography seems to have more composition limitations than traditional picture-taking, such as its elimination of the upper and lower thirds of the picture area, you'll come to see that this is merely conventional thinking. When you compose panoramas, you shouldn't try to force back into the picture what you are losing; you have to think about what you are gaining. You must remember that the compositions are tighter and more precise.

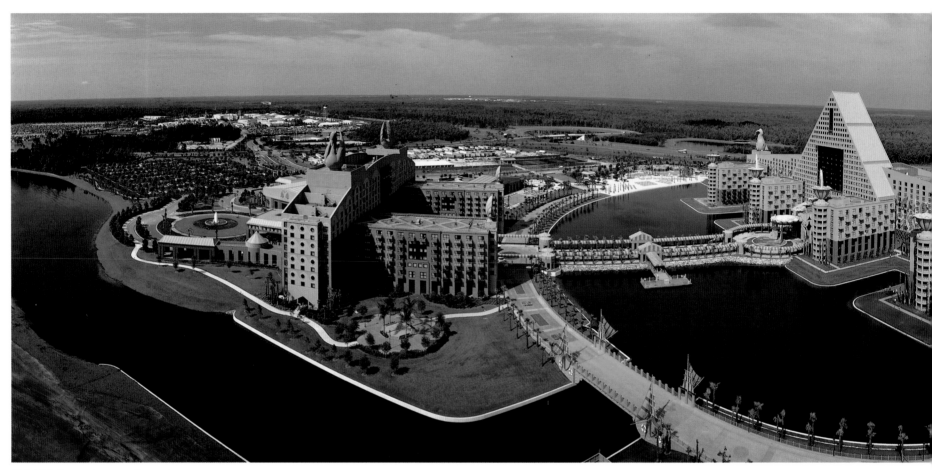

This 220-degree view was shot with a modified Round Shot 70mm panoramic camera and exposed for 1/250 sec. at f/8 on Ektachrome 64. Hired by Disneyworld to create dramatic aerial photographs of its new resort hotels, Mark Segal was asked to also include the MGM Studios, shown on the far left of the image, and the Epcot Center, shown on the far right. Working with mid-morning, early-summer light, Segal was able to highlight the variety of architectural details on the Swan and Dolphin Hotels. When shooting panoramic aerials, you must consider such factors as horizon-line shift, height, and closeness to the subject area. (© Mark Segal/P.S.I. Chicago 1990.)

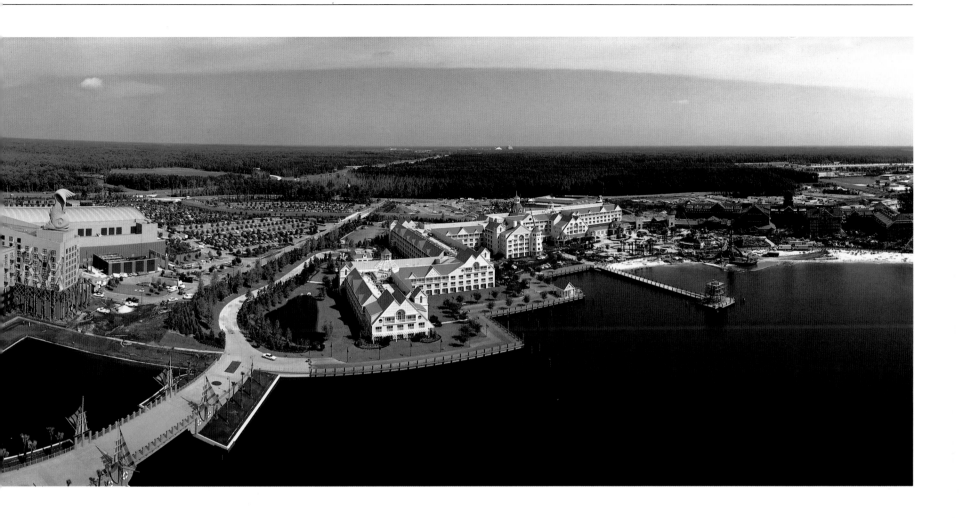

You need to precrop the image, including and rejecting parts of the scene in terms of the way they relate to the whole. You can't lose sight of the essential elements of the picture even though you're usually trying to capture a large vista.

When I'm composing a panorama, I find it helpful to think about it much the say way I do a closeup. The only difference is that I'm not selecting one subject, such as a flower, but continually uniting elements. This is true whether I'm shooting a skyline or a portrait. Both types of pictures contain dominant elements, but the interdependence between the dominant parts and the other components in the picture is the key to a strong image. What makes a panoramic photograph so intriguing is that you first experience its total effect and can then spend time looking at its separate elements and appreciate how they work together to create a unified vista.

PANORAMIC CAMERAS VERSUS WIDE-ANGLE LENSES

Because panoramic cameras record wide, expansive views, people tend to think of them as wide-angle cameras. They are, and then again, they aren't. One of the main differences between shooting with panoramic cameras and with wide-angle lenses is the way they handle distortion. Several types of distortion commonly occur with wide-angle lenses, especially ultrawide-angle lenses, whose fields of view are very close to those of panoramic cameras. Distortions may be the result of the lens' optical design or the way photographers use the lens.

The designs of the three types of panoramic cameras produce wide angles of view. The nonrotation, or stationary-lens, camera design, shown on the left, involves a wide-angle lens on a long format. In the short-rotation, or swing-lens, camera design, shown in the center, the lens moves over a fixed piece of film to increase the angle of view. The third type is a 360-degree rotation camera, shown on the right. Here, the entire camera rotates through a circle while the film moves at the same speed past the lens. Both the short-rotation and 360-degree rotation cameras have a thin slit behind the lens. As a result, light is literally painted onto the film during the rotation. (Modified from a design by Karl Heinz, Inc.)

Perspective and Size Distortion

Wide-angle lenses increase how much of a scene is recorded on film and make objects appear smaller than they do when photographed with a standard lens. For example, photographing two people 10 feet away from you with a standard 50mm lens on a 35mm camera will produce an angle of view of 43 degrees in the final image. A 24mm wide-angle lens, on the other hand, will take in an angle of view of 84 degrees, or about twice as much of the scene, and will shrink the subjects proportionally. If, however, you move in close when using the 24mm lens until the people appear in the viewfinder the same size as they were with the 50mm lens at a distance of 10 feet, you'll notice something rather unusual. The people will seem much larger in relation to background objects compared to their size when photographed with the 50mm lens. This size distortion is a favorite technique of wide-angle-lens users who move in close to isolate and emphasize foreground subjects.

Line Convergence

This effect occurs when originally parallel lines remain straight but converge when the camera isn't held parallel to the subject, such as when it is tilted up or down. Line convergence is characteristic of all lenses but is exaggerated by wide-angle optics. With this type of distortion, when you tip the camera up to take in more of the scene, the lower half of the film plane is closer to the subject, making it appear larger. At the same time, the upper half of the film plane is tipped

away from the subject, increasing the distance between them and decreasing its apparent size. Line convergence is a particularly troublesome form of distortion for panoramic photographers because they strive to shoot on a level plane. Unfortunately, many subjects—skylines, mountain ranges—are higher than the position of the camera during the actual shooting.

Curvilinear Distortion

With this type of distortion, straight lines bow inward around the center of the field of view, causing what is often referred to as the *fisheye effect*. This is a consequence of the design of wide-angle lenses—especially ultrawide-angle lenses—rather than the way they are used, as is the case with line convergence.

Photographers exploit the distortion effects of wide-angle lenses to compose dramatic and unusual pictures. In general, photographers try to avoid these effects when shooting panoramas because they contradict the guidelines for panoramic composition. This is because panoramic photographers want to create pictures in which lines are straight, subjects are level, and size is represented accurately, particularly when they work with nonrotation (stationary) cameras. However, even when photographers shoot with rotation cameras—which have tremendous angles of view and therefore a greater chance of producing distortion—they make an effort to render subjects as realistically as possible. For example, size distortion results when photographers move very close to their subject.

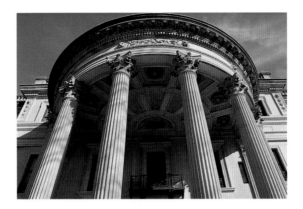

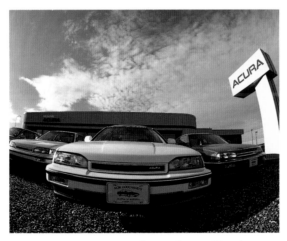

Line convergence proves to be a serious problem for panoramic photographers. For the top photograph, I shot the building with a 28mm wide-angle lens on a 35mm SLR camera that I tilted up. The photograph directly above is an example of curvilinear distortion, another problem that can be turned into an advantage. Here, I used a 35mm full-frame fisheye lens on a 6 × 7cm camera to achieve this unusual view of a car dealership.

Panoramic cameras usually don't allow close-focusing. Furthermore, shooting a subject from such a short distance limits the ability to compose unified elements along a continuum. Also, panoramic-camera lenses are almost entirely free of curvilinear distortion. Finally, panoramic photographers strive to avoid tilting their cameras in order to prevent both the convergence of vertical lines and the bending of horizontal lines.

So, while wide-angle-lens photography is most like panoramic photography when the objective is to shoot (from a distance) a distortion-free picture with a wide field of view, it still differs in a critical way. Panoramic cameras use elongated formats that eliminate prominent sections in the upper and lower halves of a picture. Cameras with wide-angle lenses, on the other hand, tend to expand these same areas as their angles of view increase. As a result, wide-angle-lens distortion is most prominent in these areas.

As you explore panoramic photography, I think that it is important for you to keep in mind a working definition of this fascinating specialty. In panoramic photography, subjects are usually limited to the middle third of conventional photography's field of view. A panoramic camera either has a nonrotation wide-angle lens or allows you to rotate the lens—or the camera itself—to increase angles of view up to and beyond 360 degrees. The film formats used have aspect ratios of at least 1:2. A serious attempt to control distortion is made. Finally, the goal of panoramic photography is to produce striking, sweeping images.

NONROTATION CAMERAS

All nonrotation, or stationary, panoramic cameras share certain characteristics that set them apart from rotation panoramic cameras. A typical nonrotation camera has an elongated camera body with a viewfinder for composing. These cameras call for manually operated wide-angle lenses that have been either permanently mounted on the camera body or set into a coupling that allows them to be interchanged. As a class, nonrotation models are the most distortion-free panoramic cameras. Nonrotation panoramic cameras produce large fields of view, but they are on the low end of the panoramic range. Typically, their diagonal angles are limited to less than 100 degrees. While two limited-production models, the Ipan and the Panorama, take 35mm film, the most popular film formats are 6 × 12cm and 6 × 17cm. A typical 6 × 12cm camera yields six exposures on a roll of 120 film and 12 exposures on 220 film. The 6 × 17cm format reduces the number of shots possible with each type of film to four and eight, respectively.

ACCESSORIES

All nonrotating panoramic cameras require two important accessories: lens hoods and tripods.

Lens hoods are essential protection against extraneous light falling on the lens, which causes flare. Tripods enable panoramic photographers to carefully compose and to shoot at slower shutter speeds. They also improve picture sharpness at any shutter speed by completely eradicating camera shake. In addition, many ultrawide-angle lenses require a unique center-spot filter to even out the light falloff at their edges.

LENS HOODS

Because nonrotation cameras have wide fields of view, using lens hoods with them is highly recommended. Photographic lenses are designed to focus reflected light onto film. When light from the sun or some other source strikes the lens directly, it causes a condition called *flare*. This problem shows up in several forms, including bright areas and spots. In general, flare degrades an image by reducing contrast and introducing unwanted elements into the picture. The best way to prevent flare is by using a lens hood that blocks light from entering the lens on the sides. Lens hoods are available for the Linhof and Fuji panoramic cameras; these are shaped in the aspect ratio of the film format. If, however, you decide on a conventional circular lens hood, you

must get an oversized model to prevent the hood from appearing in the corners of the pictures. This intrusion, in turn, causes another effect called *vignetting*. This is the darkening of a photograph's corners, which results when the lens hood (or filter) gets into the picture.

CENTER-SPOT NEUTRAL-DENSITY FILTERS

Exposing with nonrotation cameras can also benefit from the use of a unique accessory, a center-spot neutral-density filter. This filter prevents some light from passing through the center of the lens, which helps compensate for the light falloff at the edges that commonly occurs with ultra-wide-angle, large-format optics. As a result, you have to increase exposure by one or two stops, depending on the amount of neutral-density material on the center of the filter. While most panoramic-camera and lens manufacturers recommend using these filters, many photographers claim that they usually aren't necessary. A simple test can help you decide whether or not to invest in an expensive center-spot neutral-density filter. Set up your nonrotation camera to take in a white or light-colored wall, and make a series of exposures on color-transparency film using the entire range of apertures, from the

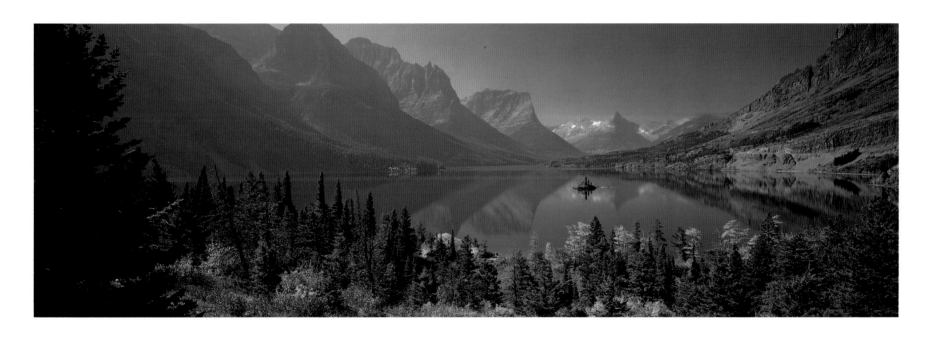

smallest to the largest. Then compare your results. The larger the dark areas in the corners of the frame are, the more falloff there is—and the more this filter will improve your images.

TRIPODS

A tripod is the most important accessory for all types of photography because it eliminates camera shake and ensures successful compositions.

Tripods are, in fact, critical for panoramic photography. First, most panoramic cameras are large, heavy, and somewhat awkward to work with. Almost all of the 360-degree rotation cameras aren't handholdable. While many photographers shoot handheld with certain smaller panoramic cameras, all would agree that pictures taken with a tripod are sharper than those taken without one.

This spectacular photograph was made in Glacier National Park. (© J. Krawczyk/P.S.I. Chicago 1990.)

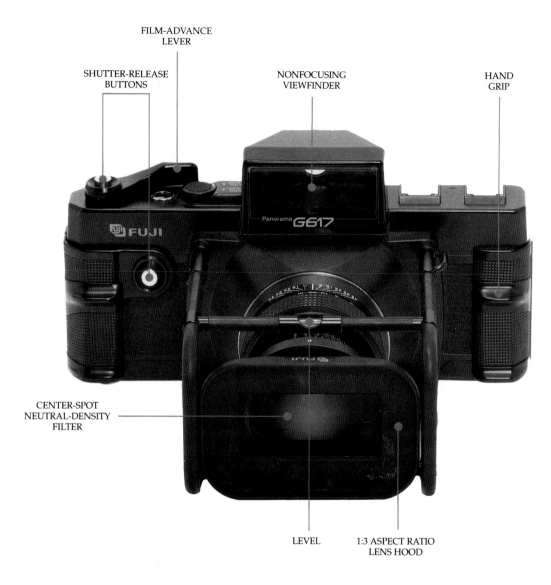

FILM-ADVANCE
LEVER

SHUTTER-RELEASE
BUTTONS

NONFOCUSING
VIEWFINDER

HAND
GRIP

CENTER-SPOT
NEUTRAL-DENSITY
FILTER

LEVEL

1:3 ASPECT RATIO
LENS HOOD

This Fuji G617 is an example of a nonrotation-lens panoramic camera.

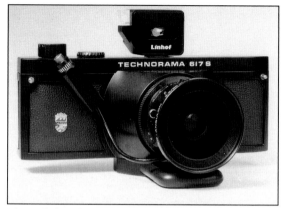

The Linhof Technorama 617 camera is highly regarded by panoramic photographers for its precise design, excellent optics, and accurate viewfinder. The camera shown here is an updated version of an earlier model that was the first modern, long-format, nonrotation-lens panoramic camera.

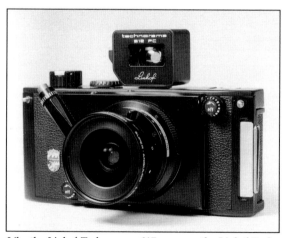

Like the Linhof Technorama 617 camera, the Linhof Technorama 612 PC camera is a favorite of panoramists. This smaller version, which was recently introduced, has the added features of perspective control and interchangeable lenses. (Courtesy: Ken Hansen Photographic, Inc.)

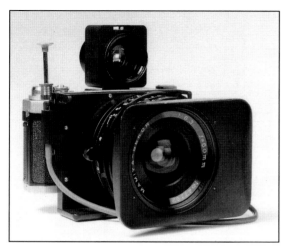

This Panorama 35mm camera has a Mamiya-Sekor 50mm f/6.3 Universal lens. Focusing this lens requires estimating the distance and turning the built-in focusing tube that has been mounted on a Nikon camera body. The lens has its own shutter, so the cable release is connected directly to it. Here, the camera body's film frame has been milled out. (Courtesy: Ken Hansen Photographic, Inc.)

For panoramic photography, a lens hood should have the same aspect ratio as the camera's format. If it doesn't, vignetting will occur. Another vital accessory is the center-spot neutral-density filter. This filter helps to even out light falloff, a common problem when wide-angle optics are used on large, elongated formats.

NONROTATION-LENS CAMERAS

Camera Model	Lens	Diagonal Angle of View	Film-Negative Format
Fuji Panorama G617	105mm, f/8	93 degrees	120/220 (617)
Linhof Technorama 617	90mm, f/5.6	98 degrees	120/220 (617)
Linhof Technorama 612 PC*	135mm, f/5.6	45 degrees	120/220 (612)
	65mm, f/5.6	86 degrees	—
Art Panorama 612**	127mm, f/4.7	50 degrees	120/220 (612)
	75mm, f/5.6	80 degrees	—
Art Panorama 617**	—	—	120/220 (617)
Art Panorama 624**	—	—	120/220 (624)
612/47 Superwide***	47mm, f/5.6	115 degrees	120/220 (612)
Ipan	65mm	—	35 (24 × 112cm)
Panorama	—	—	35

* The Linhof Technorama 612 PC has a rising front, and two lenses are available for this camera.
** Two lenses are available for the Art Panorama 612. Both the Art Panorama 612 and 617 have adjustable backs. The 617 model can be converted to a 612, and the 624 model can be converted to a 617. In addition, all three models are supplied with lensboards to fit wide-angle optics from all major large-format-lens manufacturers.
*** This is a converted Brooks very wide.

Stability

A tripod must be stable and solid. In addition, I find that after I mount my camera on the tripod, hanging my camera bag over the base plate (which holds the camera) increases the tripod's stability. My bag usually contains at least two other cameras and plenty of paraphernalia, and weighs at least 10 to 12 pounds. Incidentally, this arrangement also makes reaching for such items as film, note pads, and cable releases as I shoot more convenient.

Height

A tripod's height is important. Panoramic photography calls for you to spend a great deal of time trying to find a high vantage point. This minimizes the chances of having pictures marred by "ground objects," such as cars and people, and line convergence. I often extend one of my tripods so that it is more than 6 feet tall.

Ball Heads

These allow you to make small adjustments easily when you level your camera in any direction. A few years ago, I invested in a heavy (and expensive) ball head for my tripod and was so pleased with it that I now own three ball heads in different sizes—and will never go back to lever-type heads. A word of caution, however. Not all ball heads are well made. Be sure that the one you're thinking of buying can both move in small increments and maintain its position under the weight of a camera.

Quick-Release Units

Heavy-duty quick-release units make changing cameras very easy. I find them helpful because I routinely work with several different cameras.

I know that a tripod with all of these features is expensive, and that the cost might stop some of you. Before you make your final choice, though, think about how much film is wasted and, even more important, how many spectacular shots are ruined because of poorly constructed, wobbly tripods.

OPERATING THE CAMERA

Panoramic photography isn't filled with motor drives and electronic "auto-everything" technology. Just about every part of the process involved in operating nonrotation cameras is a separate step that must be completed manually, and just about every part of the cameras—for example, the lenses, shutter, and film advance—is mechanical in design. After you compose the shot, set your camera on the tripod and level it, using the camera's internal level or a bubble level placed on the camera's accessory shoe. Load the film into the camera and indicate the estimated distance on the lens by turning the distance ring. Meter the scene. Next, set the *f*-stop by turning the aperture ring, and the shutter speed by moving the shutter-speed dial. Advance the film, cock the shutter, and then release it either by using a cable release or by pressing the shutter-release button.

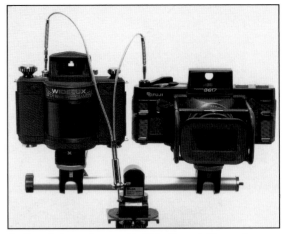

I often photograph a scene with both a rotation and a nonrotation camera, using this setup for a 6 × 17cm camera and a medium-format Widelux. Having the right accessories is essential for panoramic photography. Note the ball head, sturdy tripod, and quick release at each of the camera positions, as well as the double cable release.

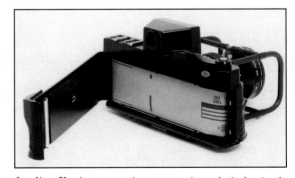

Loading film in nonrotation cameras is a relatively simple procedure. Insert the film into the takeup reel, advance the roll to the marker as shown, close the camera back, and advance to the first frame. This camera is a medium-format roll-film model.

LOADING FILM

Loading film into nonrotation cameras is straightforward. For cameras that take 120 roll film, insert the film into one end of the camera, pull it across the film guides, and place it in an empty takeup spool at the other end. Each camera has a marker on the inside of its back to show you how far you should advance the film before closing the camera back, and all roll films have an arrow that lines up with this marker. After you close the back, advance the film to the number "1" on the frame counter. Remember, advancing the film doesn't cock the shutter on any of these cameras—this is a two-step operation. Advance the film, and then cock the shutter.

It is easy to make double exposures accidentally when you're shooting, so it is a good idea to decide on a specific procedure and stick to it. For example, I always make advancing the film and cocking the shutter part of the same operation. Then if I see that the shutter isn't cocked, I know that the frame number showing has been exposed. The process of loading nonrotation 35mm cameras is quite similar to the one used for conventional 35mm cameras. Drop the film cassette into the camera, pull the film across the camera back, and continue inserting the film into the takeup spool until it is securely rolled up. Then close the back and advance the film to the first frame.

FOCUSING

You can focus nonrotation cameras two ways.

You can turn the lens in a hellicoid focusing tube, which changes the film-to-lens distance. The other way is to use a focusing-rail-and-bellows arrangement, as you would on a view camera. Whatever method your camera offers, you have to estimate the distance and adjust the lens accordingly. Remember, viewfinders on nonrotation cameras are for composing only; they aren't connected to the lens' focusing system and aren't parallax-corrected. But because you rarely focus close with panoramic cameras, this is only a minor disadvantage.

In general, the viewfinders on all cameras are fairly accurate. When knowing exactly what will be captured on film and what will be in focus is critical, you can place a groundglass plate on the back of the camera to see what the final image will look like. This is a simple procedure. First, open the empty camera and set the lens on "B" (Bulb). Cock the shutter, and then release it via a cable release; this locks the plunger in the "down" position, thereby keeping the lens open.

Next, place the groundglass over the film guides and view the inverted image. Because the image will be dim, you'll probably need an opaque cloth for blocking out extraneous light and a loupe for critical focus. Although you'll obtain the brightest view with the lens aperture wide open, it is important to look through the viewfinder with the actual f-stop you intend to use for the exposure. This relates to *depth of field,* the area of sharp focus. The smaller the aperture opening, the greater the depth of field. And be-

cause panoramic photographers usually want everything in their pictures to be sharp, they tend to favor very small lens openings, such as f/16, f/22, f/32, and f/45. But these apertures greatly reduce the amount of light passing through the lens. Consequently, panoramists need to use slower shutter speeds when they shoot—as well as a tripod.

DETERMINING EXPOSURE

Panoramic cameras have no built-in meters or any autoexposure capabilities. All f-stops and shutter speeds must be set manually. Because nonrotation cameras use mostly large-format optics, aperture and shutter settings are built into the lens. So the first step is to meter the scene and decide on the combination of f-stop and shutter speed you'll be using. Next, you set the aperture by turning a ring or a dial to the chosen f-stop number. Similarly, you set the shutter speed by moving a lever and then cocking the shutter. The final step in determining exposure is to press a cable release or trigger lever in order to release the shutter.

HANDHOLDING THE CAMERA

On occasion, you'll want to handhold your nonrotation camera. Keep in mind, however, that preventing camera shake and composing on a level plane might be problematic. The easiest way to prevent camera shake is to use a fast shutter speed. Photographers who shoot with 35mm SLR cameras ordinarily adhere to the guideline

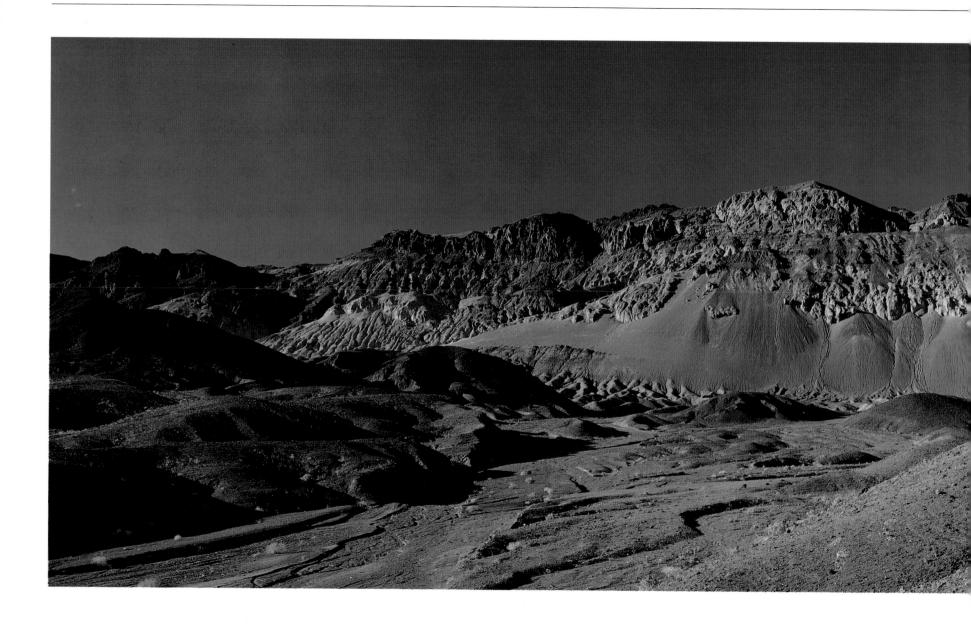

that a minimum shutter speed of 1/60 sec. produces sharp images, but faster shutter speeds of 1/125 sec. and 1/250 sec. are better. With medium-format cameras, the minimum shutter speed is generally considered to be 1/125 sec. or 1/250 sec. These guidelines are highly dependent on both the photographer and the camera.

To help you determine which shutter speed works best with your nonrotation camera to prevent camera shake, try the following exercise; it has worked well for me over the years. Load your camera with either color-transparency or black-and-white negative film. Then select a scene that contains a high number of horizontal and vertical lines, such as the windows or the brickwork of a big building. Handholding the camera at shutter speeds of 1/60 sec., 1/125 sec., 1/250 sec., and 1/500 sec., and then at 1/60 sec. using a tripod, shoot the scene both at infinity and at the lens' closest focusing distance.

After processing the film, cut the frames and shuffle them. Examine the same window or brickwork area in each image with an 8X loupe.

Nonrotation cameras can render subject matter in a straightforward, distortion-free manner with extensive depth of field. I used a 617 camera with a polarizer for this shot of rock formations in Death Valley.

Rank the frames from best to worst in terms of sharpness. Next, identify the corresponding shutter speeds by the film-frame numbers. When I completed this exercise with 617 and 612 cameras, I found that a shutter speed of 1/125 sec. is fine for shooting at infinity, but that 1/250 sec. or even 1/500 sec. is necessary for close-focusing distances.

The other problem you need to solve is how to keep a handheld camera level. The design of a few nonrotation cameras allows you to see their bubble levels through the viewfinder while you compose. However, these levels are limited to the horizontal plane; they don't indicate if the camera is being tipped forward or backward. Unlike viewfinders in 35mm SLR cameras, viewfinders in nonrotation cameras aren't accurate enough to detect this problem. Maintaining proper camera position, then, comes with practice. Although it helps to be able to see the bubble level as you compose and shoot, ultimately, your best solution is to repeat a handholding technique until it becomes second nature, as is true about so much of photography.

Using a Tripod

While you can handhold nonrotation cameras and even take "grab shots" with them, they perform best mounted on a tripod. They produce high-quality, well-composed images when you pay attention to such important steps as reducing camera shake, setting level perspectives, and composing the scene in the camera.

Completing a few simple steps will enable you to successfully shoot panoramas with your non-rotation camera mounted on a tripod. First, remove the lens cap. Set the camera on a tripod, both parallel and level to the subject, having composed through the viewfinder. (Most cameras have built-in levels, as do some tripods.) To facilitate critical composing and focusing, view the image through the lens on a groundglass placed on the film plane, using a cloth to block extraneous light. Next, load the film into the camera and advance it to the first frame. But this doesn't automatically cock the shutter, so watch out for a double-exposure error. Then meter the scene and estimate the distance. Finally, set the f-stop, shutter speed, and distance on the lens and make the exposure.

Alternative Methods

You can use a number of accessories to minimize camera shake if you handhold your camera. These include pistol grips, shoulder gunstocks, and monopods. Using a monopod is a fairly convenient alternative to setting up a tripod, and it helps quite a bit to steady the camera. You can also try other methods, including bracing yourself against a wall or propping your elbows—or the camera itself—on a sturdy surface, such as a table or fence. Whatever approach you decide to try, use the fastest shutter speed the depth of field allows. Once again, I suggest that you test these various accessories and techniques to determine just how effective you find them.

Eliminating Line Convergence

Another aspect of keeping the camera parallel to the subject as well as level while you shoot is the problem of line convergence. This type of distortion, which is also called the *keystone effect*, occurs when the camera is tipped up. The ideal shooting situation, of course, is to be able to find a vantage point that allows you to fully capture a scene without having to tilt the camera up. But this doesn't always happen. Tipping a camera upward to include an entire subject produces a number of important changes. First, the film plane, which was originally parallel to the subject, now runs diagonal to it. As a result, the subject matter in the bottom half of the picture is closer to the film and therefore appears larger. And, conversely, the subject matter in the top half of the image appears smaller. At the same time, however, the amount of the scene shown in the bottom part of the picture is less than that in the top. The overall effect of these changes is to alter the size perspective of subjects on film and to cause straight vertical lines to close in toward the top of the picture. In photographs, this line convergence makes single buildings appear to fall backward, the tops of straight trees move toward each other in the sky, and skyline buildings seem to tilt toward the center of the image.

You can eliminate line convergence two ways. Either raise the height of the camera to maintain the parallel relationship between the film plane and the subject, or raise only the lens a few millimeters to take in more of the top portion of the

scene. While the lens-shift option doesn't provide a great deal of movement—between 10mm and 15mm—it is often just enough to enable you to include the part of the scene that is out of view. This lens-shift feature is available on some nonrotation cameras (as well as on many conventional cameras that can be converted to panoramic formats, such as view cameras and field cameras—see Chapter 5).

Using a lens-shift mechanism to correct line convergence is a straightforward procedure. First, mount the camera on a tripod. Then as you're composing, adjust the camera so that it is level and parallel to the subject, even though this position might not take in all of the upper parts of the scene. Using a groundglass for focusing, raise the lens until you see the image you want to shoot. You might have to make one other change at this point: an exposure increase because you are about to photograph the scene with the lens shifted off its center. This means that you're going to take the picture through an area of the lens that is most prone to light falloff.

COMPOSING WITH NONROTATION PANORAMIC CAMERAS

When you pick up a nonrotation panoramic camera and look through the viewfinder, you probably tend to hold the camera level and move it from side to side as you compose. This is because tilting the camera up or down doesn't seem appropriate. The wide field of view is impressive,

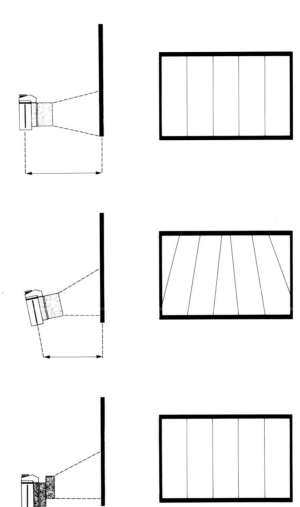

Line convergence occurs when a camera is tipped in order to include a complete subject in a picture. In the top diagram on the left, the camera is level and parallel with the columns. As a result, the film plane and subject plane are parallel, which keeps the vertical lines straight. But the camera is too low to take in the entire subject. Tipping the camera back, as shown in the center diagram, allows more of the subject to be included in the frame, but the film plane is no longer parallel and line convergence results. In the bottom diagram, only the lens has been raised; the camera remained stationary. Here, the film plane and subject plane are parallel and the vertical lines straight. This image is distortion-free.

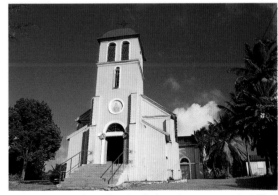

This small church on the island of Antigua seems to be falling backward because I had to tilt a 35mm camera equipped with a 28mm lens back to take in all of the scene.

After composing the image of the northern Arizona landscape
shown above, I photographed the expansive scene with a 617
camera. The uncluttered sunset shot on the right was made
with a Panorama camera. (Courtesy: José Gaytan.)

but the "tightness" of the image in the view-finder is even more striking. The camera's format and angle of view draw you naturally to the middle third of the scene. Even though these cameras are similar to conventional cameras, there is no question that they are a different kind of machine. They are vista cameras, plain and simple. They clearly view the world as a wide expanse along the continuum of the middle third. What you see here is generally a very tight concentration of subject matter, uncluttered by vast areas of foreground or sky. This tells you that the subjects will be rendered in a very straightforward, distortion-free fashion.

A nonrotation camera can, in effect, teach you how to shoot vistas if you keep in mind the basic principles of panoramic photography. You'll also have to remember not to treat this type of camera like a conventional camera. Don't attempt to force your nonrotation camera to do any tasks for which it wasn't originally designed and intended. For example, don't compose a shot by tilting the camera down as you would with a wide-angle lens, and don't come in very close to the subject to exaggerate the foreground. Because nonrotation cameras have an affinity for level, distortion-free, tightly composed shots of expansive vistas, you must consider the horizon line and how the various subjects in the picture relate to it. Remember that the camera can lead you in this direction, but it can't prevent you from thinking about such conventional-composition elements as single, dominant subjects; dynamic diagonals; and negative space.

You must continually remind yourself to look at large sections of a scene and the overall image. Suppose you want to photograph a skyline that is dominated by two tall buildings. While you can't avoid including these structures in the picture, you can find a vantage point that allows your camera to integrate, not emphasize, them in the scene—to present the skyline as a continuum, rather than as a background for the dominant buildings.

FLASH PHOTOGRAPHY

Nonrotation cameras are perfect for photographing large groups as result of their large negative size, wide-angle lenses, and elongated format. In addition, using fill-in flash is simplified because all of the lenses "sync" with electronic flash at every shutter speed. The only complications are the cameras' large angles of view. To adequately cover these, you need a flash unit powerful enough to deliver the 2:1 lighting ratio favored for fill-in flash. This ratio means that the flash (a fill source) delivers one stop less than the illumination dictated by the existing, or natural, light, which is considered the main light source.

For example, suppose the existing light in the scene you're shooting calls for an exposure of f/16 at 1/250 sec. To use fill-in flash, set the flash unit as if it were the only source of light; here, the correct setting is f/11, one stop less. You don't have to worry about shutter speeds because they aren't fast enough to control the flash. I find that the Metz 45T flash unit provides both plenty of

power and with the manufacturer's wide-angle attachment, a 65-degree horizontal arc of light. This is sufficient for most fill-flash applications unless the large group you're photographing is arranged corner to corner on film; the light drop-off at the edges will then be obvious.

You can also use flash as your sole light source. To cover the extensive angles of view in these situations, some photographers shoot with two flash units set a slight distance apart from one another on lightstands; others mount the units on the camera and angle them away from each other. Whichever system the photographers use, however, they need to do some testing and calibrating before they shoot.

The ability of nonrotation cameras to create distortion-free images exceeds that of both rotation cameras and conventional cameras with ultrawide-angle lenses. Nonrotation cameras best present large, elongated subjects in a straightforward, uncluttered manner. No part of the images these cameras produce is wasted—no unwanted foregrounds, backgrounds, or imposing skies, just the subject presented as a whole. Nonrotation cameras really enable you to capture the enormity and essence of a scene. Equally important, these cameras offer the best way for you to develop a panoramic viewpoint. Then, once "thinking panoramic" becomes second nature, you can move on to rotation cameras that produce 360-degree views but also result in distortion and make previewing the image difficult. Shooting with nonrotation cameras is excellent preparation.

ROTATION CAMERAS

Panoramic cameras that achieve their wide fields of view through a rotation mechanism are unique. Rotation cameras fall into two distinct classes. The first group consists of *short-rotation* or *swing-lens* models, whose lenses move across a stationary section of film in a set arc of between 110 degrees and 150 degrees, depending on the particular camera. The other group of cameras consists of *360-degree-rotation* or *full-rotation* models. In these cameras, the lenses are in a fixed position and move as the camera moves, not independently. The 360-degree cameras can, however, also be set for shorter rotation arcs, such as 110 degrees. The film formats for all rotation cameras have high aspect ratios, such as 1:6 and 1:10. These cameras differ from both nonrotation and conventional ones in another important way as well. Rotation cameras have an unusual shutter mechanism, referred to as a slit-scan shutter. These two features—the ability to rotate and the slit-scan shutter—combine to produce a picture-taking mechanism in which light is progressively laid down on film from one end to the other, in contrast to reaching the film all at once in conventional cameras. So although the basic tenets of panoramic composition apply here, composing with a rotation camera differs in critical ways from composing with a nonrotation camera.

The key to these differences is understanding the design of the slit-scan shutter and the way it operates. This shutter mechanism is both the heart of every rotation camera and the reason photographers can capture fields of view up to 360 degrees on film. While you don't have to know as much about the shutter as an optical engineer does, it is important for you to fully understand the basic principle behind it. You'll then be able to anticipate the shutter's effect on your images and to use it to your advantage.

THE SLIT-SCAN SHUTTER

The slit-scan shutter is composed of a lens whose rear portion becomes a vertical slit through which light is focused onto the film. In some 360-degree rotation cameras, you can adjust the size of this slit, thereby gaining greater exposure control. All rotation cameras have a full range of *f*-stops that are set via the aperture. In some models, you can adjust the focus. Shutter speeds for short-rotation cameras are determined by the speed of the scan over the film, and for 360-degree models by the speed of camera rotation. Typically, short-rotation cameras have two or three speeds while 360-degree cameras have many more. Exposure is then determined by changing the aperture and shutter speed.

The slit-scan shutter affects the way time and light sources are recorded on film. Photographs made with rotation cameras at fast shutter speeds look essentially the same in terms of shutter-speed effects as those taken with conventional cameras: the images are sharp and the action is frozen. But if you shoot a rotation camera at a slow shutter speed, such as 1/8 sec., you can really play with time and movement. At slow shutter speeds, a rotating lens or camera can take several seconds to move through its arc. As a result, moving subjects might look stretched in the image or appear to be a continuous blur across the whole frame if they can follow the lens' movement. A more common method of taking advantage of slow shutter speeds with rotation cameras is to have a person dash from one end of the image to the other during the rotation across the field of view. The person then appears at both ends of the photograph.

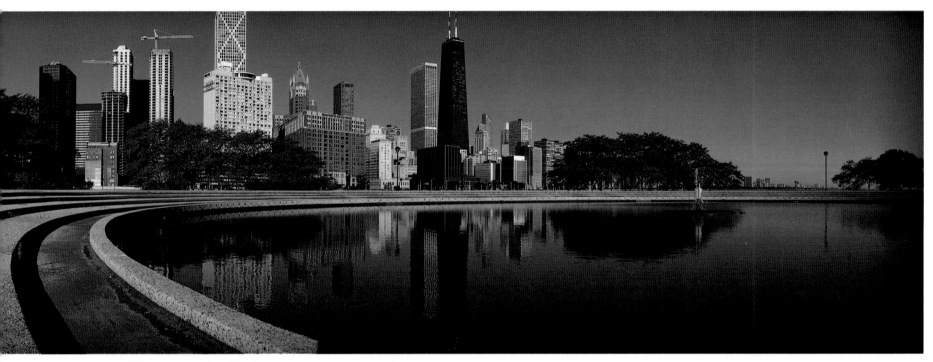

The sweeping "S" curve on the left side of this super-wide shot, made with a Cyclops camera, provides the skyline vista with a sense of depth. It is also an example of how the eye finds the horizon. (Courtesy: W. W., Inc.)

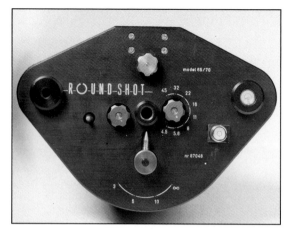

The 360-degree Round Shot cameras have similar configurations and operating procedures; only the focus and perspective-control features vary from camera to camera. The remote-control device sets both the arc of rotation and the start/stop sequence. (Courtesy: Tekno, Inc.)

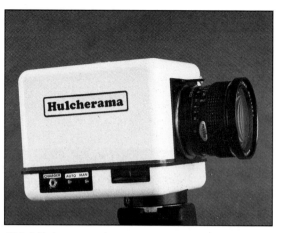

This 360-degree-rotation camera, a Hulcherama model 120, has nine shutter speeds and twenty-four combinations of slit widths and rotation speeds. The camera lens is readily accessible, so attaching lens hoods and filters is simple. (Courtesy: Charles A. Hulcher Camera Co.)

The Alpa Rota with its triangular head and accessible lens was the first of the modern 360-degree-rotation cameras. It was considered a significant improvement over its predecessors because it uses modern films and incorporates reflex viewing, adjustable slit openings, perspective control, and remote controls. (Courtesy: Karl Heinz, Inc.)

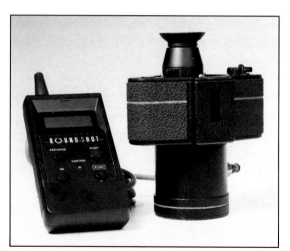

On all Round Shot cameras, including the 65/70 model shown here, most of the controls are located on the top of the camera body. (Courtesy: Tekno, Inc.)

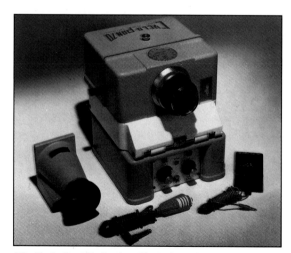

The Cyclo-Pan 70, developed by Jack Rankin and Ken Meeks, weighs 20 pounds and measures 8 square inches. This camera uses interchangeable lenses up to 200mm and 100-foot-long 70mm film. (Courtesy: Panoramic Photography Co.)

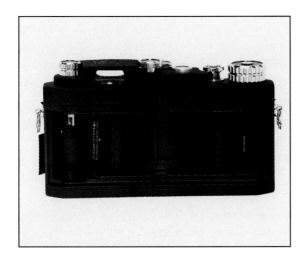

The slit on the rear of the Widelux F camera shown on the left serves as a shutter when the lens moves over the film, enabling the camera to record 360-degree views.

The effect of a sudden change in a scene's illumination during the rotation of the slit-scan shutter is apparent in the shot below. The white, overexposed area was caused by the studio flash, which was fired after the swing lens scanned the main part of the photographer's studio. Although this problem seems to be an example of banding, it is the result of a momentary light-level change, not an irregular movement of the lens. (Courtesy: Dean Collins Associates.)

The slit-scan shutter requires a continuous light source in order for you to be able to record a scene with even illumination. Any variation in lighting at any point during the scan of the slit lens is recorded at different places on the film. If the change in lighting is sudden, as with a burst from an electronic flash unit, *banding* results. Banding also happens because the lens slows down during its rotation, thereby producing overexposed bands, or strips. The problem takes the form of either a thin—a few millimeters wide—vertical strip in a horizontal photograph or a thin, horizontal strip in a vertical shot. The bands appear as dark strips in black-and-white and color prints, and in color transparencies.

You can illuminate huge areas with a single light if you can follow the lens' field of view as it moves across its arc. In this situation, though, you must make sure that the beam of light is wide to help offset the difficulty of staying precisely in the middle of the lens' track.

Banding is the most common malfunction among all rotation cameras. If banding is present in your images, you must have your camera repaired. Some photographers who use Widelux F cameras move the lens manually through its arc three or four times before cocking the shutter and taking the picture. They claim that this technique helps prevent the banding caused by a sluggish rotation mechanism.

The process of loading film into short-rotation cameras varies with each model. With the smaller Widelux, shown here, the film is passed under two sets of rollers; the rollers on the larger Widelux seen are attached to the camera back.

The Cyclops, another short-rotation camera, has a curved back with no roller mechanism.

OPERATING SHORT-ROTATION CAMERAS

Three-short-rotation cameras are currently in production: the Widelux F and 1500 models, and the Cyclops Wide-Eye camera. Operating each of these cameras is based on the same principles guiding the operation of a moving slit-scan lens. Exposure is controlled by setting the aperture and controlling the speed of the lens' swing action. The angles of view of these lenses are moderately wide when stationary. When the cameras rotate, however, they have different arcs. The Cyclops moves through an arc of 110 degrees, while the Widelux F and the Widelux 1500 models move through arcs of 140 degrees and 150 degrees, respectively.

PREPARING TO SHOOT

The typical picture-taking sequence for rotation cameras is to mount the camera on a tripod, level the camera so that it's parallel to the subject, compose, set the *f*-stop and shutter speed, cock the shutter, and shoot. The Widelux F model is an exception to this rule; with this camera, winding the film also cocks the shutter. Incidentally, cocking the shutter on short-rotation cameras means moving the lens back to its original pre-swing position.

As with nonrotation cameras, you manually operate short-rotation cameras by following a series of steps while you shoot on a plane parallel to the subject. Once again, you must level the camera. This is critical because the lens moves across the scene and exaggerates any mistakes. All three models have built-in, circular bubble levels. Furthermore, you can focus only the Widelux 1500 model. To do so, place a finger inside the lens barrel and turn the small wheel that moves the focusing ring on the lens until the distance you want is indicated on the scale. Then to

SHORT-ROTATION-LENS CAMERAS

Camera	Lens	Shutter Speed	Diagonal Angle of View	Film-Negative Format
Widelux F8*	26mm, $f/2.8$	$1/15$, $1/125$, $1/250$ sec.	140 degrees	35mm (24 × 56)
Widelux 1500**	50mm, $f/2.8$	$1/8$, $1/60$, $1/250$ sec.	150 degrees	120mm (612)
Cyclops Wide-Eye	82mm, $f/8$	$1/60$, $1/250$ sec.	110 degrees	120mm ($2^{1}/4 \times 6^{1}/4$)

* The Widelux F8, like its "F" series predecessors, is small, light, and easy to use. Its built-in, nonfocusing viewfinder, however, is notoriously inaccurate. Cocking the shutter and advancing the film can be accomplished in one step.
** The Widelux 1500 model, introduced during the mid-1980s, is bigger and heavier than the Widelux F models. Nevertheless, it is still easy to operate. Advantages include a much larger negative, an adjustable focus to 2.5 meters, a more accurate viewfinder, and additional coverage of 10 degrees. Advancing the film is separate from cocking the shutter, which permits double exposures.

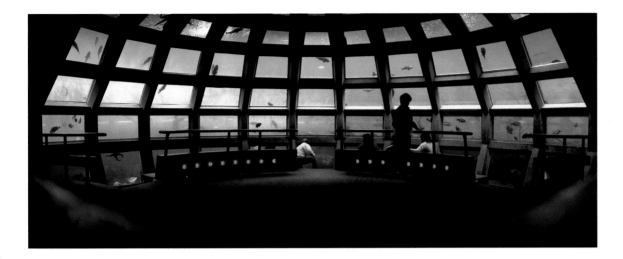

Just how sharp can a panoramic photograph shot handheld with a short-rotation camera at slow shutter speeds be? For this picture in the Seattle Aquarium, I rested my elbows on a railing (which is visible in the foreground) and exposed the image at f/5.6 for 1/8 sec. The room, incidentally, was round but appears elliptical here because I wasn't standing exactly in the center of it.

set the aperture, turn the wheel on the other side of the lens barrel until the desired *f*-stop appears. On both the Widelux F and the Cyclops, the aperture settings are located on the top plate.

Because you can't focus and compose a short-rotation camera via a groundglass—the small slit on the back of the lens prevents you from seeing an image—focusing is based on an estimation. To shoot some critical closeups with the Widelux 1500 model, I've used a metric tape measure to be as accurate as possible. In general, however, the best way to maximize the depth of field is to use such small apertures as *f*/16 and *f*/22. These cameras are equipped with lenses that would be considered wide-angles (providing extensive depth of field) if they remained stationary.

Handholding the Camera

Short-rotation cameras are relatively easy to handhold. With practice, you'll be able to pro-

duce level shots. All three cameras have bubble levels that can't be seen through the viewfinder. Because short-rotation cameras have swing lenses and exceptionally large fields of view, you must be careful to keep your fingers out of the picture. This problem will occur unless you hold the Widelux cameras between your thumbs and other fingers rather than in the palm of your hand—the way you're supposed to hold your 35mm SLR cameras. I prefer using a pistol grip or a small chest tripod, both of which provide stability.

Using a Tripod

Using a strong, steady tripod with short-rotation cameras is vital. And, because these cameras rely on a moving lens and therefore have much greater angles of view, they must be absolutely level. Even the slightest misalignment will be noticeable in a scene that you want to render as

distortion-free as possible. All three short-rotation cameras have bubble levels in a circular configuration. When used with a ball head, these cameras can be leveled quite quickly.

Focusing

The Widelux 35mm and Cyclops cameras are fixed-focus cameras, so you don't have to adjust their lenses. Keep in mind, however, that you must consider their minimum focusing distance when you compose. The medium-format Widelux has a focus adjustment beginning at 2.5 meters. But in all situations, paying careful attention to composition within the technical limits of your camera will reward you with excellent images.

Overcoming Exposure Limitations

While the limited shutter speeds on short-rotation cameras might appear to be a disadvantage, most photographers find that this isn't the case.

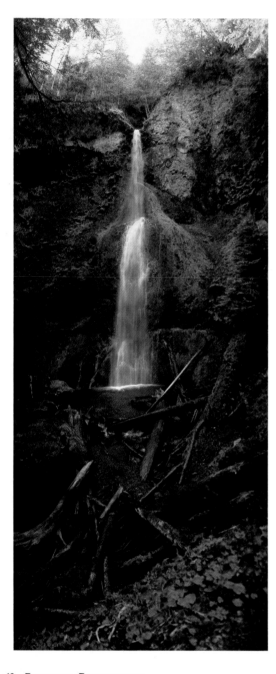

These cameras can use quality films with just about every speed rating available and have an ample range of aperture settings, so few situations pose insurmountable problems. Also, you can use neutral-density filters with these cameras, thereby enabling you to make further changes in exposure independent of *f*-stops and shutter speeds (see Chapter 4). Because these cameras feature recessed lenses that serve to protect the optics from stray light, using lens hoods isn't necessary.

One definite drawback, however, is the lack of very slow shutter speeds. This prevents you from producing many common slow-shutter-speed effects, such as the blurring of cascading water. You should keep in mind, though, that more of a blur can be captured on film when the subject's moving in an opposite direction to the swing direction of the lens. On the positive side, handheld shots taken at slower shutter speeds are fairly sharp because only a small part of the film is exposed at a time. (Conventional cameras expose the whole frame at once and therefore "catch" all the shake at once.) Handholding a short-rotation camera and shooting at faster shutter speeds, such as 1/125 sec. and 1/250 sec., generally stop action and produce sharp images.

I photographed these cascading waterfalls in the Seattle rain forest from a distance of about 100 feet. Using a Widelux 1500 camera, I exposed at f/8 for 1/8 sec. to achieve the blurred effect seen here.

COMPOSING WITH SHORT-ROTATION CAMERAS

The unusual design of short-rotation cameras makes composing with them a bit tricky. Although the general principles of panoramic composition apply, such as center dominance and unified vistas, you must pay attention to a few unique elements. The viewfinders in these cameras are only compositional aids. The effective way to compose with short-rotation cameras is to develop a panoramic eye in relation specifically to them and to know how they translate the arrangement of subjects and camera viewpoint onto film. The Widelux F model sees about two-thirds of the actual picture area. The Widelux 1500 camera, on the other hand, sees more of the scene but the final image isn't very sharp. The Cyclops now has an accessory viewfinder.

When I work with these cameras, I first mentally compose the scene by looking for subjects that appeal to me. Next, I think about how they will be affected by the rotation and the slit-scan shutter. I often use a small, cutout card that approximates the angle of view when I hold it at a certain distance from my eye. The camera's position—high or low, up or down—and the distances between the lens and the various subjects determine how different parts of the picture will appear on film. Remember, a wide field of view is only part of the effect. The camera's rotation and slit-scan shutter have more of an impact on composition. After completing this previsualization, my last step when composing is to look through the viewfinder.

As you compose with short-rotation cameras, keep in mind that their aspect ratios are comparable to those of nonrotation cameras. For example, the Widelux 1500 and Linhof 612 PC cameras are both 6 × 12cm models with aspect ratios of 1:2. But don't let the similarity of their formats mislead you. The slit-shutter mechanism of short-rotation cameras introduces major perceptual changes that set them apart from nonrotation models.

CIGAR-EFFECT DISTORTION

Holding a short-rotation camera level and parallel to a scene doesn't prevent line convergence or render horizontal lines straight. The lens rotation causes the distance between the film and the subject to change. Suppose you're working with a short-rotation camera and the arc of the lens is 140 degrees. Your subject is a wall with a drawing of the rule-of-thirds grid on it. If your camera is positioned close, level, and parallel to the wall, then horizontal lines will bend away from each other in the center of the grid and will constrict at the ends, roughly in the shape of a fat cigar. This type of distortion also results when the camera is on a vertical plane, for the same reason that horizontal lines converge as you tip a camera back. The subjects that are closer to the camera will appear larger on film than those that are farther away. But any vertical lines in the scene will remain straight. This is because the parallel/level relationship of the camera to the scene is maintained during the arc of the lens' swing. You can, however, camouflage this cigar-effect distortion

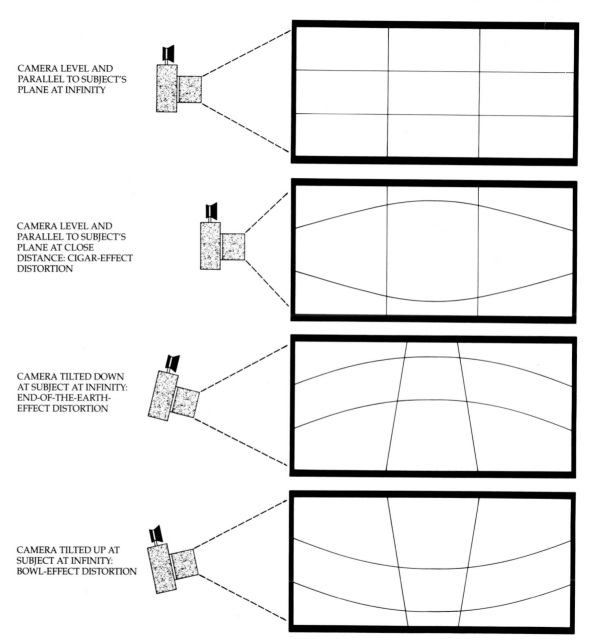

CAMERA LEVEL AND PARALLEL TO SUBJECT'S PLANE AT INFINITY

CAMERA LEVEL AND PARALLEL TO SUBJECT'S PLANE AT CLOSE DISTANCE: CIGAR-EFFECT DISTORTION

CAMERA TILTED DOWN AT SUBJECT AT INFINITY: END-OF-THE-EARTH-EFFECT DISTORTION

CAMERA TILTED UP AT SUBJECT AT INFINITY: BOWL-EFFECT DISTORTION

This diagram shows the effect of short-rotation cameras on straight lines.

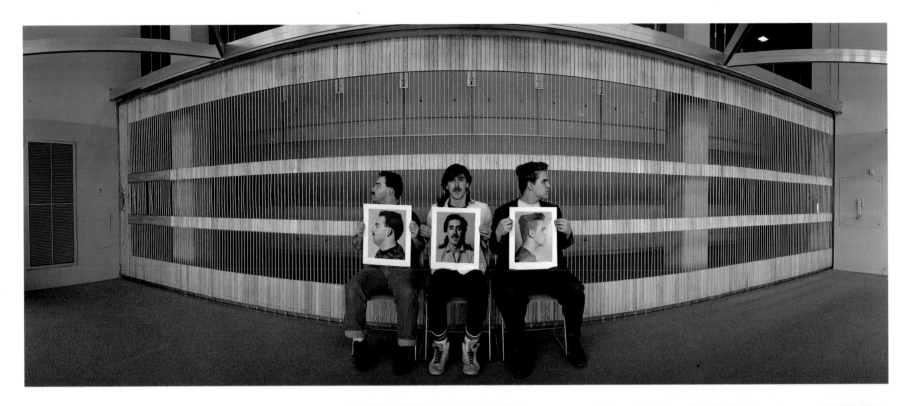

To photograph these young men, I positioned a 150-degree short-rotation camera directly in front of, level with, and parallel to the center subject. I also made sure that the camera was at the same height as his head. Notice how little distortion there is along the middle third of the camera's path.

The environmental portrait of author and media expert Tony Schwartz shown on the right illustrates how the cigar effect and a short-rotation camera's extremely wide angle of view can combine to frame a single subject with a continuous flow of visual information. Here, I used a Widelux 1500 and exposed at f/5.6 for 1/8 sec.

when the subjects aren't on one continuous, flat plane across the entire image and you set the lens at infinity.

You can minimize cigar-effect distortion with short-rotation cameras another way. Avoid getting too close to your subject and find a viewpoint that makes the swinging lens work with the composition rather than against it. For ex-ample, if you're shooting a seascape, try to position rocks in the far left and/or right thirds of the image. The cigar effect won't be obvious. In addition, you'll be able to emphasize parts of the picture while keeping the flow of the middle-third continuum.

Cigar-effect distortion resembles the curvilinear distortion of a full-frame fisheye lens. But the bowing of lines into a cigar shape is based on changes in distance that occur during the lens' rotation, rather than the optical design of the lens.

END-OF-THE-EARTH-EFFECT DISTORTION

Panoramic subjects are sometimes well served by the changes produced by a short-rotation camera. A common example occurs when you photograph a distant vista, such as a seascape or a skyline. When you tilt short-rotation cameras up or down, both horizontal and vertical lines are affected. Tilting the camera down causes an elongated bending of the horizon, which is referred to as the end-of-the-earth effect. Here, the tilt works well because the idea of the earth's curvature seems to be part of the illusion of the image. A clever variation is first to tip the camera down to produce the bowing of the horizon, and then to hide the effect in the lower half of the picture by using a "neutral" foreground in which there are no lines.

BOWL-EFFECT DISTORTION

This is the reverse of end-of-the-earth distortion. Here, the horizon is bent upward or in the shape of a bowl. Finding appropriate subjects, however, is a bit difficult. The reason is quite simple. Compositions that are straight, either horizontally or vertically, are more common. Horizon lines that bend upward at both ends are relatively rare. Downward curvature, as seen in end-of-the-earth-effect distortion, is more plausible because views from high altitudes and from space are familiar.

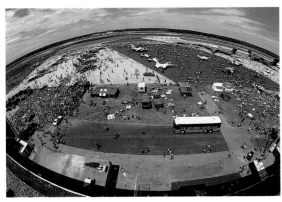

I photographed the scene shown above while standing on a building 50 feet above the field. For this shot, I used a Widelux F. Notice how the lines bow here, a result of cigar-effect distortion. I made the shot on the left of the same air show from the identical vantage point using a Sigma full-frame fisheye 16mm lens. This curvilinear distortion is produced by the lens' optical design.

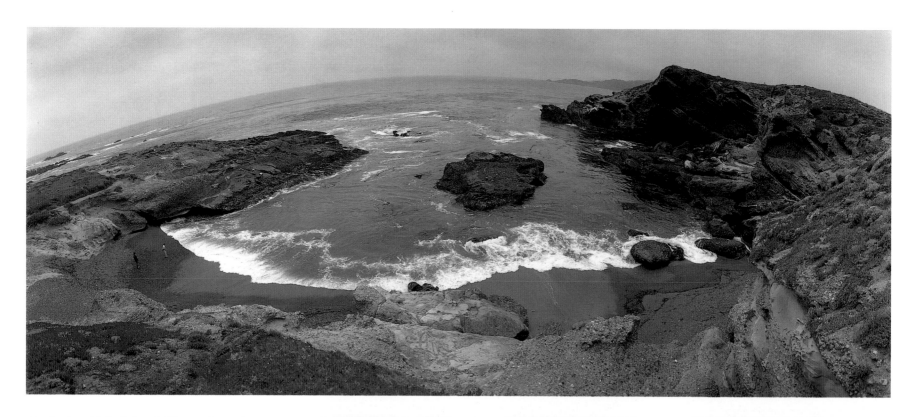

For the shot of Point Lobos, California, shown above, I stood about 50 feet over the cove. The tilt of the camera resulted in end-of-the-earth-effect distortion. To appreciate the expansive nature of this image, note the two people in the far left-hand corner of the cove. With a Widelux 1500, I exposed for 1/60 sec. at f/8.

When a short-rotation camera is tilted up, bowl-effect distortion occurs. In the cityscape on the right, the horizon turns upward and the vertical buildings turn inward.

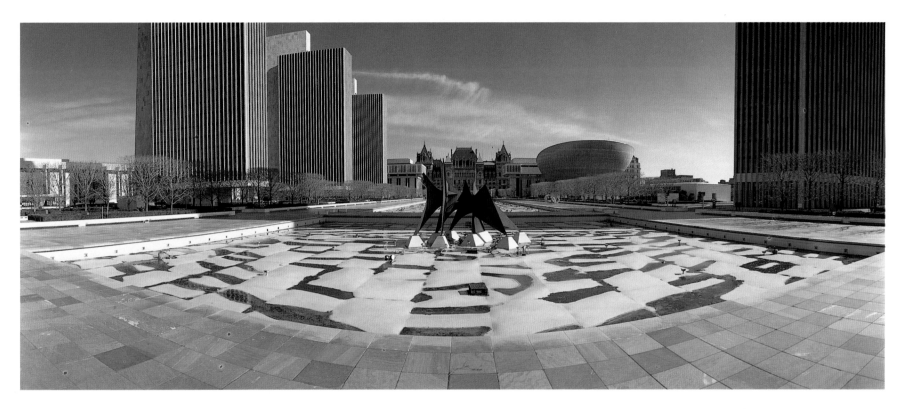

Distortion can enhance panoramic images when used effectively and selectively. Here, the camera was level but close to the empty reflecting pool in the foreground. As a result, cigar-effect distortion made the rectangular-shaped pool appear to be curved, making the composition interesting. Notice, however, that the buildings in the background show no sign of curvature; this is because they were so far away from the camera. For this shot in which distance was the controlling factor in the amount of cigar-effect distortion rendered, I exposed for 1/60 sec. at f/22 with a Widelux 1500.

Distortion as a Compositional Tool

Panoramic photographers use all of the idiosyncrasies of the slit-scan shutter and the rotating mechanism to produce striking photographs. For example, cigar-effect distortion can be an ideal compositional device for large-group shots. The bulge effectively calls attention to the center of a scene but still maintains the continuum. So the middle part of the picture shows a few of the people in some detail, while the receding rows give a sense of the mass.

To sum up, if you want distortion-free shots when shooting with a short-rotation camera and its very wide field of view, your camera must be level and parallel but not too close to the subjects. Also, when you compose, you must place subjects in the outer thirds of the image to decrease the cigar effect. When you are close to a subject on a flat plane, the center bulge is unavoidable. If you find yourself in such a shooting situation, try to use the bowed lines running along the upper and/or lower continuum as frames.

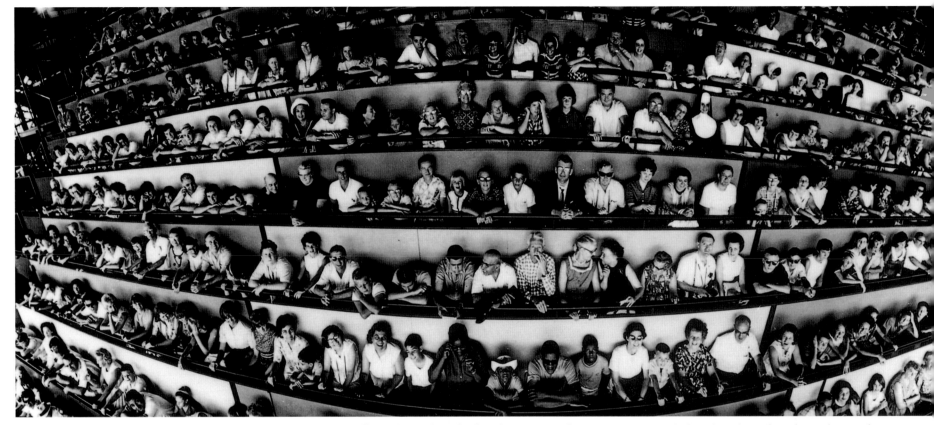

The cigar effect really "makes" the shot of spectators at the IBM exhibit at the 1965 World's Fair shown above. A Widelux F camera was used to capture the "IBM People Wall." (Courtesy: E. Peter Schroeder © 1965.)

The photograph of people at the seashore shown above on the opposite page is a good example of effective distortion. Notice the land formation in the upper left-hand section of the image. (Courtesy: Peter Klose.)

Notice how the curve of the garage door provides a frame for the image taken at a nude-photography workshop shown below on the opposite page. A Widelux 1500 camera mounted on a tripod and an exposure of f/11 for 1/60 sec. were used here.

CONCENTRIC LAYERS AND "STRAIGHT CIRCLES"

Another perceptual idiosyncrasy of short-rotation cameras is their tendency to portray subject matter in layers, somewhat like the concentric half-circles of a contour map. Most frequently, concentric layering can be seen in the lower half of a picture of a wide-open vista; the upper half usually shows the sky and/or clouds. This happens in part because of the cigar effect. But it is also a consequence of finding circular elements in a scene and using the camera's swinging lens to emphasize them. Layering is most obvious when there are already half-circles in the foreground that curve away from the camera and you shoot from a low vantage point.

Conversely, when lines in a scene curve around the camera, the opposite effect occurs. Suppose you're shooting in a stadium or a circular room. Under these conditions, the arc of the lens can reduce the curvature in the scene to make circular patterns appear to be "straight circles." Circular rooms are perfect subjects for short-rotation cameras because the rooms' shape is so similar to the arc of the lens. A circular room or wall will appear straight if the camera's placement enables the distance between the lens and the subject to remain constant during the rotation. Perfectly straight lines can therefore be achieved if the arc of the subject is parallel to the arc of the lens' rotation.

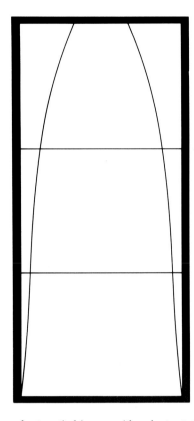

When you shoot vertical images with a short-rotation camera, subject matter in the foreground appears exaggerated in size because it is so close to the camera. At the same time, lines in the upper half of the image curve inward, as shown above. With a Widelux 1500 mounted on a tripod, I composed the scene on the far right so that the foreground was quite close to the camera. I then exposed the steps in downtown Seattle at f/22 for maximum depth of field. The vertical shot of a San Francisco street scene on the right required me to mount my Widelux 1500 camera on a tripod and expose at f/22. I wanted to achieve maximum sharpness throughout. Once again, the foreground subjects are exaggerated in size and cigar-effect distortion is present in the upper portion of the image.

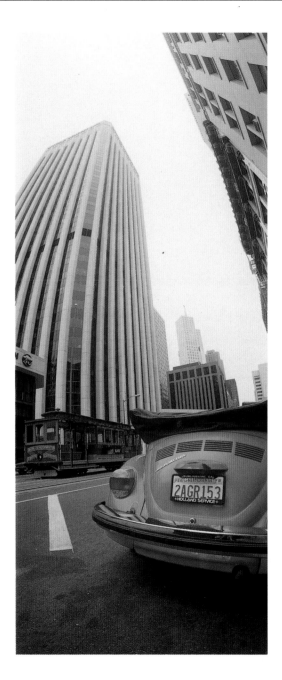

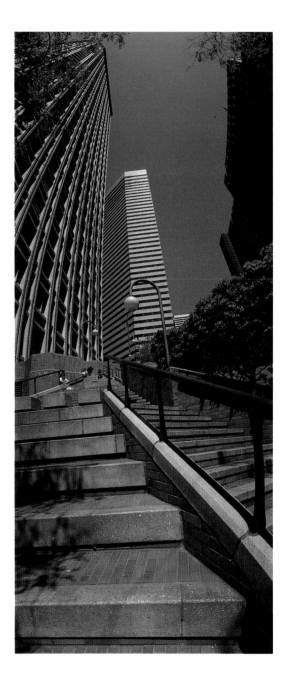

SHOOTING INTERIORS AND VERTICALS

Photographing the interior of a square or rectangular room with a short-rotation camera can be quite challenging. It is impossible to make the corners where the walls meet appear square because the lens moves in a circle in relation to the corners of the room. As a result, the corners seem to flare outward like the wings on a gull—as some photographers refer to this effect. There is simply no way for you to eliminate the bowing and flaring of square or rectangular walls. Your only option is to try to use the effects of the rotation as creatively as possible.

This is exactly what I set out to do for the shot of photographer Newton Phillips on page 131. I aimed my camera so that the center of the image shows the corner where the walls seem headed toward a vanishing point. The walls themselves are on the edges of the frame. As the lens swung around, it brought the center of the room closer and elongated the walls on either side, thereby creating the sense that they enclose the room.

One of the easiest ways to produce strikingly different photographs with short-rotation panoramic cameras is shooting verticals. When composing, however, you must remember that your subjects are often close to the camera at the bottom of the frame and farther away at the top. As a result, the lower half of the picture won't show the inward curving of lines. And, rather than the subjects appearing smaller or farther away at both ends of the frame, foreground subjects in the lower half of the image will be exaggerated in size if they're close enough to the camera.

What you're actually doing here is composing an image with one-half of the cigar effect. The center of the cigar has been extended to the bottom edge of the film, which is why you don't see converging lines. You might even manage to get divergent lines if you shoot close enough to the subject. In other words, the sizes of foreground subjects will be exaggerated because, in effect, you're using a wide-angle lens in close.

These, then, are the key points to think about when composing with short-rotation cameras. Most photographers consider their very wide fields of view to be their most important characteristic. Although this is true and vital to your panoramic viewpoint, keep in mind what produces those views. The rotating lens and the slit-scan shutter have their own ways of affecting subjects and, in turn, your final images, when you move in close, tilt the camera, or hold it vertically when shooting.

This photograph graphically illustrates what can happen when you combine the versatility of a short-rotation camera and a little imagination. Here, you can see the effect of coming in close to your subject: note the photographer's feet in this portrait of Erika. (Courtesy: Peter Klose.)

OPERATING 360-DEGREE CAMERAS

These cameras, which rotate fully, are designed somewhat differently from the simpler short-rotation cameras. First, 360-degree cameras can take in a much larger field of view. When you shoot, the whole camera with its fixed-position lens rotates in a circle, and the light enters the lens and exposes the film. The lens, as usual, focuses the image, and part of the exposure is controlled by the lens' built-in aperture. It is essential that the film move at the same speed as the camera; then the image focused on the film isn't moving in relation to the film. This technique is called the *slit-scan method* (see opposite page). If camera motion and film motion are synchronized, a sharp, evenly exposed picture will result. If they aren't, the subject will be distorted and/or banding will mar the image.

Preparing to Shoot

As you become more familiar with 360-degree cameras, you'll notice that they differ from short-rotation cameras in other ways as well. They require a separate approach to both handling and shot preparation. In short, successful shooting with 360-degree cameras demands more planning, care, patience, and technical knowledge than with any other panoramic camera. You must read your camera manual carefully, follow instructions exactly, and run tests. You have to discipline yourself to follow specific procedures as you set up and shoot, all the time thinking "panorama." Because 360-degree cameras are one-of-a-kind machines, detailing the operating instructions for each is beyond the scope of this book. I will simply mention that eight 360-degree cameras are available (see below for a summary of their features) and will discuss those methods of operations common to all or most of the 360-degree cameras.

Choosing Accessories

As with some nonrotation cameras, several 360-degree-rotation cameras require you to use accessories. The need for such items as filters and lens hoods is determined by an individual camera's design. Generally speaking, cameras with recessed heads can't use filters and don't require lens hoods. With 360-degree cameras, you ordinarily view a scene through a type of reflex viewing system, or auxiliary viewfinder. A few 360-degree-rotation models also allow you to focus the lenses. As far as handholding these cameras is concerned, only one model lends itself to this technique, the Globuscope.

ROTATION-LENS CAMERAS

Camera Model	Lens	Equivalent Shutter Speed	Film	Motor
Alpa Rota 60/70*	75mm, f/6.8	$1/15$ sec. to $1/250$ sec.	120/220 (70mm), 360 degrees equals 18.7 inches	Electric
Globuscope**	25mm, f/3.5	$1/100$ sec., $1/200$ sec., $1/400$ sec.	35mm, 360 degrees equals 6 inches	Spring Motor Fluid
Hulcherama 120***	35mm, f/3.5	$1/3$ sec. to $1/200$ sec.	120/220, 360 degrees equals 9 inches	Electric
Round Shot 35/35	35mm, f/2.8	$1/15$ sec. to $1/1000$ sec.	35mm, 360 degrees equals 6 inches	Electric
Round Shot 28/35	28mm, f/2.8	$1/8$ sec. to $1/500$ sec.	35mm, 360 degrees equals 6 inches	Electric
Round Shot 65/70****	65mm, f/4.5	$1/4$ sec. to $1/250$ sec.	70mm, 360 degrees equals 17 inches	Electric

* On the Alpa Rota, the camera lens has a front rise and can be focused, and the slit opening can be adjusted.
** The Globuscope can be handheld easily.
*** The Hulcherama 120 lens has a front rise.
**** The Round Shot 65/70 lens has a front rise and can be focused.

THE SLIT-SCAN METHOD

Ron Globus and Rick Globus
Globus Brothers Studio
New York

It is interesting to realize that even though photography is 150 years old, only two basic methods of creating a picture using light, lenses, and film exist. And almost all—99.9 percent—types of modern photography uses the *shutter method* of creating a picture. In this method, the shutter, which is ordinarily in a closed position, opens to allow light to fall onto the image plane for an instant in time. This length of time is called *delta T*. The film remains stationary relative to the lens during this process. The resulting picture contains the height and length of a subject exposed within a particular delta T from a single perspective in space with a single vanishing point. This two-dimensional view of the world is widely accepted. But the world is actually multidimensional. Just think about it: everything is happening everywhere all at once from every possible angle and point of view. Furthermore, all of this is happening along a stream of time.

Using the *slit-scan method*, on the other hand, you can create a picture with the same camera, but the approach is fundamentally different. With this method, an image is recorded on a moving piece of film as it is being exposed through a slit. No shutter opens and closes during the exposure. Because there are no frames, the resulting picture is seamless and continuous in time. There is no opening and closing of a shutter. What you get is a representation of the action in the scene as "seen" through a thin slit by the moving piece of film. The slit, then, forms an "event horizon." Perhaps most important, the final image contains an enormous number of perspectives, the product of the scanning motion.

As a result of the film's continuous motion, a secondary focus that isn't associated with the lens exists. This perfect focus, called *synchronization*, is the image clarity created when the speed of the moving film matches the apparent speed of the subject. Of course, synchronization doesn't always take place. If the film motion is faster than that of the subject, the subject is elongated. Conversely, if the film motion is slower than that of the subject, the subject is compressed. Keep in mind, however, that not all lenses are designed the same way, and that it is impossible to synchronize all speeds present in a scene when using a single depth of focus. For example, a subject near the horizon appears to be moving more slowly than a subject close to the camera. Finally, you should also remember that the thinner the slit, the more depth of synchronization and the clearer the image. But as the size of the slit is reduced, the camera system becomes more and more sensitive to changes in exposure. Consequently, the film records any small change of speed by creating an unsightly dark and light band along the axis of the slit.

When the following conditions exist, using the slit-scan method essentially turns a conventional camera into a high-grade panoramic camera. First, the lens must be rotated around its optical axis. Then during the exposure, a ray of light enters the lens and cuts the optical axis; this position is called the *nodal point*. The film is wrapped on and off the stationary drum in a synchronized pattern, called a *planetary drive*, as the lens rotates but is stationary at the moment of exposure. A thin slit inserted between the lens and the film plane forms the slit-scan lens arrangement.

All cameras have a focusing mechanism, but a panoramic camera has two: one for the image on the film and the other for synchronized focus of the moving lens and film plane. Photographs taken with nodal-point panoramic cameras are mathematical phenomena. To determine picture length, use this equation: length = pi × 2 (lens focal length in inches). For example, with a 25mm lens whose focal length is about 1 inch, picture length is pi × 2 × 25mm, or approximately 6 1/4 inches. If the actual picture length is shorter than the calculated length, the image will be compressed. Conversely, if the actual picture length is longer, the image will be elongated. Also, if the actual picture length isn't exactly equal to the calculated length, the image will be pushed out of focus—no matter how the lens is focused.

Setting Up the Tripod

Unlike short-rotation cameras that can be tilted up and down and moved in close to a subject when you photograph, 360-degree-rotation cameras produce better images when they're kept level during operation. You must make sure that the tripod's camera base is absolutely level. When buying a tripod, you should look to see if it has a built-in level, or that you'll have a means of verifying by hand that the tripod is level. It is important to check all batteries for rechargeable models and to try out the rotation mechanism to make sure that it works properly—that the camera will remain level while you shoot before you begin. To ensure that your camera is level at the start, the first step in the actual picture-taking process is to take the time to carefully set up and secure the tripod. Then mount the camera and check its position. But remember, the entire camera rotates, not just the lens.

DETERMINING EXPOSURE

Exposure calculations for 360-degree cameras differ from those for all other panoramic cameras. First, load your camera, and then set the corresponding exposure and distance ratings indicated in the camera manual. For 35mm cameras, I recommend shooting a roll of Polaroid instant-slide film with a speed close to that of the film you're using. This will enable you to check exposure, focus, camera level, and composition—and whether or not you're operating the camera properly. Polaroid instant-slide film comes with a small processor so that you can shoot a roll, process it, and analyze the results in minutes right in the field.

Another difference you must consider when determining exposure with these cameras is the much wider range of illumination over the 360-degree arc. I measure the light through the circle of the picture with an incident-light exposure meter. I then expose for the part of the image I want to emphasize. The other areas may be too dark or too light to record on film, but the most important section of the scene won't be. To avoid this potential problem, you can try to shoot scenes in which the illumination is even. (See Chapter 4 for a more complete discussion of metering techniques.) Your choice of *f*-stops on most 360-degree cameras is extensive.

Setting shutter speeds on 360-degree rotation cameras is more complicated than with short-rotation cameras. Here, the controls correspond to the speed of the rotation. The faster the motion, the faster the shutter speed. The Round Shot 65/70, for example, has ten shutter speeds that translate into ten rotation speeds. Suppose your meter reading of a scene calls for an exposure of *f*/22 for 1/125 sec. With most 360-degree-rotation cameras, setting the aperture usually means turning a ring on the lens. Next, you look up the

shutter speed on a chart that translates the camera's rotation into "equivalent shutter speeds." Here, the 360-degree revolution over a 2-second span is equal to a 1/125 sec. exposure. All you simply have to then do is set that shutter speed.

The shutter speed can also be controlled by changing the size of the slit opening on some cameras. The Hulcherama 120 has four slit openings, each with its own shutter speed: opening A has a speed of 1/25 sec.; B, 1/50 sec.; C, 1/100 sec.; and D, 1/200 sec. The Alpa Rota camera even enables you to adjust the size of the opening at the top and bottom to control bright skies and/or bright foregrounds. In addition, the arc can be limited to less than 360 degrees, which in turn determines the number of exposures available per roll. Conversely, you might be able to shoot beyond 360 degrees—that is, to allow the camera to continue rotating until the film runs out, thereby rephotographing the same scene.

ROUND SHOT 65/70 SHUTTER SPEEDS AND ROTATION TIMES

Rotation Time	Equivalent Shutter Speed
1 second	1/250 sec.
2 seconds	1/125 sec.
4 seconds	1/60 sec.
8 seconds	1/30 sec.
15 seconds	1/15 sec.
1 minute	1/4 sec.
2 minutes	1/2 sec.
4 minutes	1 sec.
8 minutes	2 sec.
16 minutes	4 sec.

ALPA ROTA 60/70 CAPABILITIES

Angle of View	Number of Exposures			Film Length
	120 Roll Film	220 Roll Film	70mm Film	
90 degrees	4	12	36	118.75mm (4.7 inches)
180 degrees	2	6	18	237.5mm (9.4 inches)
270 degrees	1	3	9	356.25mm (14 inches)
360 degrees	1	3	9	475mm (18.7 inches)

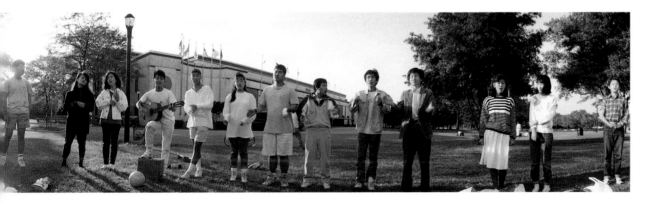

Metering a scene with a 360-degree (or more) arc is a challenge. In this shot, the subjects were in a circle and the camera, a Round Shot 35/35, was positioned in the center. Notice the shifts in brightness between the frontlighting, rimlighting, backlighting, flare, and shade. (Courtesy: Alan Abriss.)

COMPOSING WITH 360-DEGREE CAMERAS

Generally, 360-degree cameras are positioned on a level plane when you shoot, and the majority of images are horizontals. As a result, the possibility of either end-of-the-earth or bowl distortion is essentially eliminated. What you have to watch out for is the cigar effect when you shoot subjects up close. Keep in mind the guidelines for photographing interiors, corners, and circular rooms; they apply here as well. But 360-degree cameras take them one step further, thereby increasing the creativity of your images. The camera's long sweeps mean that it is possible to get several cigar effects and rounded, flaring corners in one picture. This type of repetition produces its own pattern of composition that must be considered in terms of its relation to other elements in the picture—for example, as a background that frames the main subjects.

Perhaps most important—when you compose with 360-degree cameras, you should realize that you're capturing on film perspectives that no one is used to seeing. To get a 360-degree view of any scene, people have to rotate their bodies. The ex-

perience is somewhat disorienting and hard to appreciate, even as it is being done. Similarly, when people look at a long photograph, they can be momentarily confused as they try to figure out where the image begins and ends.

So as a panoramic photographer working with a 360-degree camera, you have to carefully choose subject matter. Some subjects are less likely to cause confusion than others. For example, a mountain range in a straight line is more appropriate than the multiple flaring corners of a room. When you're composing, then, you have to be aware of this problem for two reasons: the effect on the audience and the visual effect on film. Being able to predict how subjects will appear on film will improve your compositions. Because you already know how close subjects dominate a picture and how bulges form, you can think about the symmetry of subject matter. How will the main elements along this very narrow strip of film be recorded? One of the best approaches is to consider the shape of the scene in relation to the subject-to-film distance. This can tell you a great deal about how the 360-degree rotation will or won't distort the subject.

Take a look at the schematic diagrams on the opposite page. These provide a bird's-eye view of some typical shooting situations. In the circle and elliptical setup, if the camera is positioned at the center of a scene or is as equidistant as possible to the sides (refer to lines a, b, and c), the picture will contain little horizontal-line distortion and no vertical-line distortion. This result is typical of round rooms with a doorway and windows. In fact, the picture will appear free of distortions.

Next, turn your attention to the square and rectangle setups. These will cause problems because the distances for the three lines (a, b, c) differ in length and there are sharp corners. This is what happens when you photograph a typical interior or in the middle of a street. While you can't do much about the distortion of corners, you can balance their appearance in the picture by centering the camera in relation to all sides.

When shooting interiors, some photographers look first for the "best place" based on a room's contents. This, of course, is important, but their very next question should be: How can I minimize distortion? This is particularly essential

when the walls will provide the background for subjects who are posed as shown in the diagram on the right. In this ballroom, the people are positioned in a semicircle around the camera. However, the camera has been carefully centered. As a result, the corners flare out in a balanced pattern behind the people. If the camera had been placed more to one side of the room, the pattern would have been uneven.

Because 360-degree-rotation compositions are so all-encompassing, your choice of shooting locations is limited. You have to give careful thought to the impact of objects close to the camera, such as telephone poles or overhead wires. They can easily become unsightly, dominant features in a photograph that is otherwise tightly composed. Such intrusions often force you to shorten the arc of the rotation.

The final aspect of composing with 360-degree cameras involves understanding what makes the resulting photographs so striking. Their strength comes from effectively stringing together a number of subjects within a very narrow strip. But envisioning exactly what this composition will look like when you're composing is hard. I some-

times use a small cutout on black mounting board to help me previsualize the scene. After making an 8-inch horizontal slit in the card, I hold it in front of my right eye at a distance that roughly matches the verticle angle of the lens, close my left eye, and scan the scene while holding the card level. I do this several times, concentrating and trying to get a mental picture of the final image. I get a clearer idea of which rotation arc and which vantage points are best for the scene. Previewing also saves me the trouble of setting up the camera before I am sure I want to photograph a scene.

I also like to test with Polaroid film. Several photographers I know who shoot in the 70mm and 120/220 film formats first go to a location and shoot handheld panoramas on 35mm print films with lenses approximating the available focal lengths for their medium-format rotation cameras. These photographers then rough-cut and paste the prints together to get an idea of composition and vantage point. Clearly, using 360-degree cameras requires extensive preparation before shooting and careful attention to details while operating the camera and composing.

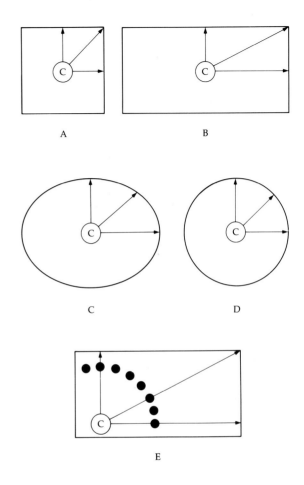

A B

C D

E

Most 360-degree-rotation cameras are actually multi-rotation cameras that are capable of shooting at any number of settings larger than 360 degrees. As this street scene shows, these cameras can go beyond 360 degrees in the sense that they can reshoot a subject many times—as long as there is film in the camera. This produces a motor-drive effect. (Courtesy: José Gaytan.)

These diagrams show typical camera setups for 360-degree cameras. When composing, panoramic photographers face one of two basic geometric configurations. A scene may contain either corners, such as a square or rectangular room or street intersections, as shown in the top and bottom diagrams. On the other hand, a scene may contain rounded planes, such as a circular or elliptical room, an arena, or a stadium, as shown in the center diagrams.

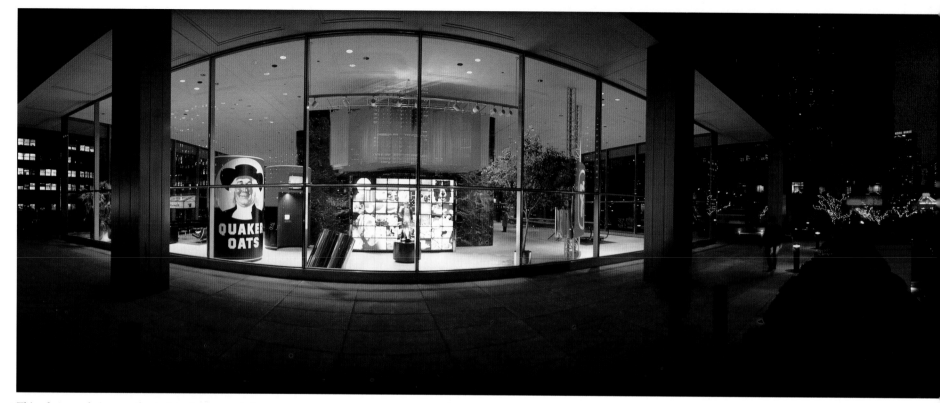

This photograph is one of a series of panoramic images created at different locations that include the Quaker Office Building. Choosing a position halfway between the lobby's glass wall and the Chicago River, Mark Segal used a 360-degree-rotation customized Hulcherama camera and Fujichrome 100, and shot at the slowest rotational speed of 2 sec. with the lens wide open. The river and trees help to accentuate the jewel-like effect of the building lights shortly after sunset. (© Mark Segal/P.S.I. Chicago 1990.)

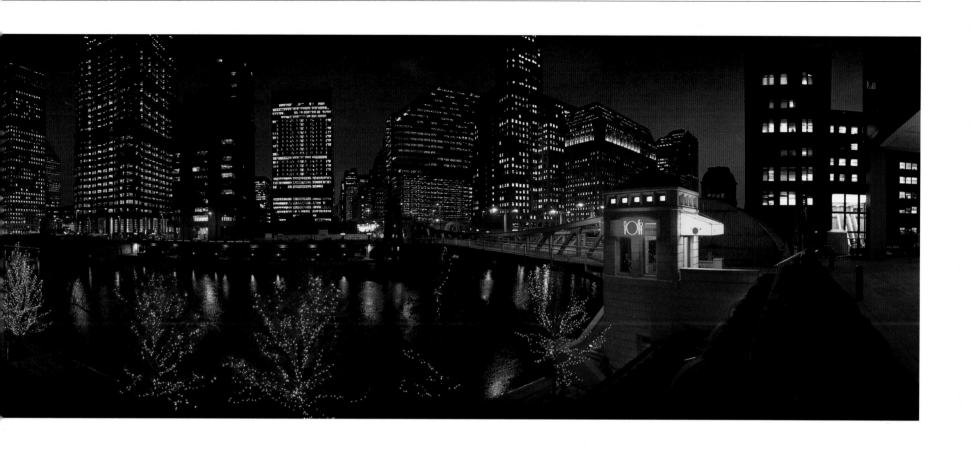

PANORAMIC PHOTOGRAPHY

Conventional-Shutter Cameras

Printed Panoramic Assemblages from Conventional Cameras
- Butt-Joint (No Seams)
- Segmented (Visible Seams)

Projected Assemblages from Conventional Cameras (35mm and 6 x 6cm Slides)
- Butt-Joint
- Overlap (Soft-Edge Masks)

Wide-Angle Photography

Wide-Angle Cameras
- Banquet
- Horizon
- Brooks Veri-Wide
- Zeiss Hologon
- Cambo Wide
- Gowland Wide
- Globus Wide

Wide-Angle Lenses
- Fisheye
- Extreme Very-Wide
- Ultra-Wide

Special Lenses
- Hill Cloud Lens

AND ITS CLOSE RELATIVES

Slit-Scan Cameras

Nonrotation (Stationary-Lens) Panoramic Cameras	Short-Rotation (Swing-Lens) Panoramic Cameras	Strip Cameras	360-Degree-Rotation Panoramic Cameras
Conversions / **Cameras**			
Fuji 617	Widelux F	Periphery	Alpa Rota 60/70
Linhof 612	Widelux 1500	Aerial-Strip	Globuscope
Linhof 617	Cyclops	Photo-Finish	Hulcherama
Art Panorama 612	Horizont		Round Shot 28/35
Art Panorama 617	Panon		Round Shot 35/35
Art Panorama 624	Electropan		Round Shot 65/70
Ipan			Round Shot 65/220
Panorama			Round Shot 65/5-inch
612/47 Super-Wide			Lipari-Rama
			Corrales 360
			(Also earlier models, such as: Kodak Cirkut, Al Vista, Panoram)

LINHOF 6 × 17cm CAMERA, 90mm LENS

FUJI 6 × 7cm CAMERA, 90mm LENS

FUJI 6 × 17cm CAMERA, 105mm LENS

ART PANORAMA 6 × 24cm CAMERA, 120mm LENS

IPAN CAMERA

WIDELUX F CAMERA

To compare the various panoramic cameras, photographer Alan Abriss, with Dale Trilling's help, shot this series of images. Clearly, major differences exist between the ways nonrotation and rotation cameras render a scene. But there are also subtle differences between shots made with cameras with similar specifications. Consider these examples. The Widelux 1500 has a 10-degree advantage in terms of its horizontal sweep over the Widelux F, and the Fuji 617 has a 105mm lens while the Linhof 617 has a 90-degree optic. The pictures also show that the vertical angle of view is often a critical compositional factor, as seen in those made with the Ipan and Art Panorama 624 cameras. Although these two cameras render nearly identical horizontal views, the Ipan's smaller vertical angle of view produces a much more tightly composed middle third. (Courtesy: Lens and Repro Equipment Corp.)

WIDELUX 1500 CAMERA

ROUND SHOT 35/35 CAMERA, 360-DEGREE ROTATION

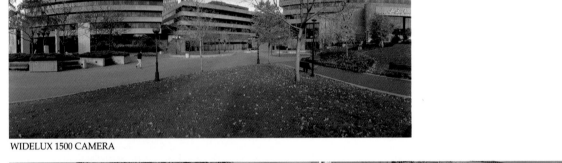
ALPA ROTA CAMERA, 270-DEGREE ROTATION

FILM, EXPOSURE, AND

All photographers are concerned with film selection, exposure methods, and filters. After all, the purpose of photography is to produce an image on film using light. Today, more films and filters than ever before are available. But the same questions persist. Which is the best film to use: print or transparency, black-and-white or color, fast or slow? Which exposure meter is most appropriate, and how do I use it? Are filters creative tools or unnecessary accessories that alter the pure photographic image? While the answers to these questions depend, to a large extent, on your convictions and goals, understanding them in the context of panoramic photography is essential to effective picture-taking.

SELECTING FILM

Whenever photographers get together and talk shop, the subject of film selection inevitably comes up. The choices seem endless. Nevertheless, all photographers have their favorites. I, too, have favorites for panoramic photography. I based my decisions on three factors: the characteristics of the film, the peculiarities of panoramic photography, and the way I shoot my photographs. While my choices might not work well for you, understanding the variables involved in the selection process might help you decide which film or films to use. Photographers have different goals and standards, but all have to work under certain technical conditions. Recognizing these parameters will enable you to select the film best suited to your purpose.

The complicated process of film selection becomes manageable when you think of it in terms of a number of variables. The first decisions you have to make are whether you want to shoot prints or slides, and whether you want the prints or slides to be color or black and white. Films come in two basic forms: a negative emulsion for making prints and a transparency emulsion (reversal film) for making slides. Both forms are available in black and white, although monochrome slides are somewhat unusual. Most images used in publishing are color transparencies, while the consumer marketplace is dominated by color-print films. Fine-art photographers tend to favor black-and-white film. Other characteristics you have to consider are film speed—indicating how grainy your final photographs will be—and image quality.

COLOR-TRANSPARENCY FILM

This type of film, also called color-slide film, offers the highest quality in terms of sharpness and color fidelity. Unfortunately, photographs taken with color-transparency films are "one-of-a-kind" images. Slides can be duplicated and in the process, sometimes improved or manipulated. But in general, the original, first-generation image is the best. Most photographers agree that only a second exposure taken at the same time as the original can equal its quality. The extreme measures photographers take to protect their original slides are strong evidence of just how seriously they believe this.

Because slide film can't be significantly changed during development, you must alter the image when you shoot. This includes making sure that the exposure is accurate and effective—perhaps by slightly underexposing or, less frequently, overexposing the film. Altering the image can also mean using filters to balance or change color or to produce special effects. Keep in mind, though, that these films are the least tolerant of incorrect exposure.

Color-transparency film is balanced for either daylight or tungsten light and provides you with

FILTERS

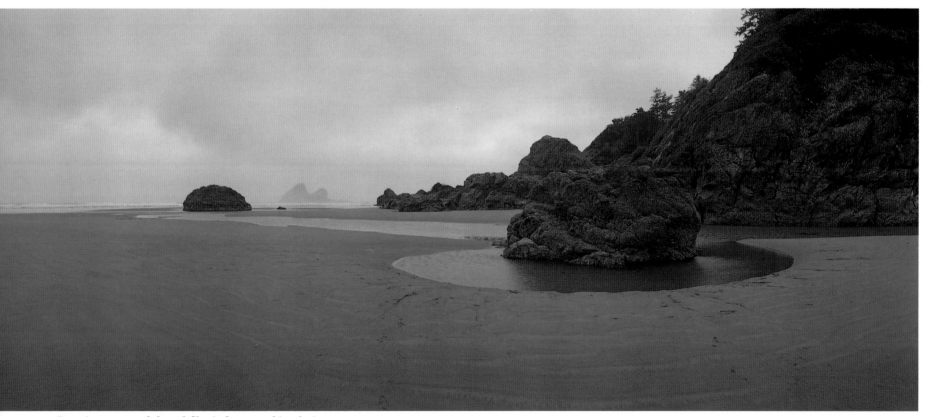

By using tungsten-balanced film in hazy sunshine during the late afternoon, I was able to create the perfect mood for this photograph of a seascape. Shot under this lighting condition, the tungsten film produced a blue cast in the final image. The exposure was f/11 for 1/60 sec.

another way to change the image during exposure. *Daylight-balanced film* is balanced to record the color qualities of daylight accurately, while *tungsten-balanced film* is balanced for standard tungsten-lighting sources. Manufacturers have standardized these films according to the Kelvin scale for color temperature. For example, most daylight-balanced films are rated at 5600K, while tungsten-balanced film comes in two variations, 3200K and 3400K. On the Kelvin scale, the higher the color temperature, the more likely cooler colors will dominate. Also, the lower the color temperature, the more likely warmer colors will be emphasized. The chart below gives examples of effective light-source, film, and conversion-filter combinations; these are ranked according to the film's color temperature.

Your opportunity to affect exposure comes when you shoot tungsten film outdoors and daylight film under tungsten lighting, both without filtration. The results can sometimes be quite dramatic. Tungsten film shows a heavy blue cast, and daylight film has a very warm coloration. I prefer the blue cast of tungsten 3200K films for photographing overcast seascapes and for snow scenes when sunlight is diffused by heavy mist or overcast skies. There are fewer situations when you can shoot daylight film under tungsten lighting. But outside lights on buildings and interiors illuminated by ordinary light bulbs work well.

COLOR-PRINT FILM

Today's color-print films provide excellent image quality; however, the success of your pictures depends greatly on how the films are printed. Unless you do your own enlarging, you must rely on the judgement of a lab printer. Generally, color printing falls into two categories: machine prints and custom prints. The quality of photographs that are machine-printed can vary significantly, while custom prints are generally better. But whatever printing method you choose for your panoramic images, you will undoubtedly encounter some problems because of the pictures' unusual size and shape. (See Chapter 6 for more information on printing and enlarging.) Color-print films have some major advantages over color-transparency film. For example, color-print films are more tolerant of under- and overexposure. Colors can be changed or corrected during the printing process. Also, unlimited copies can, of course, be made from one negative. For these reasons alone, many panoramic photographers favor color-print films.

EFFECTIVE LIGHT-SOURCE, FILM, AND CONVERSION-FILTER COMBINATIONS

Light Source	Temperature (Kelvin)	Film	Conversion Filter	Exposure Adjustment
Household Light Bulbs	2800 degrees	3200 (B)	82C	+ 2/3
100- to 500-Watt Bulbs	2900 degrees	3400 (A)	82C, 82A	+1
Studio Bulbs Quartz-Rated for 3200K	3200 degrees	3200 (B)	—	—
		3400 (A)	82A	+ 1/2
Studio Photo Floods Quartz-Rated for 3400K	3400 degrees	3200 (B)	81A	+ 1/3
		3400 (A)	—	—
Midday Sun, Clear Day, Electronic Flash	5000 degrees or more	Daylight	Skylight IA, UV	—

BLACK-AND-WHITE-PRINT FILM

As a group, black-and-white print films tolerate exposure variations better than color-print film. In addition, you can greatly manipulate black-and-white prints by changing contrast and brightness. You have two other methods of altering a black-and-white photograph: *burning*, which is the process of adding light to certain areas of the image, and *dodging*, which is the holding back of light from parts of the picture. Color prints can also be burned and dodged, but not as extensively or dramatically. The amount of control you have over a final black-and-white print is enormous. The initial exposure of the negative, then, can be considered only the beginning of a lengthy, creative process of manipulation and improvement.

FILM SPEED AND IMAGE QUALITY

When selecting film, you have to consider film speeds and image quality, too. In general, as the film speed increases, the more that grain pattern, color, and tonal rendering change. This results in lesser, but not necessarily poor, picture quality. For example, an ISO 100 color-print film has a smaller, tighter grain pattern that holds up better during enlargement than an ISO 1600 film does; the faster film's grain pattern produces a coarser enlargement. But because films have improved so much during the last few years, many photographers find that they can use high-speed films with no loss in overall quality. So once again your decision depends on personal standards. Do you

These pictures show the entrance hall in the Vanderbilt mansion in Hyde Park, New York. While shooting, I noticed that it was illuminated by both tungsten lamps and sunlight. So

I decided to use two types of film. For the top shot, I loaded a Widelux 1500 with tungsten-balanced film. The bottom shot was made with daylight-balanced film.

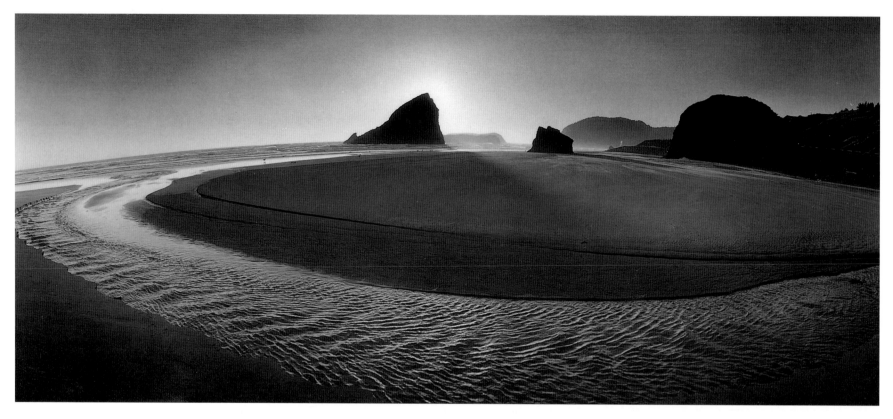

For this photograph of the Northern California coast at sunset, I shot T-Max 400 film pushed one stop. With a Widelux 1500, I exposed at f/11 for 1/60 sec.

want the ultimate quality of a fine-grain, slow film, or the flexibility of a grainier, faster film that allows you to shoot pictures and record scenes you might otherwise miss?

Choosing film for panoramic photography involves special considerations. Subjects are often detailed, such as a skyline or a landscape. So you might think that a slow, fine-grained film that can accurately record small areas is appropriate. But panoramic film formats are larger than conventional formats, and the larger the negative (or transparency), the better the quality of the im-

age. To understand just how much larger panoramic films are, take another look at the formats on pages 82–83. The smallest panoramic medium format, 6 × 12cm, is twice the size of the smallest conventional medium format available, 6 × 4.5cm. Notice that the 6 × 12cm, 6 × 17cm, and 6 × 24cm panoramic formats are equal in length to 4 × 5-inch, 5 × 7-inch, and 8 × 10-inch sheet film, respectively. Even in the 35mm formats, panoramic images are two to three times larger than conventional pictures. And film required by 360-degree cameras provide total im-

age areas greater than a sheet of 8 × 10-inch film. Obviously, the large size of panoramic film formats gives you an edge.

Another aspect of film speed is *push processing*. When you push film, you set the film-speed dial to an ISO rating higher than the actual one of the film. For example, you can push an ISO 400 film to ISO 800. Then when you have the film developed, you must tell the lab to adjust the processing because you have exposed the film at an ISO rating higher than the one indicated. Each time you double the film speed—from ISO 400 to ISO 800, and then to ISO 1600—one stop less light reaches the film. As a result, the film must receive additional development time to make up for the decrease in exposure. Conversely, a film can be *pull processed*. Here, you overexpose the film by one stop when you shoot. If you have a roll of ISO 400 film, you can pull it to ISO 200 by changing the film-speed rating from 400 to 200. Then when the film is processed, it will require less development time than normal. Not all films respond the same way to pushing and pulling, so be sure to check the specifications of the film.

Resolving these somewhat conflicting requirements for each type of film may seem overwhelming. I have simplified the process by selecting two film speeds, ISO 100 and ISO 400, for all of my color and black-and-white photography in 35mm and medium formats. This reduces the confusion that arises when you try to calculate exposure and determine depth of field for many different film speeds. I usually shoot Fujichrome 100, Ektachrome 400 (and sometimes Ekta-

chrome 160 tungsten-balanced film in daylight), and T-Max 100 and 400. This system works perfectly for me because I often shoot a scene with a 35mm camera and one or two medium-format panoramic cameras, including the Widelux 120 cameras and several 617 and 612 cameras. Of course, I've come to know these films quite well and can predict what they'll do under various lighting conditions. Together they can handle just about any situation, from handheld shots to low-light compositions requiring a tripod. When I shoot in the 70mm format, I use Ektachrome 400 exclusively. I choose the same color film for working with 360-degree cameras as I do for 35mm cameras; I never work with black-and-white films in 360-degree cameras. I don't use color-print films because I prefer to have my transparencies printed on Cibachrome materials.

I reserve the ISO 400 films for handheld shooting and for extremely low lighting that calls for a tripod. In fact, I shoot about ten rolls of ISO 100 film for every roll of ISO 400 film. When neces-

sary, I push process an ISO 400 film one stop (to ISO 800) to gain extra speed; this is my custom with Ektachrome 400 film. I also push process T-Max 400 film in my own darkroom to ISO 800 or sometimes to ISO 1600. Overall, I base my film choices on practical considerations rather than on maximum image quality or the "best" film for each condition or situation.

Why don't I shoot ISO 50 or ISO 64 film, or the venerable Kodachrome 25 for even sharper images? First, slower film speeds mean slower shutter speeds that often cause moving objects, such as birds in a seascape, to blur. The larger panoramic formats more than offset any loss in image quality caused by an ISO 100 film. The color-transparency films I use are processed in E6 chemistry, available in almost every large city, whereas fast processing for Kodachrome films isn't readily available. So because I do most of my shooting on the road and need to see the results before I move on to my next location, accessibility to speedy processing is essential.

TYPICAL PUSH/PULL CONVERSIONS

Film	Normal ISO	New ISO Rating Pushed 1 Stop	Pushed 2 Stops	Pulled 1 Stop
T-Max 100	100	200	400	50
T-Max 400	400	800	1600	200
Fujichrome	100	200	400*	50**
Ektachrome	400	800	1600*	200

* When pushed two stops, this film will appear grainy and may have a yellow cast.
** When pulled one stop, this film may have a blue cast.

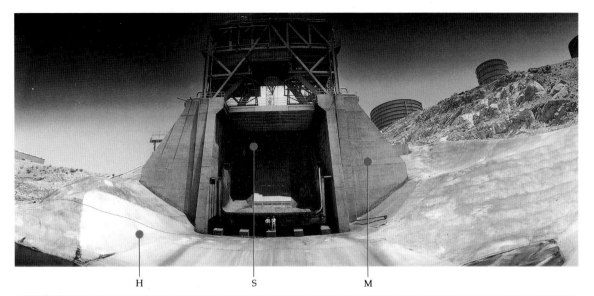

H S M

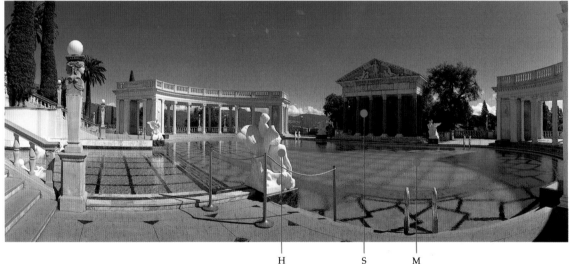

H S M

The top photograph contains highlight (labeled "H"), midtone (labeled "M"), and shadow (labeled "S") areas in a black-and-white image. In the shot directly above, the high-

light ("H"), midtone ("M"), and shadow ("S") areas in a color photograph are also clearly indicated. Exposing for extremes in brightness levels is tricky but not impossible.

A final point about panoramic cameras. Whatever type of film you select, if you intend to handhold the camera, you must use fast shutter speeds. And, because many lenses have minimum apertures of *f*/8 and *f*/5.6, you'll have to shoot at around *f*/11 or *f*/16. This works out well because the aperture settings in the middle of a lens' *f*-stop range provide the sharpest images. When working with larger films, you must also remember that the amount of apparent depth of field is less than that of 35mm film. As a result, medium-format nonrotation cameras using large-format lenses have *f*-stops as small as *f*/32 and *f*/45 to compensate for this noticeable loss in depth of field.

DETERMINING EXPOSURE

Film, whether it is transparency or print film or fast or slow film, must be exposed properly. This requires adhering to certain unalterable principles as well as experience and a willingness to do some testing. First and foremost, exposing film is about measuring light. It also involves deciding which parts of a scene to exclude because the film you're using can't capture the range of brightness present. You can think about light several ways, but most photographers simply divide a scene into three parts: the highlight areas, the midtone areas, and the shadow areas. The highlight areas are the brightest parts of a picture. They contain either the lightest grays in a black-and-white image or the lightest colors in

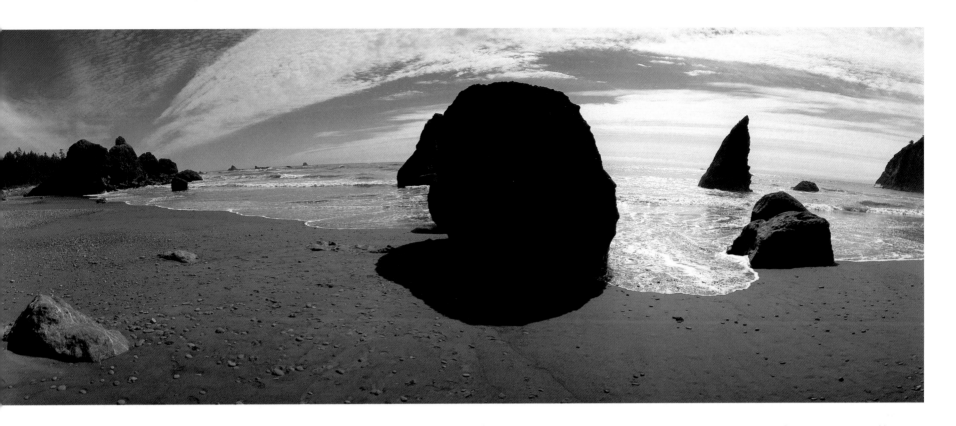

a color shot. The shadow portions contain the darkest subject matter and are composed of the darkest grays and colors. In between these two parts of a picture are the middle grays and colors. Middle gray is a shade exactly halfway between white and black. This area reflects 18 percent of the light falling on it and represents a standard photographic reference point for all meters.

Each scene has a certain brightness range that can be measured from the highlights to the shadows. Your goal is to determine an exposure that can record the various light values on film. A film's ability to capture this range will determine how well it can tolerate incorrect exposure. (In other words, each film has a latitude beyond which it can't properly record an image.) If the scene you wish to shoot exceeds the film's capabilities, you'll have to decide what to "save": highlight or shadow areas. Generally, color-transparency films are the least tolerant of incorrect exposure, followed by color-print films and then black-and-white emulsions.

This coastline shot shows what happens when the brightness in a scene exceeds a film's latitude. Here, I wanted to preserve the highlights in the water, foam, and sky. So with a Widelux 1500, I exposed at f/22 for 1/60 sec. Later, I had the film pull-processed one stop. The final image contains detail in both the highlight and midtone areas; capturing detail in the large rocks in the shadows was beyond the film's capabilities.

METERING LIGHT LEVELS

Camera lenses are designed to focus *reflected-light* images on film. This means that the light from a source strikes a subject that in turn reflects the light toward the lens and onto the film. The nature of the subject is disclosed by what happens to the light as it's reflected. Some wavelengths of light are absorbed, and others are reflected. For example, a red shirt reflects red wavelengths and absorbs blue ones, while a blue shirt reflects blue wavelengths and absorbs red ones. In black-and-white photography, the film translates colors into different shades of gray.

In addition, the amount of reflected light and the way it casts shadows on and around subjects as it bounces off them provide information about surface textures and forms. The smooth surface of a car's hood, for example, reflects more light than the rough surface of the car's seats. And the glossy, mirror-like chrome bumper shines so brightly because almost all of the light is reflected. Shadows cast by the fenders as well as by the car itself reveal the subject's form.

To determine exposure, you can measure the light at two points: before it strikes the subject—this is called *incident light*—or after it bounces off the subject—this is called *reflected light*. So, logically enough, exposure meters falls into two groups: incident meters and reflected meters. Incident meters are identified by a small, white, translucent dome that the light falls on as you stand in front of the subject and point the meter toward the camera when you take a reading. On the other hand, you point reflected meters at the

subject. These are available in two forms. Some are handheld models, and others are built into a camera. Panoramic cameras, however, don't have built-in meters. The angle of view of handheld reflected-light meters is approximately equal to that of a standard lens. The angle of view of built-in reflected meters is controlled by the lens on the camera.

Before you can decide which type you would prefer to use, you need to know a little more about exposure meters. First, all exposure meters—no matter what their design—are calibrated to provide an exposure reading that will render the subject middle gray. In terms of reflectance, this tone is exactly halfway between black and white. Because no color reflects less light than black or more light than white, this includes the reflectance of all colors. The exact shade of middle gray, which represents 18 percent of the light falling on a subject, is available on a *gray card*. You can find gray cards in any photo shop. The science of exposure is based on the assumption that an average subject reflects back 18 percent of the light falling on it. So every reflected meter assumes that it's looking at an average subject when you point it at a scene, and it provides readings accordingly. For example, metering a white wall gives a set of readings that will result in a medium-gray wall in a black-and-white print. The different readings indicated when you meter a black wall will also render a medium-gray wall in a black-and-white shot. Incident meters, on the other hand, always translate the light falling on them into settings that

Measuring the amount of light falling on a subject requires an incident meter, shown in the top shot. This type of exposure meter gathers light through a translucent dome and determines how much light is present in a scene before it strikes a subject. Unlike an incident meter, a reflected-light meter, shown directly above, measures the amount of light bouncing off a subject. This type of meter can be located in the camera or can be separate, handholdable units.

assume an 18 percent reflectance from the subject. As such, they'll give the same reading as a reflected reading off a gray card.

Panoramic photographers spend a great deal of time shooting pictures of "average" scenes in which 18 percent of the light is reflected. Typically, they photograph evenly illuminated vistas. So they should be able to use an easy but accurate method of determining the amount of exposure required by an average subject. As a matter of fact, you can put aside your exposure meter under these conditions and take advantage of a simple rule that has guided photographers for years: the *sunny f/16 rule*. Between the late-morning and early-afternoon hours on a sunny or a bright, hazy day, you can correctly expose an average subject by shooting at *f*/16 and using the shutter speed roughly equal to the speed of the film. For example, following the sunny *f*/16 rule when

shooting Fujichrome 100 or T-Max 100 film, you would expose at *f*/11-*f*/16 for 1/125 sec. If you were using Ektachrome 400 or T-Max 400 film, you would shoot at *f*/11-*f*/16 for 1/500 sec. (Setting the aperture between *f*/11 and *f*/16 offsets the slightly faster shutter speeds that are closest to the film speeds of ISO 100 and 400, respectively.)

The sunny *f*/16 rule also enables you to compensate for changing light conditions. By opening up one stop when you're shooting on a cloudy day and weak shadows are present, you can effectively capture the scene. When you're photographing on an overcast day and no shadows exist, you can open up two stops for a correct exposure. Opening up three stops for a subject in deep shade on a sunny day will produce a remarkably accurate image.

So, which type of exposure meter is more suitable for panoramic photographs? I believe that

the incident meter is the better choice because panoramic subject matter is often average in terms of light reflectance. Furthermore, an incident meter is easy to use. All you have to do is to point it in the direction of the camera as you stand in the light that's falling on the subject. In practice, this usually means remaining by your camera and simply turning around to take the light reading. I'm in the habit of estimating the exposure based on the sunny *f*/16 rule and "confirming" this with the meter reading.

Because no panoramic camera has a built-in exposure meter, your only other option is to use a handheld reflected-light meter. You can either directly measure the light falling on the scene or point the meter at an 18-percent gray card. Using the gray card ensures an average reading—the same one you would get, of course, if you used an incident meter. However, I've found that directly pointing the meter at the scene sometimes yields incorrect exposures because of highly reflective subjects and specular highlight areas, such as bodies of water or glass buildings. Although using a gray card solves this problem, it also means carrying yet another accessory with you on location. For me, determining exposure via an incident-light meter is a way of life, especially when I'm shooting transparency films.

On occasion, however, I do use a *spot meter*. This is a reflected-light meter whose angle of view might be as narrow as 1 degree. As a result, you can measure very specific areas of a scene. I use this unique meter when a subject contains extreme contrasts of highlights and shadows.

DETERMINING EXPOSURE

Lighting Condition	Exposure Settings	Change in Exposure (in *F*-stops)*
Bright Sun	*f*/16, 1/125 sec.	—
Bright Sand or Snow	*f*/22, 1/125 sec.	+1
Bright, Hazy Sun	*f*/11, 1/125 sec.	−1
Cloudy	*f*/8, 1/125 sec.	−2
Overcast or Deep Shade on Bright, Sunny Day	*f*/5.6, 1/125 sec.	−3

* These changes in exposure are based on the "sunny *f*/16 rule." With the camera set at *f*/16 in bright sun, the shutter speed should approximate the ISO rating of the film used. For example, a shutter speed of 1/125 sec. is appropriate for an ISO 100 color-transparency film shot in bright sunlight.

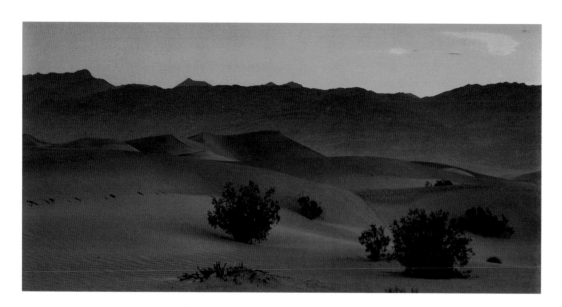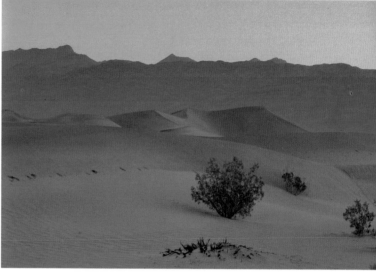

Over the years, certain lighting conditions have compelled me to practice using a spot meter. For example, on days when the weather is unsettled and brightness levels are continually shifting, some of the most spectacular lighting conditions exist. This is when I pull out a spot meter and measure the range of brightness in the scene; I take readings from the highlight and shadow areas I want to capture in detail on film.

But whichever exposure meter I decide to work with, I adhere to a simple guideline. When I shoot color-transparency film, I want to record detail in the highlights 1½ stops over the exposure setting that renders the middle-gray areas correct, as well as in the shadows 1 stop under this setting. Of course, beyond these ranges are highlight areas that are effectively washed out and shadows that go black on film. I also make

sure that the parts of the scene I want to record in the middle-tonal range match the exposure setting. I first compose and then look at those elements that are essential to the picture's unity, such as the buildings in a skyline or a range of mountains in a landscape. Next, I check to see that the light levels of these subjects are equivalent to an 18-percent gray. To do this, I meter the incident light. At this point in the process, I read the middle areas with a spot meter to see if they match or come very close to the incident reading. (This step isn't necessary under average lighting conditions; experience has taught me that an incident reading usually places middle-tone subjects correctly on the highlight/shadow continuum.) Then I look around for the most important highlights and check to see if they fall within the 1½-stop range of brightness. I remind myself that

these highlights should contain important detail and not be such reflective elements as the shine of the sea. The last step is to check the shadows. These can be saved only if they stay within the 1-stop range of underexposure.

I follow the same procedure when I shoot black-and-white film, making only a few changes. First, I extend the range to three stops for highlight detail and to two stops for shadow detail. If the shadows go beyond the two-stop limit, I alter the incident reading until the shadow detail falls within the desired range. This guarantees that shadow detail will be recorded in the negative, which is the most important objective when shooting in black and white. I then compensate for this exposure adjustment when I develop the film development. I also use enlarging papers of different contrast grades to en-

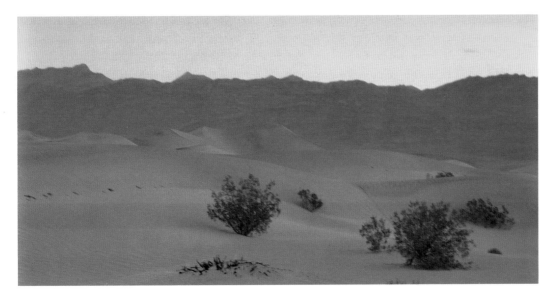

To "help" this sunrise, shot in Death Valley with a Linhof 612 PC camera and a 135mm lens, I used a tobacco-colored graduated filter to enhance the sky and a graduated neutral-density filter to decrease the brightness level of the sand. Although the center photograph was "correctly" exposed at f/11 for 1/15 sec., it may not be the image you prefer. I bracketed the other two pictures in half-stops.

sure an accurate rendering of both the highlights and the middle areas.

BRACKETING

When I work with slide film, I *bracket* exposures. I shoot one frame at the indicated exposure, and then shoot one frame ½ stop underexposed and ½ stop overexposed. In the panoramic world of mechanical shutters, I find that bracketing exposures is good insurance. Besides, the correct exposure isn't always the most effective or appealing shot. And if I'm shooting a truly exceptional scene or one in which the lighting is changing quickly, I shoot more than one roll of film. Later on, after the first roll has been developed, I decide if the remaining rolls should be push or pull processed. Shooting several rolls of film of one scene on one occasion guarantees not only a correctly exposed image, but also a set of "original dupes."

USING FILTERS

Although some photographers object to using filters, claiming that they detract from the natural quality or purity of a scene, I like to use filters for the same reason that I enjoy photographing the same subject under various lighting and weather conditions: to bring out its different aspects. Also, photographic filters are another tool with which you can enhance the final image. They're divided into three broad categories. There are filters designed specifically for black-and-white films, color films, and for both black-and-white and color films. Another group of filters has recently become quite popular; these produce such special effects as streaks, starbursts, and fog. Panoramic photographers use many standard filters and occasionally some special-effect filters. However, using filters on panoramic cameras can cause some problems as well as adversely affect the final images. It is important to choose—and use—filters carefully.

Filters are manufactured in three forms. The most common are gels that come in 3 × 4-inch squares and are approximately 0.1mm thick. When compared to the two other types, gels scratch easily. The other filters are composed of rigid plastic and optical glass. Plastic filters have become popular in the last few years partly because they allow photographers to place them on lenses of different sizes via a bracket. The brackets come with rings that fit each lens so you can switch the filters whenever you want or need to.

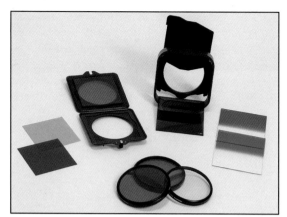

Panoramic photographs can benefit from the selective use of a number of filters. There are: gel filters with holders, such as neutral-density and color-correction filters, shown on the left; glass filters in screw mounts, such as neutral-density and color filters, shown in the center; and plastic filters with holders, such as graduated-color filters, shown on the right.

The brackets also have lens hoods that snap on in sections as well as a lens cap that slips on. Glass filters, on the other hand, are set in threaded rings that you screw into the front of the lens. Thus, different-size lenses require separate glass filters. Most photographers feel that a high-quality glass filter gives the best results, but I have used all three types of filters and, quite honestly, have never noticed any distinctions.

FILTERS FOR BLACK-AND-WHITE FILM

Filters colored red, orange, green, and yellow are effective for working with black-and-white films: they alter contrast by emphasizing or de-emphasizing various tones in the final print. Each filter lightens any part of the scene that is the same color as it is, as well as darkens any subject matter that is complementary in color and any areas of clear sky. Color filters also penetrate atmospheric haze to various degrees, thereby eliminating some of the fog-like effect so often seen in distance shots. Using these filters requires you to increase the indicated exposure because they absorb some of the light passing through them. This increase in exposure is expressed as a *filter factor*, which is designated by such numbers as 1X, 2X, 3X, and 4X and is usually stamped on the filter's mounting ring. A 1X notation, for example, means that no increase in exposure is necessary, while 2X means that one stop more light is warranted. (See the chart below for more information on filter factors.)

CONVERTING FILTER FACTORS TO *F*-STOPS

Filter Factor	Increase Exposure by (*f*-stops)
1	0
1.25	1/3
1.5	2/3
2.0	1
3*	1 2/3
4	2
5	2 1/3
6	2 2/3
8	3

* To convert filter factors between 3 and 4, 4 and 5, etc., use the above figures for 1 through 2.0 as a standard.

COLOR-FILTER EFFECTS ON BLACK-AND-WHITE FILM

Filter Color	Blue Subjects	Red Subjects	Green Subjects	Additional Effects
Blue	(–)*	(+)**	(+)	Emphasizes fog and mist
Green	(+)	(+)	(–)	Helps separate red, orange, and yellow tones in and around clouds at sunset
Orange	(+)	(–)	(+)	Enhances fall foliage
Red	(+)	(–)	(+)	Turns very dark blue skies black when combined with polarizing filter
Yellow	(+)	(–)	(–)	Slightly darkens blue skies, lightens Caucasian skin tones

* The minus sign (–) indicates that the filter lightens this particular color.
** The plus sign (+) indicates that the filter darkens this particular color.

Many panoramic photographers who work in black and white use colored filters extensively, in part because the wide vistas they photograph often appear to homogenous. Suppose you're shooting a long line of trees in a park that is set against a background of buildings. Without filtration, both the trees and the buildings will record as the same shade of gray in the final print. Using a green filter would lighten the trees, while a red filter would darken them. Whichever filter you were to choose, the contrast between the two parts of the scene would help to distinguish them from one another. In addition, the clear sky above the buildings would be rendered a darker gray.

FILTERS FOR COLOR FILM

When you shoot color film, particularly slide film, you may often want to alter or correct colors. As mentioned earlier, you can create some dramatic effects by mismatching films and light sources. One such example is using tungsten film outdoors. You can shoot a tungsten film balanced for 3200K outside if you place a *color-conversion* filter over the lens. Kodak's Ekta-chrome 160 tungsten film "converts" to daylight

For this dramatic photograph of Hoover Dam, I mounted a Widelux 1500 on a tripod and placed a 25A red filter on the lens. I then exposed for 1/60 sec. at f/11 using color-transparency film.

film through the addition of an 85B filter. But this conversion, however, results in a loss of film speed: the original film-speed rating of ISO 160 drops to ISO 100. Daylight-balanced films can also be converted. Shooting Ektachrome 400 daylight film, for example, under tungsten 3200K lighting calls for an 80A filter. Again, the film speed decreases, from ISO 400 to ISO 100. (See the chart on page 86 for more information.)

But the mismatching of film types and light sources can be problematic, too. For example, imagine that you want to photograph an interior. Because fluorescent lights vary so much from brand to brand, you can never be quite sure of their color temperature. Without using a filter, your resulting images will usually have a strong bluish-green cast. Several filter manufacturers make fluorescent filters for both tungsten and daylight films, which helps you balance the light reaching them. If you're using a color-print film, you have an additional edge because the processing lab can remove some of the blue-green cast during development. If, however, you're using a slide film, you're at the mercy of how well the particular fluorescent filter you have matches the light source.

Keep in mind that when it is absolutely essential for you to achieve perfect color balance, you must measure the quality of the light with a color meter and use *color-compensating* (CC) filters. These filters can either add or subtract any color in various strengths. For example, a CC10M is a color-compensating filter that provides half as much magenta as a CC20M filter does. You can

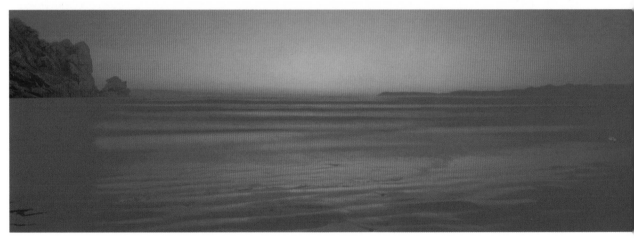

While photographing this scene with a 6 × 17cm camera, I decided to use a center-spot neutral-density filter for the top picture, and to leave it off for the shot directly above.

The photograph of a college art class on the opposite page, taken with a Widelux F camera, shows the effects of fluorescent lighting on daylight-balanced film. A strong green cast in the left- and right-hand sections of the image is readily apparent. The center of the picture is color-balanced because the primary light source is the sun coming through several skylights.

CHANGING EXPOSURES WITH NEUTRAL-DENSITY FILTERS

Camera Setting	Neutral-Density Filter Needed*			Camera Setting	Neutral-Density Filter Needed*		
Shutter Speed	2×	4×	8×	F-Stop	2×	4×	8×
1/1000 sec.	1/500 sec.	1/250 sec.	1/125 sec.	f/5.6	f/4	f/2.8	f/2
1/500 sec.	1/250 sec.	1/125 sec.	1/60 sec.	f/8	f/5.6	f/4	f/2.8
1/250 sec.	1/125 sec.	1/60 sec.	1/30 sec.	f/11	f/8	f/5.6	f/4
1/125 sec.	1/60 sec.	1/30 sec.	1/15 sec.	f/16	f/11	f/8	f/5.6
1/60 sec.	1/30 sec.	1/15 sec.	1/8 sec.	f/22	f/16	f/11	f/8
1/30 sec.	1/15 sec.	1/8 sec.	1/4 sec.	f/32	f/22	f/16	f/11
1/15 sec.	1/8 sec.	1/4 sec.	1/2 sec.	f/45	f/32	f/22	f/16

* If the shutter-speed or f-stop setting on the camera isn't adequate and must be changed for a proper exposure, adding a particular neutral-density filter (ND) will solve the problem. For example, if the camera's shutter speed of 1/1000 sec. isn't suitable, it can be changed to 1/500 sec. by adding a 2× ND filter, to 1/250 sec. by adding a 4× ND filter, or to 1/125 sec. by adding an 8× ND filter. Altering f-stops via ND filters is also possible. For example, an f-stop of 5.6 can be changed to f/4 with a 2× ND filter, to f/2.8 with a 4× ND filter, or to f/2 with an 8× ND filter.

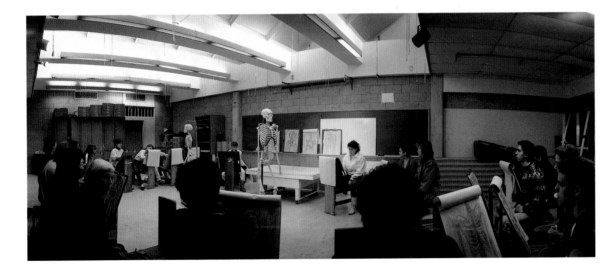

use CC filters in other ways, too; these include adding color to a scene to produce a particular effect rather than to correct the color balance. For example, a CC30M can enhance a sunset by giving a magenta cast to the darker sections of an orange-red sky that commonly appear a few minutes after the sun goes down. This filter can also be helpful when you want to shoot the exterior of an office building at sunset: the filter will balance the building's interior fluorescent lighting. Obviously, then, color-conversion and color-compensating filters provide you with many different ways to manipulate and successfully reproduce the colors in a scene.

FILTERS FOR BLACK-AND-WHITE AND COLOR FILM

Skylight and *ultraviolet* (UV) filters can be used with any type of film. They allow you to reduce the UV haze effect in distance shots without exposure compensation. Skylight filters have a slight pink cast and, therefore, make color images appear warmer, especially those taken in deep shade, with flash, or on gray winter days. UV filters, on the other hand, are clear. These filters have a similar haze-cutting effect on black-and-white film. Many photographers leave one of these two types of filters on their lenses in order to protect them.

Neutral-density (ND) filters decrease light transmission without affecting the color of the light and are available in solid or graduated versions. These filters are a boon to panoramic photographers who work with short-rotation cameras.

Being able to reduce the amount of light reaching the film without having to change the shutter speed and aperture is quite helpful because these cameras have only two or three shutter-speed settings. So ND filters can effectively provide a greater range of exposure choices. Graduated ND filters in which the neutral-density material covers only half of the filter are tailor-made for panoramic photographers because they can be used to offset the excessive brightness of a shimmering body of water or the sky. Center-spot ND filters limit the light-blocking effect to the center of the lens; this evens out the light-transmission falloff common to ultrawide-angle lenses.

As instrumental as these filters are, the single, most useful and important filter in all areas of photography is the *polarizing filter,* also called a *polarizer.* Polarizing filters darken clear skies in black-and-white photographs and make cloudless skies appear bluer in color images. These filters also make colors and tones more saturated by reducing reflections off a subject, such as leaves on a tree. Polarizers can also take the place of ND filters in a pinch because they don't actually alter colors or tones, but they do reduce the amount of light reaching the film. Keep in mind, though, that using polarizers with rotation cameras present a problem. The darkening effect on clear skies diminishes as you turn toward the sun. Consequently, a photograph taken with a rotation camera may seem uneven.

I placed both a red filter and a polarizing filter on a 6 × 7cm camera to create the black sky in this photograph.

GRADUATED FILTERS

Enjoying a recent surge in popularity, these filters are used primarily for color photography and permit photographers to add color selectively across the top or bottom parts of an image. The design of graduated filters is simple. Color is applied in a progressively less saturated spray from the top down to the center of the filter. You choose the intensity you want by moving the filter up and down in front of the lens until you're satisfied with its placement. You can also use two graduated filters—one with the color portion po-

sitioned over the top of the lens, the other one with the color area over the bottom—for a compound effect. In this situation, however, you might have to adjust the exposure (it remains the same when you use only one filter). Recently, a variation of the graduated filter has been introduced. The color is spread over the entire filter, but is dense at the top. Graduated filters come in more than thirty different hues, including pink, green, orange, gray, tobacco, and mauve.

Although graduated filters seem perfect for panoramic photography because their design closely matches its vista-continuum compositional pattern, they are intended for use with SLR cameras. As a result, they're difficult to use with panoramic cameras; you can't see the effect as you move the filter up or down. With nonrotation cameras, you can try the groundglass viewing method (see page 49). But I have found a much more convenient way to see the result before you expose any film. I preview the filter's effect through a 35mm SLR camera fitted with a lens that has an angle of view similar to that of my panoramic camera. After I determine the filter's proper position on the SLR camera, I imagine that the lens is a clock and note where the coloration line is—for example, at two o'clock, three o'clock, and so on. Next, I place the filter in the same position on the lens on my panoramic camera. This method works well whether the colored part of the filter is on the top or on the bottom, or with two filters, in both places.

SPECIAL-EFFECT FILTERS

I have found some limited uses for special-effect filters, such as adding a starburst to a photograph of a stage production or shrouding a seascape in fog. But I haven't experimented to any extent with the other, more bizarre filters that fall into this group, nor have I seen much work featuring them from other photographers. Perhaps the creative and adventurous among you will explore the use of these filters and devise innovative but not overdone ways to utilize them.

Filters can be used with both Widelux cameras. The filter kit for the Widelux F contains the following filters: ultraviolet, light-orange, medium-yellow, orange, 4X neutral-density, and color-conversion. The Widelux 1500 model, on the other hand, takes a 34mm screw-mount filter.

MOUNTING FILTERS ON PANORAMIC CAMERAS

When mounting filters on panoramic-camera lenses, you should keep in mind the following general conditions. The lenses on nonrotation cameras have large thread sizes, such as 72mm, 77mm, and 82mm. Because corresponding glass filters are often quite thick, vignetting may occur. Stacking glass filters to achieve various effects compounds this problem, especially when you're using a center-spot ND filter. Choosing plastic filters instead may or may not cause the same problems; this will depend on the brand. Generally, however, you can use 4-inch-square gel filters without much trouble. Mounting filters on nonrotation cameras is an easy process.

Short-rotation cameras prevent the use of plastic filters because their recessed lenses don't permit you to attach a bracket. But you can cut and tape gel filters over the lenses on both short-rotation Widelux models. In addition, glass filters for the Widelux F7 camera are commonly available, but the Widelux 120 requires an unusual—and almost impossible to find—34mm thread. I finally gave up looking for this size and had a filter company make some glass filters for me. The Cyclops camera has no provisions for any kind of filter.

The 360-degree cameras have individual designs and features. But in general, you don't have to worry about vignetting when you use filters with them because their lenses' angles of view aren't that wide.

ALTERNATIVE METHODS

M any fascinating variations of the panoramic camera have been used in such diverse fields as anthropology, metereology, cartography, industrial manufacturing, and even race-track photography. Artists who don't own panoramic cameras have also come up with techniques for making panoramic photographs using conventional cameras and a little imagination. What links together these diverse alternative methods—whether they're for scientific, commercial, or artistic applications—is the innovative spirit behind their approach. You might even discover that you can utilize some of these techniques to create extraordinary panoramic photographs.

SCIENTIFIC PANORAMIC PHOTOGRAPHY

The slit-scan shutter used in rotation panoramic cameras can also be used in cameras that record long, "panoramic" views of subjects usually not associated with panoramic photography. But unlike rotation cameras that photograph stationary subjects, scientific cameras are based on the principle of moving the film past a slit-scan shutter as the subject moves past the lens. Scientific cameras fall into two categories: periphery cameras and linear-strip cameras.

PERIPHERY CAMERAS

These are a kind of closeup 360-degree panoramic camera designed to photograph cylindrical objects. With periphery cameras, the subject and the film move at synchronized speeds, while the stationary slit lens is trained on one plane of the subject's surface. The goal is to flatten out the circular subject so that it can be thoroughly viewed and examined in one long photograph. These images are called *periphotographs* or *cyclographs*. Applications vary greatly and range from photographing automobile tires and engine pistons, to fingerprints on round objects, to pottery, to core samples.

This tranquil panorama was shot on 35mm film, and the transparency is the length of two frames butted together.

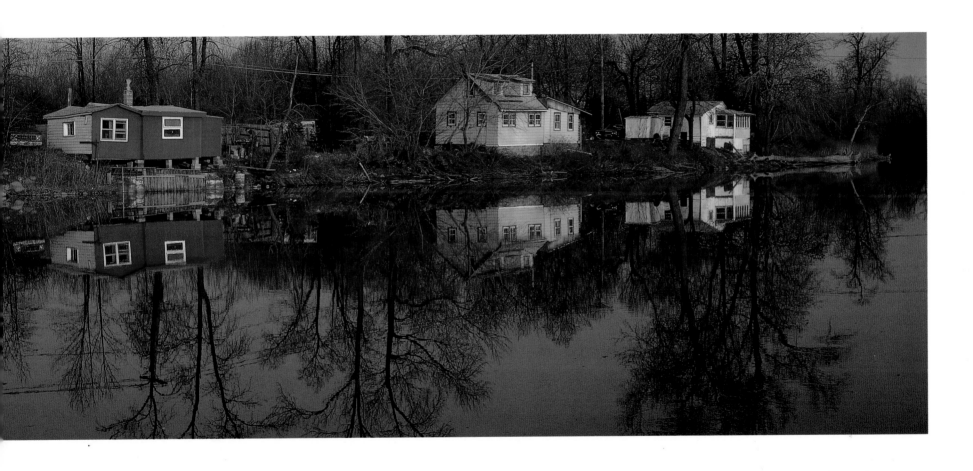

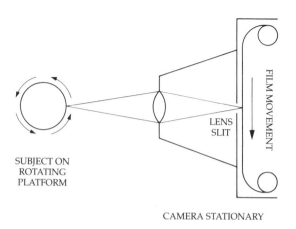

SUBJECT ON
ROTATING
PLATFORM

LENS
SLIT

FILM MOVEMENT

CAMERA STATIONARY

With a periphery camera, as the diagram shows, a subject rotates in front of a stationary slit-scan lens at the same speed that the film in the camera moves past the slit. This produces a long, continuous photograph of a round subject, whose appearance has been flattened in the process. The image on the left is a conventional photograph of a first-century A. D. Phoenician burial urn. Notice how different the urn looks in the periphotograph below. (Courtesy: Andrew Davidhazy.)

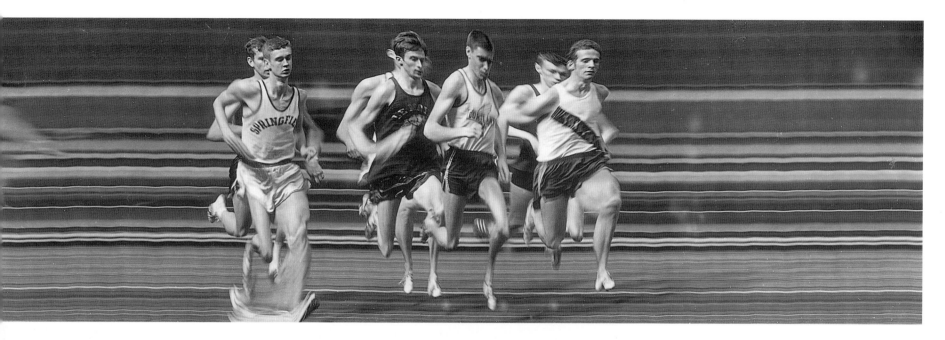

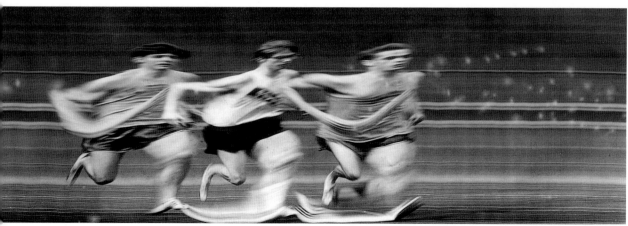

These pictures of a track event, taken with a homemade linear-strip photo-finish camera, show some of the various ways moving subjects are recorded. In the top shot, the subjects are sharp because the film, which moves from right to left in this type of camera, captured the runners as they moved from left to right. Here, their speed equalled that of the film so they appear "normal" against a blurred background. Conversely, in the bottom shot, the speed of the subjects was slower than that of the film. This difference caused them to look stretched out. If, on the other hand, the runners' speed was faster than the film speed, they would have appeared compressed in the final image. (Courtesy: Andrew Davidhazy.)

MODIFYING A 35MM CAMERA FOR STRIP PHOTOGRAPHY

Professor Andrew Davidhazy
Rochester Institute of Technology
Rochester, New York

The principal requirement of strip photography is that your conventional 35mm camera allows the film to be moved during the exposure. You can accomplish this easily via the camera's film-rewind knob. While you can use the knob without modifying it, attaching an oversized lever to it facilitates the turning. It is important to install a mask inside the camera so that the standard 24 × 36mm gate is narrowed to 24 × 1mm or 24 × 2mm. This will help you to avoid overexposing the film and to increase image sharpness. You can make the mask out of any thin, opaque material, such as Kodalith sheet film that has been exposed and developed. Cut the mask to fit between the camera's focal-plane rails to ensure that it doesn't interfere with the film's normal path. Next, tape the mask in place temporarily. You want to be able to readily remove it when you want to resume normal shooting.

An alternative to installing the slit inside the camera is to use an exterior mask. To do this, cover an oversized lens shade with an opaque mask into which you have cut a slit. The size of the slit in relation to the film varies with the *f*-stop and the focal length of the lens. If you have an SLR camera, you can estimate the most effective width of the slit by looking through the viewfinder with the mask in place. An unmasked viewfinder is approximately 36mm wide. Although the exterior-mask approach is safer for the camera, it's less efficient

and predictable. To achieve the best possible results, use a wide-angle lens set to a small aperture, such as *f*/11 or *f*/16. And, because an exterior mask reduces the amount of light entering the lens by one or two stops, you should bracket your estimated

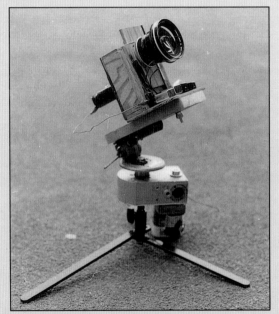

This modified 35mm 360-degree-rotation camera is positioned at an angle as it passes through its panoramic rotation. The final result: a conical representation of a scene. (Courtesy: Andrew Davidhazy.)

exposure with either one or two stops more exposure.

Consider this step-by-step example. Suppose you want to photograph people walking (who, by the way, are ideal beginning subjects). Mount your camera on a tripod, focus, and compose the scene. Keep in mind, though, that the moving film will record only whatever moves across the slit in the mask. If the slit is located at the center of the film frame, you can use the focusing circle in the center of the viewfinder as a guide. Next, as you look through the viewfinder, count the number of seconds that it takes the subject to go from one side of the viewfinder to the other. (If you're using a slit in front of the lens on an SLR camera, remove the mask so that you can see the entire image in the viewfinder.) Time the film-rewind rate, too. This is an important step because you have to make one complete turn of the rewind knob in about 1 1/2 times the number of seconds that it takes the subject to pass the slit. The length of time required to turn the rewind knob controls the exposure time. This is the total amount of time it takes a particular point on the film to cross the width of the slit.

Now, to determine the equivalent shutter speed, multiply the slit width (in millimeters) by the time required for your subject to cross the viewfinder (in seconds), and then divide that number by 36.

At this point, you can meter the light and adjust the aperture to the setting required by this shutter

speed for the film you're using. Load the camera with film, attach the lens cap to the lens, and advance all the film to the takeup spool. Set the shutter to "B" (Bulb), and lock it open with a locking cable release. (Some cameras have a built-in camera lock that holds the shutter open.)

Then, when you're ready to make an exposure, remove the lens cap. As people walk past the camera in the direction opposite to in which the film will move, slowly rewind the film past the slit back into the supply chamber. The image recorded will move forward on the film. (This is easier to understand if you open the back of an empty 35mm camera and turn the rewind knob while you visualize the motion of people and film.) Recap the lens after the exposure. You'll find that when people walk by the camera at just the right speed, they'll look normal in the final image. When they move slower than the film, however, they'll appear stretched. When they move faster than the film, they'll look compressed.

While you can make strip photographs without modifying your 35mm camera in any way, these methods—particularly masking the image to a narrow strip—will enable you to achieve striking photographs. In any case, each roll of film will contain images that are, by normal standards, quite unusual. It's exciting just to scan the developed film for that unique image.

LINEAR-STRIP CAMERAS

The design of these cameras is similar to that of periphery cameras, but their relationship to the subject matter is somewhat different. There are two types of linear-strip cameras: the race-track photo-finish camera and the aerial-strip camera. With photo-finish cameras, the subject moves past the slit, perpendicular to the film plane, and the film moves at the same rate of speed as the subject. This results in an image with a relatively sharp subject and a blurred background. The aerial-strip camera basically works the same way, but here the film speed is synchronized with the speed of the plane as it flies over the ground. The final image is a continuously sharp picture of the topography.

The periphery camera and the two linear-strip cameras have their specific scientific applications. Nevertheless, such creative photographers as Professor Andrew Davidhazy of the Rochester Institute of Technology (New York) have explored other uses for these alternative panoramic cameras. These talented individuals have come up with unusual artistic and even some commercial applications and have crafted "homemade" designs that aren't beyond the capabilities of the average photographer. For example, Davidhazy has devised a simple method for modifying a conventional 35mm camera in order to make strip photographs. He has also experimented with a camera that minimizes the distortion common to periphotographs. Perhaps his work will inspire you to attempt creative alternative techniques.

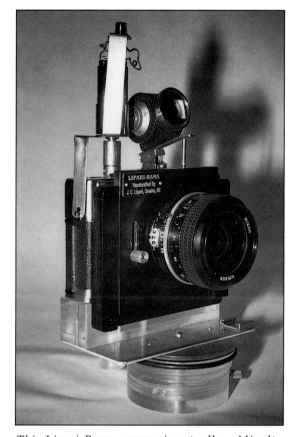

This Lipari-Rama camera is actually a Minolta Himatic 7S 35mm rangefinder camera converted to an alternative panoramic camera via a Nikkor 24mm wide-angle lens. (You can also use 28mm and 35mm lenses.) The 1/2-inch rise and fall with effective shutter speeds of 1/8 sec., 1/15 sec., and 1/30 sec. is controlled by a battery-driven rotation motor. 360° cameras such as these have their slit shutters in the rear of the lens. (Courtesy: J. C. Lipari.)

Using Conventional Cameras to Create Panoramas

For a number of years, photographers and artists have been using panoramic techniques without panoramic cameras to produce interesting and exciting works of art. There are many, many ways to do this. For example, in 1988 and 1989 New York's Hudson River Museum sponsored a major traveling exhibition entitled "The World is Round." It featured several panoramic variations popular in the art world, including quite a few fascinating photographic works. And many photographers on a limited budget have used conventional cameras to make panoramic pictures. Long ago, producers of slide shows developed methods for making multi-slide panoramic images. So whether the approach is simply cutting and pasting together several photographs taken in a visual sequence or using sophisticated or precise camera techniques that blend single images into one continuous panorama, you must give some thought to various aspects of the photographic process. Ranging from the camera to the enlarger, they can affect the quality of the image and the way it is created.

Light-Transmission Falloff

All lenses are troubled by a certain degree of light-transmission falloff at their edges. This is true of both camera and enlarging lenses, but wide-angle camera lenses and lenses of poorer quality are affected most. Light falloff is particularly noticeable when you try to match the edges of individual prints to produce a continuous assemblage. For example, the sky might appear underexposed at the end of one of the prints, thereby making the places where the pictures are joined obvious.

Matching Prints

When you butt photographs together, it is difficult to align the edges so that the junction points aren't apparent. This problem occurs because the cut of each photograph has to be perfectly matched with its mate. This technique is easier to master when subjects are diffused, such as landscapes. Matching prints that contain numerous, well-defined lines and forms, such as those seen in architectural shots, is difficult. The seams in a busy landscape are much harder to detect.

Perspective Control

When you use conventional cameras to shoot multi-image panoramas, they must be rotated on a tripod to take in more of the scene. But this leads to a type of perspective distortion. Both the distance and the angle between the film plane and subject change as you move the camera.

Action/Time

You will find that shooting two or three photographs for combination into a panorama takes time to execute. This raises the possibility that the subject might move or that the quality of the light might change in between exposures, thereby ruining the sense of continuity in the final panoramic picture.

Cut-and-Paste Panoramic Assemblages

As discussed in the introduction, panoramic assemblages have been around since the earliest days of photography. And in the last few years, there has been a renewed interest in assemblages of all kinds, including montages and collages, throughout the art world. The cut-and-paste technique is simple. But be aware that if precise alignment and a sophisticated result are your goals, this isn't the best method to use. Take a look at the cut-and-paste photograph by Scott Geffert on page 110. He shot it handheld from the stands of the Olympic Stadium during the opening ceremonies. The negatives were printed and later pasted together. There are some problems here: light-transmission falloff and mismatched prints. Still, it works to some degree because it gives the feeling of the length and breadth of the scene. So when you're not concerned about exact alignment, assemblages composed of handheld shots are ideal. They are great for snapshot albums and bulletin boards. This technique also comes in handy as preparation for setting up and shooting with a 360-degree rotation camera.

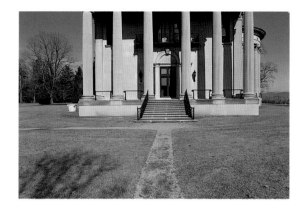
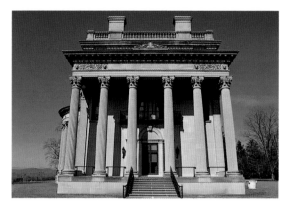
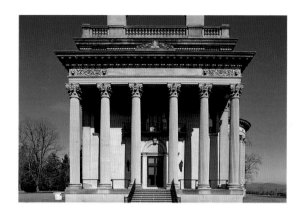

To make a two-shot panoramic image with a conventional camera, you must turn the camera on a tripod. But this setup throws the film plane out of parallel with the subject. By using the lens-shift mechanism on a view camera, a perspective-control lens, or a Zörk adapter, you can move the lens to the left and right to increase the angle of view without moving the film plane out of parallel. Basically this is the same process as controlling converging lines, as shown in the photographs above. In the shot on the left, the camera's film plane is parallel to the subject but the top of the building can't be seen. Tip the camera up, and the center picture is the result. But shift the lens up as in the diagram, and you avoid line convergence, as shown in the shot on the right.

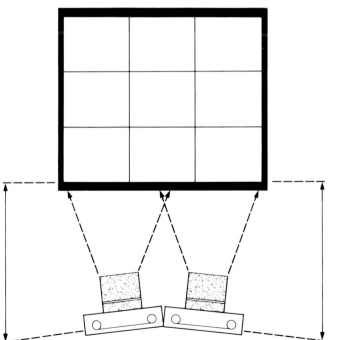
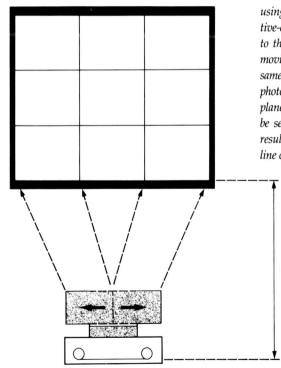

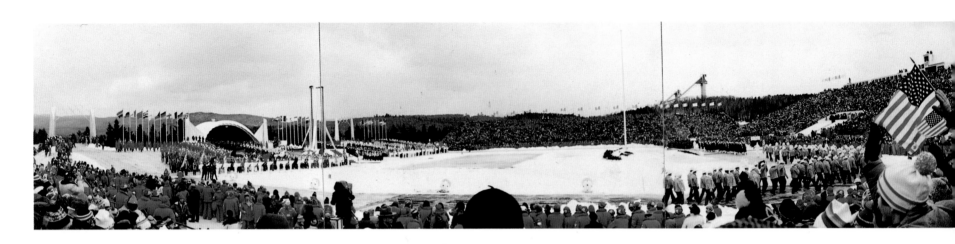

The panoramic assemblage on the top of the opposite page was photographed on color film with a handheld 35mm camera from the stands during the opening ceremonies of the Winter Olympics. The three images were then carefully cut and pasted together to create this effective panoramic rendering of a distant scene. (Courtesy: Scott Geffert.)

The images on the bottom of the opposite page and above are interesting examples of how cut-and-paste assemblages and the panoramic concept can be combined. The photographer in the bottom shot, incidentally, is using a Cirkut camera. (Courtesy: Cynthia Dantzic.)

You can let your imagination run wild and try numerous variations. For example, shoot multiple images of the front and back of a building at different times of the day, paste the matching shots back to back, and make a mobile out of them. You can also shoot all the sides of a building and assemble them in one panorama to produce an image that resembles those taken with periphery cameras.

Joining the prints for a cut-and-paste panorama is easy. Arrange the photos on a piece of illustration board. Apply a piece of cold-mounting tissue to the back of each print (you can also use double-sided tape or glue). Carefully pencil a line through the area of each photograph that you want to butt to the next one in the sequence. It is important that your prints overlap so that each one contains part of the next frame. This enables you to match the prints better. After you draw the lines, place a straightedge on the prints and cut them with a sharp artist's knife. Then remove the paper from the adhesive on the prints and lay them down in succession on the illustration board, being sure to butt edges.

During the shooting stage, however, you can make cut-and-paste panoramas more accurate in their final form. First, make sure that the camera remains level on a tripod throughout the picture-taking process and that the arc of the sweep is broken down into segments, like slices of pie. The actual division of the arc will depend on the angle of view of your lens. To facilitate this, several manufacturers mark their tripods with the

Several panoramic heads are designed for use with any tripod. All heads have the degrees of a circle marked off on them, but some, as this model does, tell you how to break down the divisions of that circle for various focal lengths.

This photograph shows the Sinar 120/220 6 × 12cm roll-film slip-in back, which is used on large-format cameras that have spring-loaded backs. This particular model can accommodate several conventional roll-film sizes as well 6 × 12cm. (Courtesy: Sinar, Inc.)

degrees of a circle, and "panoramic heads" are available as accessories. You should also overlap each shot by about 10 percent to make matching easier later on. Shooting with a standard lens produces less light falloff, and using mid-range apertures usually provides the best compromise in terms of sharpness, contrast, depth of field, and light falloff. (Wide-angle lenses yield less segmentation and greater vertical angles of view, but cause more obvious light falloff.)

You can improve the final appearance of cut-and-paste assemblages in other ways as well. For example, you don't have to butt the photographs. Instead, cut the mats so that each picture is set in an individual frame separated by a thin border. That gives the impression of looking out at a panoramic scene through a long series of windows. Some people frame their sequential pictures separately and hang the frames close together on a wall. Still another way to refine the cut-and-paste technique is to make various-sized enlargements. By making the center print larger than the prints at the ends and mounting all of them in a single frame, you produce an assemblage that mimics the cigar effect produced by a short-rotation lens.

PANORAMIC FILMBACKS

Many photographers convert their medium-format and large-format conventional cameras into panoramic-format cameras through the use of special filmbacks. This practice has become quite popular because it provides photographers with

an easy—and in many cases, a less expensive—way to get into panoramic photography. These filmbacks are available in two styles. One clips onto the international lock back that is commonly found on many large-format cameras. The other filmback is a slide-in type that slides in behind the spring-back mechanism also found on large-format cameras. Some medium-format cameras with interchangeable filmbacks also offer pano-

ramic versions. With large-format cameras, the effectiveness of the conversion is measured in terms of ease of operation; this depends on the individual camera's design. The many different types of large-format cameras are divided into several groups.

View Cameras

These large machines operate slowly, but they have a number of diverse camera movements. These give you an enormous amount of control over the way the subject will appear on film. View cameras have more features and accessories than any other type of large-format camera, including interchangeable filmbacks and lenses.

Field Cameras

These are compact versions of view cameras. Field cameras fold into portable units and can be set up quickly. However, they don't have all the movements of view cameras. Some modern field cameras have several features that speed up operation, such as viewing hoods. I often use a modified field camera for shooting 6 × 12cm film. Finally, these cameras also have filmbacks and lenses that can be easily switched.

Technical and Press Cameras

The design of this group of cameras incorporates many features of the view camera, such as perspective correction and interchangeable filmbacks and lenses. But you can handhold technical and press cameras. Most of these cameras

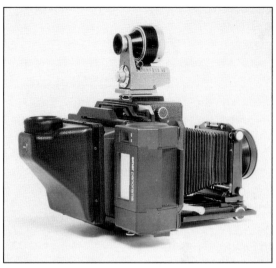

I often use a 6 × 12cm panoramic slide-in roll-film holder on a 4 × 5 field camera. This holder enables me to take advantage of the camera's inherent perspective control and interchangeable lenses. The groundglass viewing screen has a 6 × 12cm mask insert, and the reflex viewer allows for precise focusing and composition. But its size, weight, setup time, and lack of easy handholdability are disadvantages.

have some type of handle, as well as a built-in or accessory viewfinder. Some technical and press cameras even have focusing viewfinders with frame lines that show you the field of view offered by different lenses.

Wide-Angle and Architectural Cameras

These two types of cameras are quite similar to the press camera, but they're designed to work with wide-angle lenses. For this reason, they are most like nonrotation panoramic cameras. Most wide-angle and architectural cameras have a

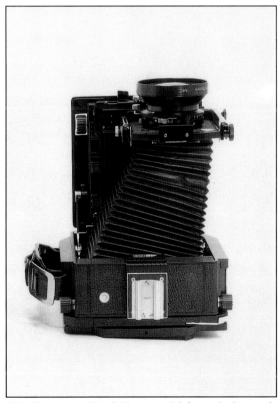

This Horseman 45A field camera is shown in its maximum lens-shift position.

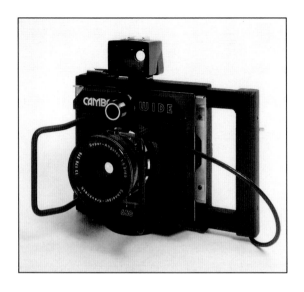

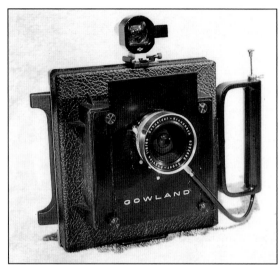

These handholdable wide-angle cameras can easily be converted to 1:2 panoramic cameras with the addition of either a slip-in or a clip-on 612 panoramic back. The viewfinders can be masked to help in composing, while focusing is estimated and the approximate distance set on the lens. Focusing and composing on a groundglass is also an option. The Cambo Wide camera directly above, the Gowland architectural camera in the center, and the Globuscope 4 × 5 camera on the right have 65mm lenses. The Cambo Wide and Gowland models also have rising fronts. (Courtesy of Calumet Photographic, Inc.; Peter Gowland, Inc.; and Globuscope, Inc., respectively.)

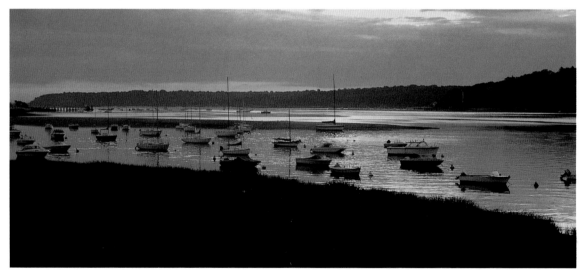

This beach scene was photographed by Steve Englima with Polachrome Instant film, a 40mm lens, and a Bronica camera with an ETRS panoramic back. He also photographed the vertical shot on the opposite page with the same equipment but with conventional transparency film. (Courtesy: GMI, Inc.)

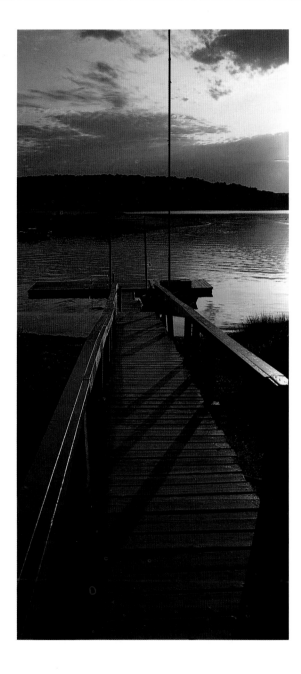

means by which you can shift the lens to control line convergence in your photographs. Unlike the other cameras described here, these can use only one or two wide-angle lenses, and most use hellicoid focusing tubes.

You can easily convert the cameras in all four groups to a 1:2 panoramic format via either a clip-on or slip-in 6 × 12cm filmback. The result: a camera with interchangeable lenses and a certain amount of control over line convergence. So your decision is just a matter of which model you prefer. View cameras have the most features and can do more, but are the least convenient to use. Field cameras significantly minimize setup time, but like view cameras, they aren't handholdable; in addition, some models can't function with the widest of the large-format wide-angle lenses. This inability is true of many technical and press cameras as well, although they are handholdable and operate more quickly. Wide-angle and architectural cameras are perfect for shooting wide fields of view, are convenient to set up, and can be handheld; however, they can be used with only wide-angle lenses. You have to consider the advantages and drawbacks of each large-format camera group as you decide.

Choosing among medium-format and 35mm cameras is less complicated. Only two medium-format camera lines offer panoramic filmbacks. Bronica makes a 1:2, 24 × 54mm horizontal-format filmback for its ETR-S, SQA, and SQ-Am cameras. Hasselblad produces a limited number of 1:2, 24 × 55mm vertical-format filmbacks. All of these backs use only 35mm film, which means that you can use certain copy films, high-contrast films, and a number of graphic-arts specialty emulsions available in 35mm but not 120mm. But don't let this stop you. Converting medium-format cameras is a simple way of moving into panoramic photography. You can interchange lenses and take advantage of the cameras' accurate viewfinders to focus and compose quickly. The macro lenses on the Bronica cameras make them particularly useful as copy cameras. And, although the image size is smaller, the Bronica 35mm filmbacks enable you to shoot a higher number of exposures; twenty-three exposures on a thirty-six-exposure roll of film.

Unlike converting large-format and medium-format cameras, converting 35mm cameras involves major mechanical alterations. First, increasing the film format's aspect ratio to 1:2 or 1:3 means exceeding the covering power of 35mm camera lenses. However, this isn't impossible. You can easily solve this problem by converting some medium-format lenses for use on a 35mm camera. For example, an adapter manufactured by Pentax allows the company's own medium-format lenses to be used on its 35mm cameras. And the independently produced Zörk adapter also enables you to put a number of medium-format optics on 35mm bodies (see page 118).

But greater lens coverage is only part of the problem when you try to convert 35mm cameras. Enlarging the space for the film to at least 54mm requires milling out the back, as in the case of

the Panorama, or fusing two camera bodies together, as with the Ipan. In either case, the focal-plane shutter will be destroyed, the viewfinder will be rendered useless, and the film-advance mechanism will have to be modified. Obviously, this is an expensive proposition.

SHIFT-LENS PANORAMAS

Up to this point, the assemblage techniques I've described are based on rotating a conventional camera to increase the angle of view. This means that the film plane doesn't remain parallel to the subject, which makes distortion inevitable. You can, however, avoid this type of distortion by using any one of three pieces of photographic equipment. These are the view camera, the perspective-correction lens, and a special device, the Zörk adapter. All three approaches yield panoramic images with horizontal angles of view between 100 and 120 degrees. The operating principle is simple—by shifting the camera lens off axis while keeping the camera body, and therefore the film plane, parallel to the subject, you eliminate distortion.

Using View Cameras

Panoramic photographs made with view cameras can be striking. You can shift the lenses on most large-format view cameras horizontally or vertically while keeping the film parallel to the subject. In addition, you can vary the position of the filmback in the same fashion. This enables you to increase the angle of view by making two photographs. The procedure is simple. Mount the view camera on a tripod and level it. Shift the lens to the left while moving the filmback to the right. Expose the film. Now reverse the movement and expose a second frame. The result: two images without film-plane distortion due to rotation that you can join.

However, if the amount of movement necessary is extensive and the lens you're using has a narrow angle of view, you might not be able to produce overlapping images. In this situation, you might need to shoot a third image in the center, nonshift position—that is, the normal position of the camera's lens and filmback before any shifting takes place. You can use a 6 × 12cm filmback or sheet film. You might try using a technical, press, or architectural camera, but their ranges of movement are somewhat limited compared to that of a view camera. If portability and lightweight equipment are important to you, consider a field camera. It is easier to carry, and its shift mechanism is fairly extensive.

Before you get too excited about using view cameras for panoramic photography, you should

know that this approach has some serious drawbacks. First, view cameras are large and bulky, which makes them inconvenient to transport and store. Furthermore, they're difficult to operate—setting up each shot, loading film, and bracketing are time-consuming chores—and they can't be handheld. And although view cameras enable you to make perspective adjustments, this advantage is mitigated because panoramists concentrate on the middle third of a scene and tend to compose on a level plane.

Nevertheless, many photographers tell me that they have occasionally created a "panorama" by cropping an image shot with a view camera. As a result, they see no need to use a panoramic camera. While it is true that such panoramic cameras as the Linhof Technorama 612 PC and the Fuji G617 can be regarded as cameras that produce cropped-down sections of 4 × 5-inch and

5 × 7-inch films, respectively, the tradeoffs in convenience are substantial. But most important, by the nature of their designs, panoramic cameras literally force you to think "panoramic."

Using Perspective-Correction Lenses
Perspective-correction (PC) lenses are wide-angle optics made for 35mm SLR and medium-format cameras. Easy to use, these lenses mimic the lens-shift feature on view cameras. The primary function of PC lenses is to control the line convergence caused by tilting a camera up or down to take in more of a subject. Most PC lenses for 35mm cameras have maximum shift ranges of 10mm or 11mm, while those designed for medium-format cameras have a slightly greater range. A typical 28mm PC lens with an angle of view of 64 degrees can produce a two-shot panorama that shows a 92-degree view of a scene.

Shift-lens panoramic assemblages aren't limited to two-shot groupings. This 360-degree view shows the problems of light falloff and accurate joint assembly, but perspective distortion is minimal, a result of the shift-lens method. (Courtesy: Ken Hansen Photographic, Inc.)

Using the Zörk Adapter

You can convert many 35mm SLR cameras to a PC-lens camera by using medium-format-camera optics via the Zörk adapter. This device permits off-axis lens shifts of up to 20mm, thereby producing remarkably accurate panoramas. The Zörk adapter consists of a two-part bracket that you can shift horizontally or vertically by turning a long, threaded shaft. One part of the bracket holds the medium-format-lens adapter, and the other holds the 35mm-camera mount.

Using "Homemade" Nonrotation Panoramic Cameras

As mentioned earlier, there is no conversion kit available that allows you to turn a 35mm SLR camera into a nonrotation panoramic camera. Converting a typical 35mm camera requires sig-nificant alteration of the camera's back, lens mount, viewfinder, and film-wind mechanism. One type of camera with some of these design modifications was manufactured some time ago: the Nimslo 3-D camera, which, unfortunately, is no longer on the market. Using four lenses, the Nimslo produced four 18×24mm frames on a 35mm strip of film that was 74mm long. If you were to come across (and purchase) one of these

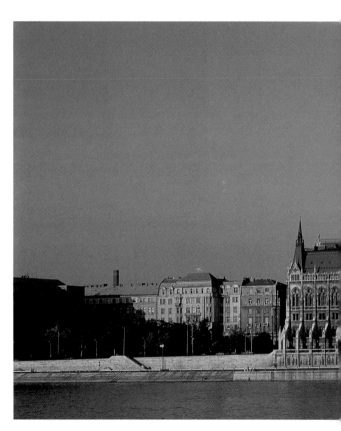

The precise alignment and distortion-free, increased angle of view that the shift-lens method produces are shown here. The photograph on the right illustrates the perspective without any shift while the larger, two-shot composite shown above was taken with a Zörk adapter and demonstrates how much greater the obtained angle of view can be.

cameras, you could remove the front of the camera and replace it with a medium-format lens that has a built-in shutter; then you would be able to expand the original 18 × 24mm frame to a 21 × 74mm frame. This would result in an image with an amazing aspect ratio of 1:3.52.

If you preferred, you could leave the Nimslo basically intact but cover its four lenses separately. All you would have to do is to modify the camera's shutter in order to recock the lenses without advancing the film. Next, you would mount the camera on a tripod with a head that is calibrated for angles of view, and level the camera. You would then take four shots individually, rotating the camera before each one. The result would be a single easy-to-print 35mm strip of film showing four images. In other words, you would've created a segmented panorama.

A converted Nimslo camera looks a bit odd, but it produces beautiful images, as the photographs of the Hungarian Parliament, shown below, and Salzburg, Austria, shown on the overleaf, prove. (Courtesy: Andrew Davidhazy.)

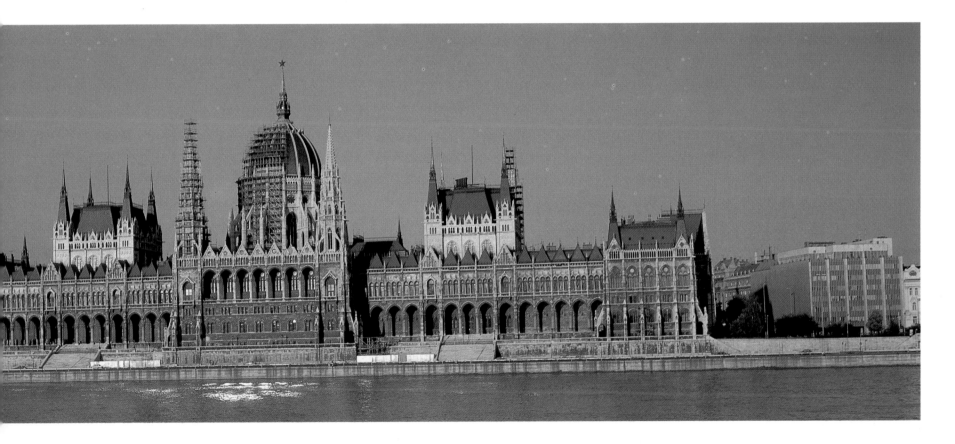

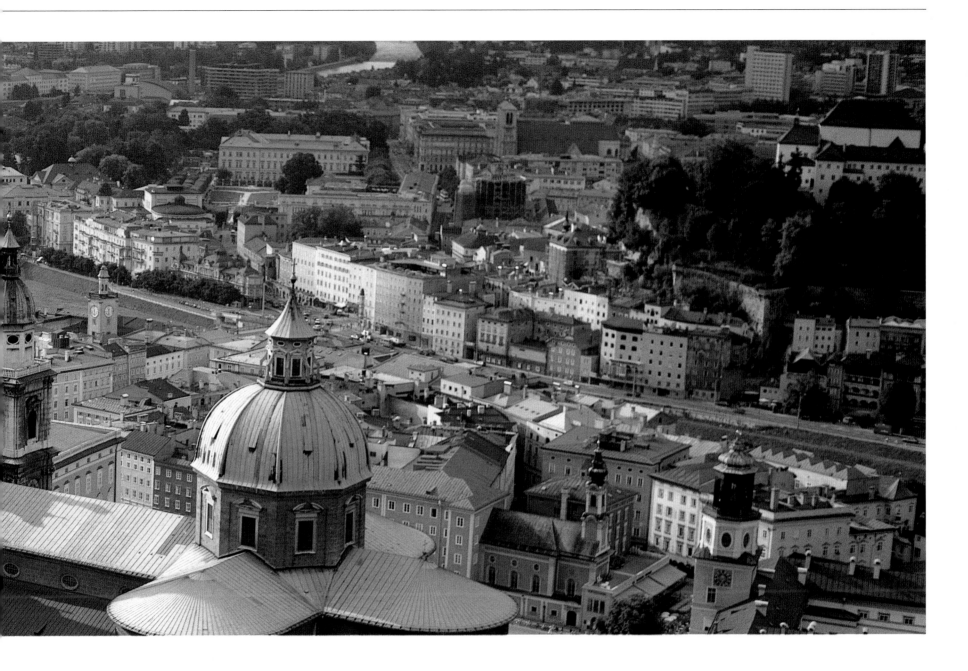

MULTI-IMAGE SLIDE-SHOW PANORAMAS

Creators of multi-image slide shows frequently use panoramic views. The method is simple in theory and precise in practice. Here, a typical panoramic image is made up of two or more transparencies that have been photographed under one of the following conditions: as "rotation panoramas" shot with a conventional 35mm camera, or as segmented dupes shot from a single, original conventional or panoramic shot. In either case, the projected slides must match up perfectly. To accomplish this, slide-show creators frequently use *pin-registered* cameras and slide mounts. This means that the camera lines up the film sprockets exactly the same way for each exposure, and that special slide mounts match this registration. When these cameras and slide mounts are combined with precision slide-duplicating equipment, the resulting dupes match up perfectly. The only problems remaining are to align the projectors and to obscure the junction points between images.

Butt-Joined Images

One way to assemble and project slides to create a panoramic effect is the *butt-joined* method. This calls for exact edge-to-edge matching of two or more transparencies, much like the way multiple photographs are joined. Failure to achieve perfect alignment can result in: a space or black line on the screen if the slides don't "touch" each other, unintentional overlapping, or a situation in which one image appears higher or lower than the ones adjacent to it.

Overlapping Images

Another approach, *overlapping panoramas*, is based on the principle of superimposing a portion of one slide's edges onto another slide's edges and blending them with *soft-edge masks.* These masks are clear pieces of film that have a graduated spray of neutral-density material on the edges. You can use them to discreetly combine images and compensate for the additional illumination that results when two projectors share the same area of the screen simultaneously. When you decide to try this approach, you must keep in mind that because a section of each slide is committed to the overlapping, the length of the total screen image is less than that of a butt-joined assemblage. You can, however, eliminate this problem by using more slide projectors. I think that the intentional overlapping of images is the better method. It is easier to control the alignment of the slides, and any imprecision might not be readily apparent because of the soft-edge masks.

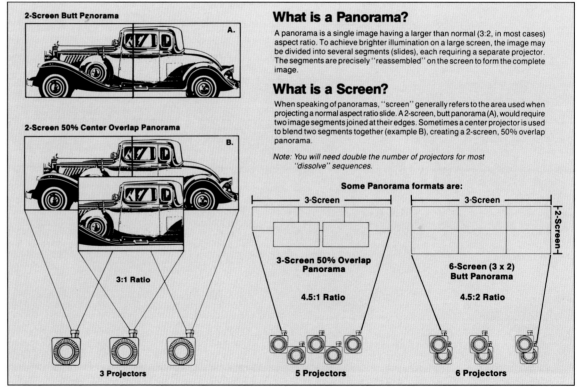

What is a Panorama?

A panorama is a single image having a larger than normal (3:2, in most cases) aspect ratio. To achieve brighter illumination on a large screen, the image may be divided into several segments (slides), each requiring a separate projector. The segments are precisely "reassembled" on the screen to form the complete image.

What is a Screen?

When speaking of panoramas, "screen" generally refers to the area used when projecting a normal aspect ratio slide. A 2-screen, butt panorama (A), would require two image segments joined at their edges. Sometimes a center projector is used to blend two segments together (example B), creating a 2-screen, 50% overlap panorama.

Note: You will need double the number of projectors for most "dissolve" sequences.

This illustration shows ways to achieve two-screen, three-screen, and six-screen panoramas. (Courtesy: Wess Plastics, Inc.)

HOW TO MAKE MULTI-PROJECTOR PANORAMAS

Robert F. Bohl
Wess Plastics Company
Farmingdale, New York

A typical three-projector panorama that overlaps by 50 percent has an aspect ratio of 3:1, while that of a standard 35mm frame is only 3:2. This means that a large portion—50 percent or more—of the original images will be cropped when the panorama is created. The resulting high projection magnifications can cause an unacceptable loss of image quality, even when high-quality 35mm originals are used. For this reason, producers may opt to work with medium- or large-format originals or originals made with such dedicated panoramic wide-field cameras as the Widelux and the Fuji G617. Of course, the best results are obtained when the original images are shot with a panorama in mind: the subject matter then lends itself to wide-screen treatment after cropping. Placing a set of L-shaped cropping masks made of paper over the originals can help you to visualize the end results.

Panoramic Splits. One technique used to create panoramic splits requires a pin-registered 35mm camera, a copystand, a color-corrected light source, and a high-precision X-Y compound table. The camera holds the image segments in tight registration as the compound table moves the original image in the increments needed to produce the proper overlap or butt-join. When you begin this procedure, make sure that you adjust the camera to the required magnification. You can calculate this number with the following formula:

$$\frac{\text{Mount Aperture Width}}{\text{Width of Original} \div \text{\# of Screen Areas}} = \text{Magnification (X)}.$$

The distance from the original to the lens and film plane would depend, of course, on the focal length of the lens. Next, you have to determine how far to shift the stage of the compound table between exposures. The following equation can be used for 50-percent-overlap panoramas. Here, the number of image segments is equal to the number of projectors, or "banks," used for a single panorama.

Width of Original ÷ (Image Segments + 1) = Shift.

For butt-joined panoramas, however, you would use this formula:

Width of Original ÷ Image Segments = Shift.

When making butt-joined panoramas, producers sometimes use a shift that is slightly less than optimal. This causes a slight overlap between segments. While this might seem like a contradiction in terms, the overlap is used to fill gaps caused by the keystone effect in projection.

Depending on the compound table used for the splits, you might find it beneficial to begin your exposures at one side of an image and work across, or work from the center of the image outward. In either case, you should do a dry run to ensure that the original transparency is properly split and positioned within the frame of the original.

Another way to produce panoramic splits calls for a color enlarger and the Wess Splitter. With this method, the film being exposed is shifted by the splitter while the original transparency remains fixed in the enlarger's film carrier.

To begin this process, place the splitter on the enlarger's baseboard. Next, mount a special white, grid-lined plate on the splitter; this will help you compose and focus the usually enlarged image. Then, under darkroom conditions, withdraw a roll of 35mm duplicating film from its cartridge and place it over registration pegs on the exposure plate (film easel). Note, but don't worry, that some film is wasted for each set of splits. The exposure plate is equipped with a pin-locating system that enables you to shift it in precisely controlled increments under the enlarger's lens. Also, small, hinged doors on the splitter selectively cover portions of the film before and after each segment of the projected image is exposed. You'll find small projections on the splitter's doors and base. These were designed to facilitate moving the exposure plate and opening the appropriate door in the dark.

With the enlarger/splitter technique, each shift is accurately and critically positioned. This is important if a show needs replacement slides or an update: a new split won't require you to realign the projectors.

AFTER YOU SHOOT

The differences between panoramic photography and conventional photography exist not only in terms of the cameras, composition, viewpoint, and technique, but also the processing and printing of your film, presenting your images in portfolios, and selling your work. Being a panoramic photographer doesn't stop after you make your last exposure. You need to think about what happens to your film once you've finished shooting it, as well as your potential career in panoramic photography.

PROCESSING AND ANALYZING COLOR TRANSPARENCIES

When you drop off your film for developing, you should request that it be left uncut and loosely coiled. This form greatly reduces handling and leaves the cutting to you. Another benefit is that you'll be able to evaluate the negatives in three-bracket shots, to determine if the ½-stop bracketed images are truly different and if the exposures are correct. I often lay out the film from an entire shoot in front of me in three-bracket strips to get an indication of how my "guesstimates" and exposures worked for a particular scene and

David A. Roark photographed this magnificent view of the interior of the honeymoon suite in the Grand Floridian Beach Resort. Such an assignment is just one example of the many exciting opportunities panoramic photography offers. (Courtesy: The Walt Disney Company. © 1990.)

Some tools of the trade for examining transparencies are a color-corrected (5000K) lightbox and high-quality loupes. For black-and-white contact sheets, I use a 4X loupe to check composition. I also have a 10X illuminated viewer to examine details before adding the image to my "to-be-printed" file.

in a particular light. I admit that this method isn't very sophisticated, but it has helped me to fine-tune my technique.

The tools I use for viewing and analyzing are a good lightbox and a high-quality 4X or 6X loupe. Loupes with these magnifications enable me to notice flaws and deficiencies in my transparencies immediately. The lightbox has a 5000K light whose brightness level helps me to determine which frame has the correct, or best-looking, exposure. The loupe enables me, for example, to pick up such details as the blurs of small moving objects and to check depth of field.

I've never found a large magnifier sharp enough to allow me to look at a 6 × 12cm or 6 × 17cm image in toto. Over the years, my process of evaluating negatives and transparencies has become quite deliberate and consistent.

In addition, I carry a microcassette tape recorder with me when I shoot in order to record exposure data and other relevant information, including a description of a scene or light levels. When I look over the film, I play back the tape. This helps me relive the shoot and make the connection between preparation, setup, and result. But the tape recorder isn't my only reference; I also keep a daily log. I jot down any unusual circumstances, such as waves breaking or telephone poles dominating the foreground, and how I dealt with them. I also make a note of the exact location, time of day, and weather conditions, as well as information about places to stay and nearby processing labs and repair services.

My film-evaluation process always ends with the same ritual. The "unacceptables" find their way to the wastepaper basket, "acceptables" are filed but kept handy for frequent uses, and the "best" exposures and compositions are safely stored. These "acceptable" shots are generally ½ stop over- or underexposed but are still good enough representations of the panoramic viewpoint. I usually take thirty or forty "acceptable" images on the road with me to show people the kind of work I do. More than once, they have given me access to someone's property or landed me a small job. Sometimes I leave them behind

as groundwork for a return trip. I also send "acceptables" out to potential customers or other photographers. This practice enables me to circulate my images freely, without worrying about losing a "best" exposure.

STORING COLOR TRANSPARENCIES

I store my color transparencies in a legal-size hanging file. I use archival storage pages that take horizontal strips of 120 film for all of my medium-format images. Archival materials are the safest way to store images. There are too many potential and real problems with nonarchival storage materials. These include the degradation of film, which is caused by the slow release of gases from the polyvinyl chloride (PVC) plastic in film pages and the residual acid compounds in paper boxes, mounts, and mat boards. Images from the Widelux 35mm and the Bronica film-backs fit two to a pocket in pages intended for 2¼-inch-square mounted transparencies. The 6-inch Globuscope frames fit a standard 35mm negative page, as do images from the Ipan and the Panorama cameras. For all formats, I transfer the film from the protective sleeves the lab returns it in and put it in archival storage materials.

I store my 6 × 12cm and 6 × 17cm images in archival clear-plastic pages made by Viewpacks, as shown on the opposite page. A page intended for 6 × 6cm mounted slides holds either one mounted transparency or two unmounted ones.

I indicate the date I shot the film in my files, so my notebook serves as an index for finding a particular image.

ANALYZING AND STORING BLACK-AND-WHITE NEGATIVES

Evaluating and storing my black-and-white negatives call for a different procedure. First, I process the film myself and select negatives on the basis of overall density and shadow detail. I then cut the negatives from 120/220 roll film into separate frames and contact-print them six to a sheet horizontally for the 6 × 12cm format and four to a sheet vertically for the 6 × 17cm format. When you process film from both the Globuscope and the Widelux 35mm cameras, I recommend printing the whole roll on one sheet. I store all of these negatives in archival negative sheets that I staple to the contact print.

A creature of habit, I follow a set procedure for contact-printing. I have a full-tone test negative of an average scene—a cityscape and a nearby park on a clear, sunny day—that prints perfectly on my standard paper grade for a cold-light enlarger. I use the parameters that produce a good contact print of my test negative for all of my contact-printing. For each session, I set the enlarger at the same height, *f*-stop, exposure time, and development time. Obviously, not all of my negatives turn out as well as the reference negative; however, when I look at the contact sheet, I can tell a great deal about a negative's density and contrast and how it will print. I scan the con-

tact sheet with a 10X illuminated magnifier to get an indication of how well the negative will hold up when I enlarge it.

The contact sheet also serves as a record of my printing. When I finish a print, I record information about the exposure time, the contrast, the opening on the enlarging lens, the height of the enlarger, the tray development time, and any burning or dodging. I write down these notes directly onto the contact sheet. This is a great help when I reprint at a later time and serves as a reference for other negatives on that contact sheet. I believe that consistently following simple procedures not only improves your technique, but also helps you to develop an intrinsic understanding of your materials and equipment.

ENLARGING COLOR PANORAMIC FORMATS

All photographers seem to favor certain sizes when making enlargements. One photographer I know loves to make prints quite large, up to 4 feet long, while another photographer's enlargements never exceed 14 inches in length. These choices are merely a matter of personal preference and your goal; there are no hard and fast rules about enlargement size. I base my decisions on materials, equipment, and personal standards. For color enlargements, I have my transparencies processed on Cibachrome materials by a large commercial lab. These materials are designed for printing from reversal film, thereby eliminating the need to have internega-

When contact-printing 6 × 12cm and 6 × 17cm black-and-white negatives, I staple the archival negative holders directly to the contact print. I also jot down notes concerning the printing on the contact sheet.

tives for printing made from your transparencies. I prefer the sharpness and unique appearance of Cibachrome prints.

Using Cibachrome materials does, however, have some drawbacks. The most important of these is price. These materials are quite expensive. In addition, they don't handle contrasty scenes well, but this is changing because the process is being improved. Another problem is that labs often print 8 × 20-inch images on a 16 × 20-inch full sheet (even though I have suggested that two prints would fit on one sheet). I have Cibachrome prints made for exhibitions, my portfolio, and personal wall displays; I don't have them made up routinely.

If you shoot color-print film, you can take advantage of labs that specialize in making prints from popular panoramic formats via machines. Any custom lab should be able to make prints for

you. The level of the lab's work usually depends as much on its procedures and equipment as on the quality of your negatives. It is important to develop a relationship with the lab personnel so that they know what you want. Most staff members will be happy to work with you and often are a great source of technical information about films and exposures.

ENLARGING BLACK-AND-WHITE PANORAMIC FORMATS

The guidelines for having black-and-white negatives enlarged by a commercial lab are basically the same as those described for enlarging color-print film. The major difference is that because black-and-white materials can be extensively manipulated, the lab's interpretation can be substantial—and might not be to your liking. I recommend that panoramic photographers do their own printing. While the process is time-consuming, having complete control of the final image and learning firsthand how black-and-white film responds are well worth the effort.

You can print black-and-white panoramic formats with some modification of equipment in any darkroom set up for 120 roll or 4 × 5-inch negatives. The Widelux F and filmbacks for the Bronica and Hasselblad cameras need only a medium-format enlarger; all 6 × 12cm cameras as well as the Ipan camera call for a 4 × 5-inch enlarger. The Globuscope, the Roundshot 28/35, and 6 × 17cm cameras require a 5 × 7-inch unit. Finally, 6 × 24cm cameras and some 360-degree cameras, such as the Roundshot 35/35 and the Hulcherama 120, as well as any other 10-inch film length, needs an 8 × 10-inch machine. None of the panoramic negatives fits any of the standard glassless negative carriers. These negatives must be enlarged in a glass carrier long enough to hold them.

Another option used by a number of photographers is having standard negative carriers milled out by a machinist. I had this done many years ago and have rarely had to use glass holders. Lens coverage for enlarging black-and-white panoramic formats follows the same guidelines that govern any conventional format. That is, a medium-format enlarger should be equipped with a lens that is at least 75mm in diameter in

Many panoramic photographers use milled-out standard negative carriers to hold oversized panoramic negatives. I use a silver 6 × 17cm carrier in an old Elwood 5 × 7 enlarger, and 6 × 12cm and Widelux F 35mm carriers in a Beseler 4 × 5 enlarger.

order to cover panoramic formats that are about 2 inches long. Formats that are between 4 and 5 inches long being printed on a 4 × 5-inch enlarger need a 135mm or 150mm lens. Finally, 5 × 7-inch enlargers take a 180mm or 210mm lens, while 8 × 10-inch enlargers require either a 240mm or 300mm lens.

CONVERTING A STANDARD ENLARGER TO A SCANNING ENLARGER

Perhaps one of the most unusual adaptations is the conversion of a standard enlarger into a scanning enlarger. The scanning enlarger is designed to move the film past the light source as the paper moves past the lens. According to Jack Rankin, the machine's designer and the co-author of *Panorama California* and *Panorama Hawaii* (Hawaii: Mutual Publishing, 1984 and 1988, respectively), this means that you "can take a single negative that may be anything from a few inches wide up to several feet wide and enlarge that negative up to six feet high by any width (several hundred feet) on one single piece of paper."

Determining Print Size

No matter what format or type of enlarger you use, deciding on a print size will depend on the size and quality of your negative, on your purpose, and on your tastes. I know a photographer who, in the tradition of "segmented panoramists" of the nineteenth century, tries to make his prints as large as possible, while another sets the print length in proportion to the film format. Whatever print size you choose, remember that

even though you're using 35mm and 120/220 roll film, the extra-long panoramic frame means that you can expect medium-format quality from the 35mm negatives and large-format quality from the roll films.

I work with three papers of varying sizes: 5½ × 14-inch, 8 × 20-inch, and 10 × 24-inch. These dimensions are exactly half of the three standard-size papers that are, respectively, 11 × 14-inch, 16 × 20-inch, and 20 × 24-inch. If you wish to make even larger prints. you'll have to buy your paper in rolls of various widths. My main objection to this is that roll paper comes in a limited number of emulsions, paper grades, and surfaces. Before a printing session, I make up the paper sizes in quantity and store them. These sizes have about a 1:2.5 aspect ratio and therefore match the Widelux F, Bronica, and Hasselblad filmbacks as well as all 6 × 12cm cameras. The aspect ratios for the other formats mentioned here are between 1:3 and 1:6. Although you can cut down the paper even further, I have found it inconvenient to tray process these narrow strips—and the savings in paper costs certainly aren't worth your trouble, especially when you add in the inconvenience of cutting and storing another paper size in the darkroom. I simply print larger negatives in the center of my standard-size papers.

Making Prints

When I make prints, I use four-blade, adjustable easels to hold the papers and a grain focuser to check the alignment of my 4 × 5-inch and antique 5 × 7-inch enlargers as well as the critical focus. I then process the papers in 12 × 26-inch stainless-steel trays that I had made by a local sheet-metal shop in order to save money on chemistry and to make my darkroom less crowded and cluttered. (Each tray is actually slightly smaller than the next so that I can fit one inside another for easy storage.) I buy fiber-based, graded printing papers, usually #3 and #4 grades. I find that these high-contrast papers work well when using cold light sources, such as the one in my 5 × 7-inch enlarger. I combine condenser and cold light in my 4 × 5-inch unit. I reserve the condenser head for low-contrast negatives, but I still print these on #3- and #4-grade papers.

Printing panoramic negatives doesn't really call for any unusual steps. I've noticed, however,

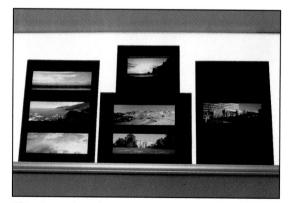

This picture shows just a sample of the variety of precut 6 × 12cm and 6 × 17cm presentation masks available from Viewpacks and Franklin Photo Products.

a more frequent need to burn in the edges with the 617 format, even though I use a center-spot ND filter when shooting. I've also noticed that cropping panoramic shots is quite rare. Generally, I'm able to print all my images full frame, which reinforces my point about previsualizing the final images as you compose and shoot.

MOUNTING AND FRAMING PANORAMIC IMAGES

Mounting these odd-shaped, reversal-film images in formal presentation mats is a relatively easy process. Just attach them to the inside border of the mat with a tape that comes off readily. The best tape to use is an artist's tape with an easy on/off design that is made of paper. Another good choice is the acid-free tape sold by archival-supply houses. Avoid cellophane tape, masking tape, and other household tapes; the chemical makeup of their adhesives is potentially damaging to film.

The actual mounting of panoramic images is simple. Finding precut mats to mount the images in is what is difficult. Again, this is because the sizes of the pictures are so unusual. But mats in a few corresponding sizes are available. Panon, which makes Widelux cameras, offers medium-format (6 × 6-inch) slide mounts that are specifically designed for the 35mm Widelux images. Weiss Plastic makes a 6 × 6-inch glass slide mount for the Bronica filmback, but it can also be used with the Widelux formats. Although the Panon and Weiss Plastic mounts are intended for

Chrom-mounts are based on an L-bracket system in which the two parts of the mount are cut to the size of the transparency and then taped together. The two sizes of mounts fit all of the smaller panoramic formats as well as the larger panoramic formats up to 10 inches in length.

slide projection, you can also fit them into medium-format slide pages for informal presentations and for filing and storage. There are also a few full-page and single portfolio precut mats for 612 and 617 cameras.

Many panoramic photographers cut mats from blanks or modify existing sizes. For example, Viewpacks' mat board, which is designed to hold six 6 × 4.5cm medium-format images, can be altered so that it holds four 612 large-format transparencies. Whether you're modifying a precut mat or making a new one, the cutting process itself is pretty straightforward. Just be sure to use a sharp mat knife or mat cutter. Falling in between precut and custom-cut mats is a unique

tom-cut mats is a unique item called "Chrommounts." These consist of two L-shaped boards that are measured against an individual transparency, cut to the exact size needed, and then pressed together as shown on the left. Chrommounts come in two sizes and are another option for portfolio presentation.

The best way to frame panoramic prints is to use the various metal-bracket frames that you can order in just about any size. When you cut the border mats, you'll waste a great deal of material because of the mismatched aspect ratios of panoramic images and conventional mounting materials. (The same situation occurs with archival storage boxes, presentation cases, and shipping cases. To solve this dilemma, I buy oversized storage boxes and divide them into two sections to hold two sets of mounted prints.)

PRESENTING YOUR WORK

I call my portfolio books my "record books." These contain clear pages that measure either 8 × 10 inches or 11 × 14 inches. I include only my very best prints in my portfolio books to show the range of my photography. I make these by printing the image in the center of an 8 × 10-inch or 11 × 14-inch sheet of paper with black borders. When I present my work, I often bring along one or two exhibition-size prints as well to demonstrate that the quality of my images holds up when they're enlarged. However, I find that portfolio books are the most convenient way for

me to show my work. Because finding the necessary oversized presentation cases poses such a problem, many photographers have impressive, custom cases made. These are expensive, but the photographers feel that they worked hard to create their images and want to show them in the best possible way.

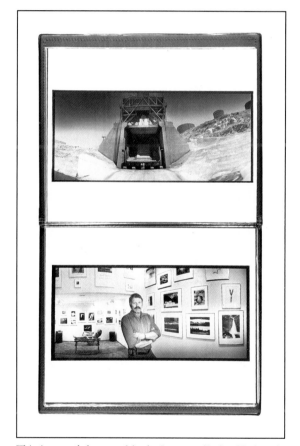

This is one of the record books I use to display black-and-white panoramic photographs.

COPYING AND PROJECTING PANORAMIC IMAGES

You can copy panoramic transparencies the same way you copy any others: either by a contact process for 1:1 reproduction or by projection for enlargements. But photographing a panoramic transparency with a camera for 1:1 copy work is uncommon. Occasionally, I have 6 × 12cm images blown up to 5 × 10-inch prints for my portfolio; they look quite impressive. Under most circumstances, however, this isn't necessary because panoramic shots are so large to begin with. More often, photographers have Widelux 35mm and Bronica transparencies enlarged to two or three times their original size for inclusion in a portfolio.

Projecting panoramic originals creates some serious problems. None of the panoramic formats can be used in a standard 2 × 2-inch slide projector unless it is "copied down" with a 35mm camera. This technique produces good results. But you must remember that the usable area of a 35mm slide, with its 2:3 aspect ratio, is quite small when you're trying to fit in images with ratios of 1:2, 1:3, or 1:4. It is much better to copy your transparencies onto 120 roll film and cut it down to fit into a 6 × 6cm panoramic glass slide mount made by Weiss Plastic. You can then show these images with a medium-format projector. The results will be spectacular. Keep in mind, though, that the cutting-and-mounting process is time-consuming. The best approach is to use a Bronica or Hasselblad camera equipped with a 35mm panoramic filmback. This enables you not only to avoid most of the cutting afterward, but also to use 35mm copy film—and it produces better dupes. (This special film isn't available in the 120 roll size.) The final slides, with their 1:2 ratio, will need some masking to accommodate the 1:3 and 1:4 ratio originals. Remember, too, that Bronica and Hasselblad panoramic images fit Weiss Plastic slide mounts, while Widelux F images call for Panon medium-format mounts for a perfect fit.

Because using conventional slide projectors to show panoramic images is so difficult, I've relied on overhead projectors in my classes and workshops for years. I've used several overhead and graphic films for display purposes. Kodak's Fine-Grain Positive film, which unfortunately is available only through the company's Graphic Arts catalog, is particularly effective with regular black-and-white negatives. This film can be exposed and processed pretty much the same way standard film is; it simply requires a special safe light. The full-tone positive that results is perfect for projecting panoramic images from either original negatives or prints. (There are also color-transparency films and processes for producing colored overheads, but I've generally found the color renditions unacceptable. Projecting original transparencies in black portfolio mounts on an overhead machine is a better choice; you'll have good-to-marginal results.)

I also have success with another approach. Although the image quality from an original negative is better, a copy negative (of a finished print) that I make with a 6 × 7cm SLR camera and a macro lens also produces excellent results. Actually, I prefer this method because I often manipulate the final print via burning and dodging, and sometimes I alter the contrast as well. Kodak's Fine-Grain Positive film, on the other hand, doesn't respond well at all to burning and dodging, and allows little control over contrast. To copy your prints, simply arrange your copy lights at a 45-degree angle to the photograph. Then with your camera mounted on a tripod or a copystand, use a gray card to set your camera's exposure meter.

MAKING A PROFIT

If your goal is to make money with your panoramic photography, consider some realities. Most potential customers don't know about—and sometimes don't even understand—panoramic photography. Also, you'll generally be selling only one or two shots to a customer rather than a series of shots. The reasons should be obvious. One photograph does it all, and the cameras are inappropriate for detailing. Another fact to face is that while more and more panoramic photographs are showing up in publications, a substantial bias against them still exists among art directors and picture buyers. Finally, relatively few photographers make a living from just their panoramic work. Those who do have specialized in a particular area: the large-group shot.

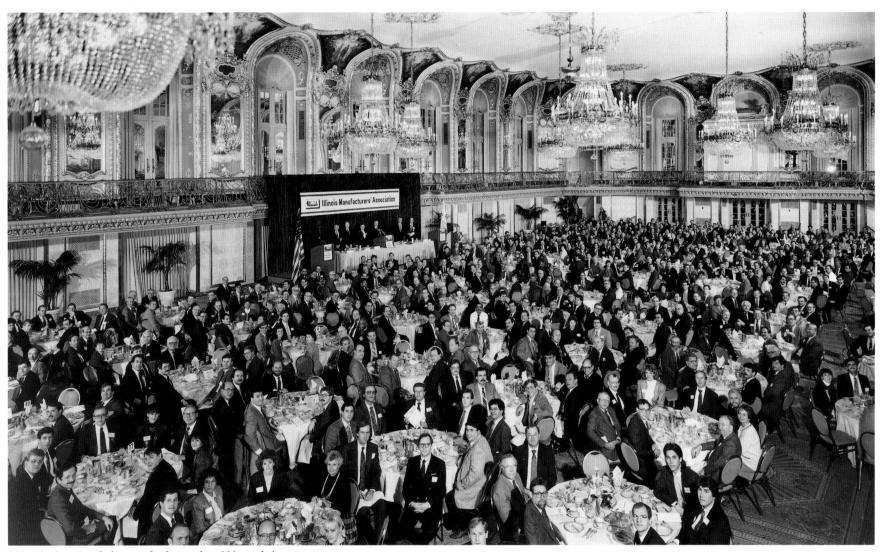

This selenium-tinted photograph of more than 900 people is an example of banquet-camera photography. Thomas Yanul made this picture in the classic tradition of flash-bulb exposure with a Folmer and Schwing 12 × 20 banquet camera. (Courtesy: Big Shot Photo Co.)

PROMOTING YOUR WORK

One of the most important points to realize about promoting panoramic photography is that most customers aren't fully aware of its capabilities. It is up to you to provide insight. You can accomplish this one of several ways. For example, compile a portfolio of some of the best images appropriate for the potential customer's purpose. Bring with you other images that you can leave behind for the customer to look at. I don't, however, mean an expensive, four-color composite; several 8 × 10-inch enlargements or contact sheets are fine.

Another approach, which I have found to be more effective, is based on comparing panoramic photography with conventional images. I do this with black-and-white side-by-side photographs, one made with a 35mm camera and a conventional wide-angle lens and other with a panoramic camera. When dealing with transparencies, I use a *flip mask.* For example, a 6 × 17cm shot in a single-page mat has a 6 × 7cm overlay. When I flip up the overlay, or mask, the full panoramic view is revealed. The effect is startling—and quite impressive. Once your client understands that your photographs are different, you've not only established the foundation for a sale, but also justified the higher price of your images. And remember, you're selling just one or two shots that can do it all for your client.

Of course, you might also want to offer conventional photographic services to round out your presentation. You must make a choice.

W.W., Inc., maker of the Cyclops camera, uses this flip mask over a black-and-white print in one of its advertising brochures. (Courtesy: W. W., Inc.)

Should you concentrate solely on panoramic photography, or should you combine it with a conventional specialty? For the most part, people making their living solely by panoramic photography are photographing large groups. There is a science to this application, and speaking with some masters about their business and techniques might give you some answers.

As with any aspect of commercial photography, the business practices of the photographer often makes the difference between success and failure. Some "panoramic-only" photographers use a combined approach in which they work with other photographers as a specialist on call while they pursue direct sales. These include exhibition prints and posters, as well as special-event photography, architectural photography, and location photography.

STOCK PHOTOGRAPHY

An area that has recently become a source of income for many photographers is selling stock. In *Shooting for Stock* (New York: Amphoto, 1987), George Schaub says, "The appetite for photography in today's marketplace can only be described as ferocious. Every day, thousands of pictures are sold and published in all printed media—in books, magazines, greeting cards, posters, calendars, advertisements, public relations brochures, annual reports, trade journals, and newspapers." All of these sources represent potential outlets for direct sales by the panoramic photographer.

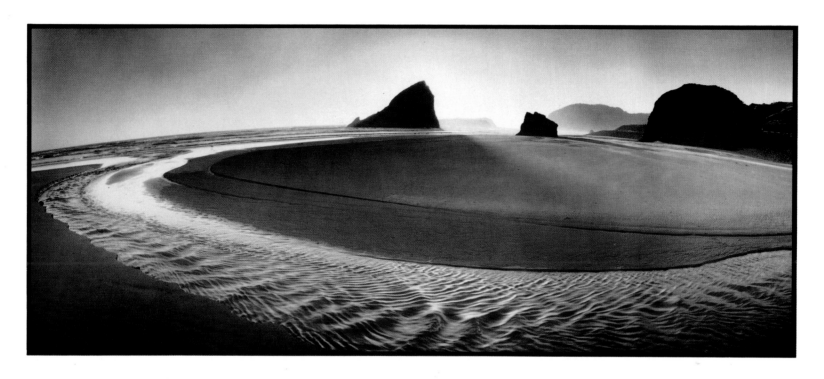

WEST COAST PANORAMICS

JOSEPH MEEHAN

I had a black-and-white poster of my "Crown of Water" image, seen on page 88, made up for promotional purposes.

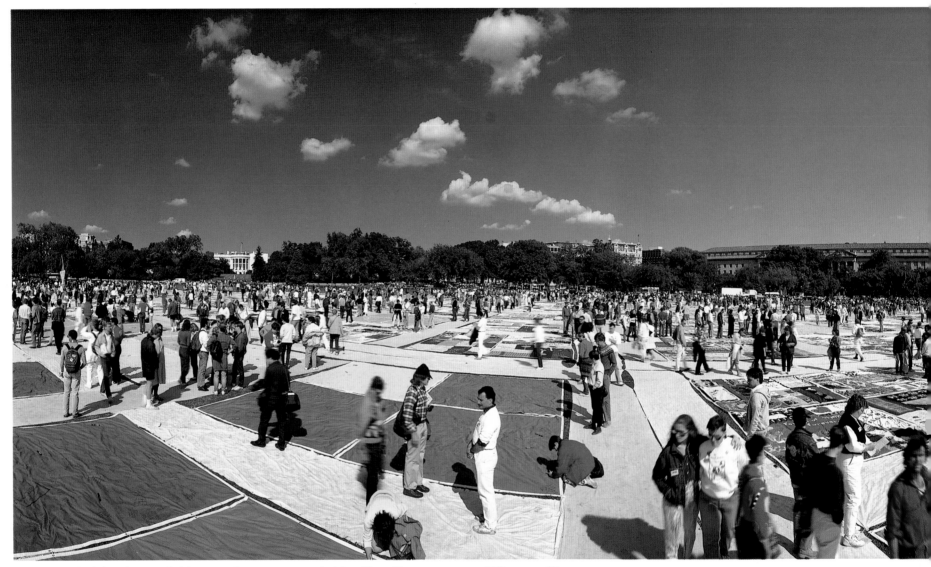

Sometimes a little bit of camera height goes a long way, particularly when a subject area is flat and vast. For this photograph of the AIDS quilt in Washington, DC, Mark Segal used a Hulcherama camera, raised 12 feet, and a polarizing filter. The exposure was 1/60 sec. at f/8 on Fujichrome 50. Because this panoramic image captures intense emotions about an important topic, it is an ideal stock shot. (© Mark Segal/P.S.I. Chicago 1990.)

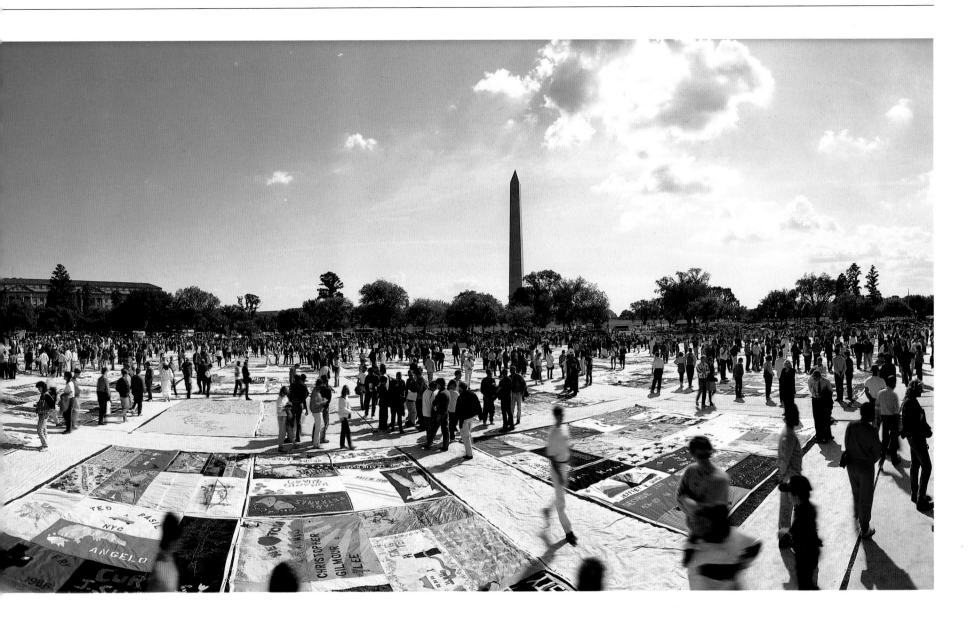

Nevertheless, many photographers prefer to sell their images through a stock house. These agencies take a photographer's work and then present it along with that of other photographers to a picture buyer. When the agency sells an image, it splits the fee with the photographer, usually fifty-fifty. This might seem unfair to the photographer, but you must remember that the stock agency is doing all the work of storing the images, selling them, and collecting payment, as well as alerting the photographer to potentially best-selling images by providing "need lists." These contain subjects the agency knows that clients need now or might need in the near future. With the increased interest in panoramic photography, some stock houses are beginning to accept panoramic images as part of their regular collections.

Finding the right stock agency for your style and output is similar to finding a job. You have to go out and match your abilities with the company's needs. Take a look at some of the books on this subject, as well as the articles about it that frequently appear in photography magazines and at workshops. One agency, Panoramic Stock Images (PSI)—as its name suggests—accepts only panoramic shots. According to owners Doug and Mark Segal, there are certain differences in working with this type of stock image that photographers should be aware of. First, while the small market for black-and-white shots is showing some growth, most of the images that sell are color transparencies.

The Segal brothers also point out that the most frequent sales are among the 1:3, 6 × 17cm formats, followed by the 6 × 12cm nonrotation and short-rotation formats and 70mm rotation formats. Images with aspect ratios higher than 1:6 just don't sell well enough for PSI to stock. This means photographs taken with 360-degree cameras at rotations that are less than full circle. And in terms of subjects, the Segals have found that the biggest sellers are cityscapes and wilderness landscapes. Other popular shots include dramatic renderings taken at night or at sunset, as well as images taken during the day that contain detailed shadows. Most of the sales the Segals make are for print-advertising usage or corporate publications, such as annual reports and sales brochures.

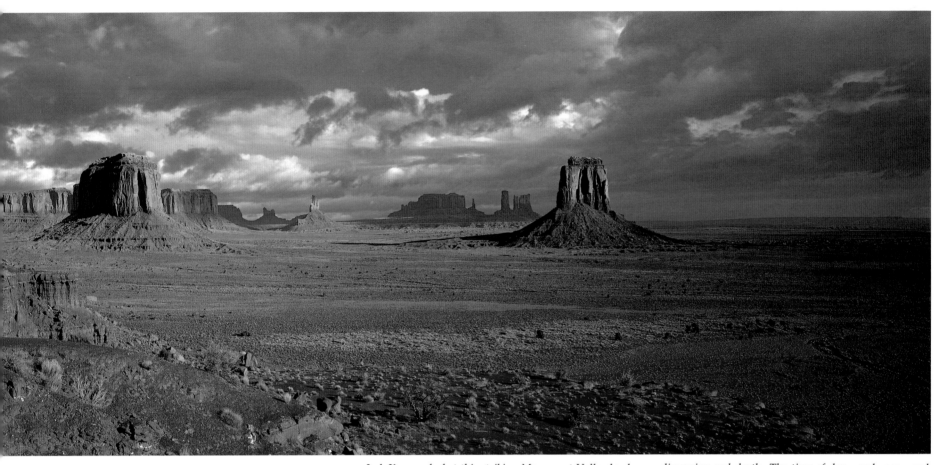

Jack Krawczyk shot this striking Monument Valley landscape with a Fuji 617 camera on Ektachrome 64. This is a strong stock panoramic because the photographer paid careful attention to composition and lighting. The foreground side subject draws viewers into the picture, while the middleground and distant background subjects provide dimension and depth. The time of day—and year—and weather conditions are the most important ingredients for successful stock panoramics. These don't occur simply by chance or good fortune: planning and patience are essential. If a scene isn't perfect, it's not worth shooting for stock. (© Jack Krawczyk/P.S.I. Chicago 1990.)

BIBLIOGRAPHY

Aver, M. *The Illustrated History of the Camera*. England: Fountain Press, 1975.

Bender, R. "The Big Picture," *Darkroom Photography*, September 1986.

Bernard, A. "Panoramic Views and How They Are Taken," *The Modern Encyclopedia of Photography*, Vol. 2. Amalgamated Press.

Burleson, Clyde W., and E. Jessica Hickman. *The Panoramic Photography of Eugene O. Goldbeck*. Austin: University of Texas Press, 1986.

Cameron, F. "360 Degree Panorama Assemblages," *Photographic Magazine*, March 1987.

Coe, B. *Cameras: From Daguerreotypes to Instant Pictures*. New York: Crown Publishers, Inc., 1978.

Dantzic, C. *Design Dimensions: An Introduction to the Visual Surface*. Englewood Cliffs, NJ: Prentice-Hall, Inc., 1990.

Davidhazy, Andrew. "Panoramic Cameras I Have Made," *International Association of Panoramic Photographers (IAPP) Newsletter*, July 1987.

—. "Peripheral Photography: Shooting Full Circle," *Industrial Photography*, January 1987.

—. "Strip Photography," *Photographic Journal of the Royal Photographic Society*, Vol. 124, No. 1, January 1984.

Davidhazy, Andrew, and L. White. "Stretch Your Vision," *Modern Photography*, July 1980.

D'Mura, J. "Widen Your Horizons: How to Make Free-Standing Off-Axis Panoramas," *Petersen's Photographic*, April 1985.

—. "Don Johnson's Panoramas," *Photo District News*, May 1989.

Duncan, K. "Testing the New Widelux 120," *IAPP Newsletter*, July 1987.

------. "The Early Panoramists," *Darkroom Photography*, Vol. 6, January/February 1984.

Ericksenn, L. "Alpa Rota Camera SM 60/70," *Petersen's Photographic*, January 1985.

—. "Fuji G617 Professional Panoramic," *Petersen's Photographic*, August 1984.

Fingesten, P. "Leon Yost, Panoramic Photographer," *Arts Magazine*, Vol. LVII, No. 6, February 1983.

Gaunt, Leonard, and Paul Petzold. *The Focal Encyclopedia of Photography*. Stoneham, MA: Focal Press, 1969.

Gelman, J. "It's a Wide, Wide, Widelux World," *Modern Photography*, October 1987.

Grundberg, Andy. "Does Changing Formats Change the Look?," *Modern Photography*, July 1980.

Hattersly, R. "Make Multiple Image Photographs," *Popular Photography*, March 1986.

Henry, R. "Cirkut Printing at a Commercial Lab," *IAPP Newsletter*, July 1989.

Howard, D. "Wide World of Panoramic Photography," *Darkroom Photography*, Vol. 11, No. 1, January 1989.

Howell-Koehler, Nancy. *The Creative Camera*. Worcester, MA: Davis Publications, Inc., 1989.

Jiskra, D. "Dynamic Panoramics: A New Way to Get the Big Picture," *Petersen's Photographic*, July 1979.

Keppler, Herb. "Expanding Your View," *Modern Photography*, January 1984.

Kraus, B. "The World in Wide Angle," *Petersen's Photographic*, October 1980.

Kubota, Hiroji. *China*. New York: W. W. Norton & Co., Inc., 1985.

Long, R. "Linhof's Technorama and the Fujica Panorama," *Petersen's Photographic*, August 1983.

McBride, B. "Al-Vista Panoramic Cameras, Part I," *IAPP Newsletter*, April 1989.

—. "Evolution of the No. 10 Cirkut Camera," *IAPP Newsletter*, August 1986.

—. "Al-Vista Panoramic Cameras, Part II," *IAPP Newsletter*, July 1989.

McKeown, James M., and Joan C. McKeown. *Price Guide to Antique and Classic Cameras: 6th Edition, 1987-1988.* New York: Amphoto, 1987.

Meehan, Joseph. "Super Wide: A User's Guide to the World of Wide Angle Lenses and Panoramic Cameras," *Popular Photography,* October 1988.

———. "Widelux 1500 Field Tests," *IAPP Newsletter,* July 1987.

———. "Wider Perspectives on Panoramic Photography," *Industrial Photography,* August 1987.

------. "New Tools: Alpa Rota 70mm SLR Panoramic 360 Camera," *PSA Journal,* Vol. 55, June 1989.

Niekamp, W. "Linhof Technar," *Darkroom and Creative Camera Techniques,* Vol. 7, No. 6, November/December 1986.

------. *The Official Price Guide to Collectible Cameras.* House of Collectibles: annual publication.

Palmquist, Peter. "Carleton E. Watkins' Oldest Surviving Landscape Photograph," *History of Photography,* Vol. V, No. 3, July 1981.

———. "The Early Panoramists," *Darkroom Photography,* Vol. 6, January/February 1984.

------. "Panorama Camera: To Get the Big Picture You Need the Big Camera," *Texas Monthly,* Vol. VII, September 1983.

Paskin, D. "Design of a Panoramic Camera," *IAPP Newsletter,* July 1987.

------. "Paskin's Passion for Cirkut Cameras," *Photo District News,* February 1989.

Rankin, Jack, and Ronn Ronck. *Panorama California: Scenic Views of the Golden State.* Hawaii: Mutual Publishing, 1988.

———. *Panorama Hawaii: Scenic Views of the Hawaiian Islands.* Hawaii: Mutual Publishing, 1984.

Ray, Sidney. *Applied Photographic Optics: Imaging Systems for Photography, Film and Video.* Stoneham, MA: Focal Press, 1988.

Ruetz, Michael. *Eye on America.* Boston, MA: New York Graphic Society Books, 1985.

———. *Eye on Australia.* Boston, MA: Bulfinch Press, 1987.

———. *Scottish Symphony.* Boston, MA: New York Graphic Society Books, 1985.

Schulthess, Emil. *Swiss Panorama.* New York: Alfred A. Knopf, Inc., 1983.

Spencer, D. A. *The Focal Dictionary of Photographic Technologies.* Stoneham, MA: Focal Press, 1973.

Stamets, John. "An Ultra-Wide Angle Skyscraper Camera," *IAPP Newsletter,* July 1989.

———. *Portrait of a Market: Photographs of Seattle's Pike Place Market.* Seattle, WA: The Real Comet Press, 1987.

States, R. "12 Foot Wide Pinhole Panoramas," *Popular Photography,* October 1976.

Stecker, Elinor. *Slide Showmanship.* New York: Amphoto, 1987.

Steinkamp, P. "Converting a Half-Frame 35 to a 360 Panoramic Camera," *IAPP Newsletter,* July 1987.

Stoliar, J., and A. Stoliar. "Spaced Out: Making Panoramic Photographs with Any Camera," *Popular Photography,* March 1989.

Westmoreland, M. "British Cirkut Photography," *IAPP Newsletter,* July 1987.

Wexler, J. "The Wonderful Widelux: A 35mm Camera Unlike Any You'll Ever Use," *Petersen's Photographic,* June 1988.

Whelan, R. "Kenneth Snelson: Straddling the Abyss Between Art and Science," *ArtNews,* Vol. LXXX, No. 2, February 1981.

Wilkes, S. *California One: The Pacific Coast Highway.* New York: Friendly Press, Inc., 1987.

Yanul, T. "Big Shot Panoramas," *IAPP Newsletter,* April 1989.

INDEX